The New Art of Color

THE DOCUMENTS OF 20TH-CENTURY ART

ROBERT MOTHERWELL, *General Editor*

BERNARD KARPEL, *Documentary Editor*

ARTHUR A. COHEN, *Managing Editor*

The New Art of Color

The Writings of
Robert and Sonia Delaunay

EDITED AND WITH AN
INTRODUCTION BY ARTHUR A. COHEN
TRANSLATED BY
DAVID SHAPIRO AND ARTHUR A. COHEN

THE VIKING PRESS NEW YORK

LIBRARY OF CONGRESS CATALOGING IN PUBLICATION DATA
Delaunay, Robert, 1885–1941.
The new art of color.
(The Documents of 20th-century art)
Bibliography: p.
Includes index.
1. Color in art. 2. Painting, Abstract.
3. Painting, Modern—20th century.
I. Delaunay, Sonia, 1885– joint author.
II. Cohen, Arthur Allen, 1928–
III. Title. IV. Series.
ND1489.D44 752 77-28840
ISBN 0-670-50636-2

Printed in the United States of America
Set in Linotype Times Roman

Special thanks to New Directions Publishing Corp. for
permission to translate from *The Selected Writings of
Guillaume Apollinaire* and *The Selected Writings of Blaise
Cendrars*. All rights reserved.

Contents

The Conversations of Robert Delaunay

Art and the State (1939–1940)

III. Essays and Poems about the Art of the Delaunays

IV. Sonia Delaunay

Appendix

Bibliography

Index 251

(*Illustrations follow page 182*)

Editor's Note

The writings of Robert Delaunay in this book, with the exception of the brief statement "Simultaneism: An Ism of Art" that appears in the Arp-Lissitzky *Kunstismen,* are drawn from the comprehensive volume of his unpublished writings *Du Cubisme à l'Art Abstrait,* edited and introduced by Pierre Francastel [Bibl. No. 84], referred to hereafter as Francastel. The translation from the Francastel volume is complete, except for essays that are repetitious or of little interest to the English reader and for notes that are essentially textual in character. My comments on the manuscript rely heavily on and are profoundly indebted to Francastel's scholarship. The translations of Robert Delaunay's writings are by David Shapiro and Keith and Paula Cohen.

The poetry of Guillaume Apollinaire, Blaise Cendrars, and Philippe Soupault has been translated by David Shapiro.

I have translated the essays of Blaise Cendrars, André Lhote, and René Crevel. The essay on Sonia Delaunay's simultaneous clothing by Claire Goll has been translated from the German by Joachim Neugroschel. Most of Sonia Delaunay's essays have appeared only in periodicals; I have translated all of her writings. My interview with Sonia Delaunay was transcribed and translated by Keith Cohen.

Guillaume Apollinaire's essays on the art of the Delaunays have been drawn from *Apollinaire on Art: Essays and Reviews, 1902–1918,* edited by Leroy C. Breunig and translated by Susan Suleiman [Bibl. No. 106]. The footnotes in this volume are by three hands. Those of Robert

Delaunay, R.D. Those by his French editor, Pierre Francastel, which appear as variants in his text or actual footnotes, are indicated by P.F. The balance of the footnotes are mine. Brackets in the text indicate my insertions for the purpose of clarity. Headnotes in italics are also mine unless otherwise indicated.

Introduction

Guillaume Apollinaire, recalling the six weeks that he lived with the Delaunays in their apartment on the Rue des Grands-Augustins in the late fall of 1912, commented, "When the Delaunays got up in the morning they talked painting."

Painting was the substance of the Delaunays' mutually respectful, noncompetitive relationship. Sonia Delaunay was indebted to the theoretical impetus of Robert's art and he honored her exponential achievement. He was more intellectual (although not an intellectual) and she was more intuitive (although not without enormous intelligence and culture). They took themselves seriously—in Robert's case, perhaps, too seriously—but it was clear to them, both "heresiarchs of Cubism," that they were defining yet another direction for the unfolding of modern art. They considered cubism only a partial break from the scaffolding of line and chiaroscuro which had characterized traditional painting since the Renaissance. They were openly sympathetic to all movements of pure abstraction, but were reserved in their admiration for artists who—like the suprematists or the constructivists—were prepared to submerge color into form. In this respect, their love of color was distinctively, passionately French. They couldn't bear surrendering color to form. Therefore, however much they opened the way to pure abstraction in French art during the second decade of this century, they were much more the legatees of impressionism (and in Sonia's case, the fauves) than they were the colleagues of Malevitch, Lissitzky, van Doesburg, or Mondrian.

The art of the Delaunays centers about the following paired concepts: modernity and construction; color and light; simultaneity and rhythm.

Each of these pairs has a significance that can be documented ideologically and polemically, marking off the art they advanced from its detractors or misinterpreters, establishing the historical connection of their art with its antecedents, defining a rhetoric for self-positioning in the movement of modern art. Of equal significance is the distinct relation between each pair of terms and the craft of painting. The word *métier* runs throughout the writing of the Delaunays—*métier* and *moyens*, craft and technique.

Modernity and construction signify a turning toward the future, a break with the traditional techniques of painting, a repudiation of literary and descriptive allusion in art. The modern is signified (and the rhetoric of Robert Delaunay is analogous to, but not derived from the language of the futurists, however much Boccioni sought to make Delaunay's use of the Eiffel Tower a bald-faced copy of the futurists' admiration for the machine) by the destruction of the intact object—Delaunay's use of Cézanne's fractured fruit dish, which he adds, "can never be put back together again,"—the end of art as transcription of nature.

Modernity finishes traditionalism, but construction is the beginning of the abstract and "inobjective" in art. Delaunay regarded his own cubist phase as essentially destructive, but whereas he considered Braque and Picasso mired in their destructiveness, he estimated his own work from 1911 to 1912 (the series of *Fenêtres* [Windows]) and Sonia Delaunay's *Prismes électriques* (Electric Prisms) as marking an advance to constructivity in art, building a new language for painting, which by the 1930s would focus on monumental painting (the murals which both executed for the Paris Exposition of 1937) and the desire to effect the integration of painting and architecture.

Throughout the Delaunays' writing on their art they have attempted to distinguish their assumptions about the nature of painting from those of their teachers and precursors. This is always a risky business, for at the same time that assured artists know best what in fact they are doing, they are often the least equipped to describe it. Language is as much a craft as painting, and fluent artists are not infrequently inept speakers. Matisse's dictum that artists should have their tongues cut out comes to mind, but the Delaunays are spared, for most of their writing remained unpublished (Robert wrote little for publication during his lifetime and

only the impeccable scholarship and care of Pierre Francastel have made his unpublished writings available; Sonia has been no less sparing in her published prose, although she has kept voluminous notebooks of reflections and reminiscences).

What has been made available—Robert's brief essay, "La Lumière" ("Light," see p. 81), originally published in Paul Klee's German translation; his notebooks, sketches, and unfinished essays deciphered and organized by Francastel; Sonia's lecture at the Sorbonne in 1926 and other more brief excursuses on her art—enables us to recognize the primacy of color and light in their art (underscored by Blaise Cendrars's essay, "The Eiffel Tower," which specifically describes the little experiments that Robert undertook to both condense and extend the understanding of the relationship between color and light).

The work of the Delaunays prior to the years 1912 and 1913, although exhibiting their preoccupation with color, was admittedly still indebted to earlier painters: Robert to Cézanne and the cubists, and Sonia to van Gogh, Gauguin, and Matisse. Color was, in their often-repeated phrase, still tied to line, to chiaroscuro, and to nature. The object, however distorted and disarticulated, was reflected. The object stayed put; the artist moved. In 1912, Robert Delaunay painted his *Les Fenêtres sur la Ville* (Windows on the City) about which Klee wrote in *Die Alpen* (1912, p. 700) that he had realized "the sort of painting that is self-sufficient, and borrows nothing from nature, possessing an entirely abstract existence as far as the form is concerned."

This work, followed by *Fenêtres en Trois Parties* (Windows in Three Parts, 1912), *Formes Circulaires: soleil, lune* (Circular Forms: Sun, Moon, 1912–1913), *L'Equipe de Cardiff* (The Cardiff Team, 1913), and *Hommage à Blériot* (Homage to Blériot, 1914), completes a sequence in Robert Delaunay's development which moves from the purely abstract creation of form by color to the reinvestment of identifiable shapes with value and relation by means of color. By this time, Delaunay had found in M. E. Chevreul's seminal *De la Loi du Contraste Simultané des Couleurs (Principles of Harmony and Contrast of Color)*, a theoretical foundation for a discovery he had already made—that even the smallest amount of light contains a universe of color; or that the diffusion of infinite light is only the mathematical replication of primary harmonies and dissonances of color. This theoretical structure—perceived by Sonia Delaunay one evening when she observed the reflections of the new

electric lights installed near the fountain of Saint-Michel—directed her to the study of colored surfaces subsequently incorporated in her Boulevard Saint-Michel studies and her *Prismes électriques*, 1914.

It came to the same thing: both had, together and separately, discovered a new modus for the investigation of the cubist plane—the reticent grays, greens, browns of the cubist palette disappeared and color overwhelmed form. The colors elicited by means of tension and contrast a new structure which was ultimately abstract, disengaged from the object, and yet not intellectual because always vibrant with the life and passion of color. This became the groundwork for the ultimate visual ideology of the Delaunays: simultaneity and rhythm.

One suspects that Chevreul gave the Delaunays simultaneity. Modern life helped; the dynamism and explosive polemic of the futurists helped also, but Chevreul gave the Delaunays and the twentieth century a term that was essentially scientific, while permitting considerable rhetorical extension. Moreover, granted the influence that Robert had on Apollinaire during the latter's writing of *Les Peintres cubistes: Méditations esthétiques* (*The Cubist Painters: Aesthetic Meditations*) (the proofs of which were fully annotated by Robert and reviewed by him with Apollinaire), it is reasonable to assume that Apollinaire made simultaneity a vocational catchphrase. Needless to remark, simultaneity also served Apollinaire—better than "orphism" served the Delaunays—for after 1912 Apollinaire was able to make trouble for everyone by linking futurism and simultaneity, provoking Delaunay and Boccioni to controversy, endorsing one, then the other, confusing both and all. Apollinaire took poetry seriously; criticism hardly at all. And yet at the time it was his criticism that everyone read, hardly ever his poetry. At best simultaneity was a condensation of a simple notion in color theory; at worst it became a weapon, a cult, and a movement, feeding off cubism and futurism, giving birth to synchromism, producing some extraordinary work by the Delaunays, Léger, and a number of others, but contributing scarcely anything useful to the development of aesthetic vocabulary.

What gave the simultaneous its value was the Delaunays' sustained use of the concept of rhythm in color and form. For both of them, but more particularly for Sonia Delaunay, the spatial placement of one color implies other colors, color become form implicates other forms and complementary or dissonant color. The rhythm of a painting—its overall

rhythm (that is the full canvas, painted to the edge, with patchwork, circles, arcs, rectangles, trapezoids of color)—implies a universe that extends beyond the edge of the painting and continues the rhythm of the picture. Each picture is a segment cut from the infinite rhythm of the universe.

The mysticism of a harmonic universe is not foreign to the Delaunays' sensibility, for however much they were nonintellectual, their sense of vocation was not only of having created a new intuition in the craft of painting, but also of having created, through painting, an analogue to Einsteinian physics and modern optics. The Delaunays created a visual notation of the music of the spheres—and that music, rushing from its origins through space, enters our solar system as light and color. However reserved they were in their enthusiasm for Apollinaire's orphic nomenclature, they were in fact closer to Orpheus the musician and poet or to Hermes Trismegistus (whom Robert quotes) than they recognized. But this diffidence is justified, since finally they wanted their honor for having seen and painted profoundly, not for having been heresiarchs or movement leaders.

ARTHUR A. COHEN

I.
Robert Delaunay
Seen by Robert Delaunay

The first selection, "Constructionism and Neoclassicism," written about *1924*, was Robert Delaunay's first effort to fill the interpretive void left by the death of his champion, Guillaume Apollinaire, in *1918*. Before that date it had not been necessary for Delaunay to explain his differences from the various neoclassicisms that populated French art before World War I, nor to distinguish his work from the reigning cubism. Apollinaire, Cendrars, and others had assisted him in that task. However, by the war's end, the circle of poets and writers had been broken and the surrealists and dadaists—with whom Delaunay shared creative enthusiasm but not common intention or craft—prompted him to undertake the writing of a book about himself. This first manuscript, unfinished and fragmented, was written in pencil on onionskin paper, folded like a book, and carried for months in the artist's pocket.

The second manuscript, "Notes on the Delevopment of Robert Delaunay's Painting," like those following it, is marked by a different spirit. No longer feeling himself obliged to justify his place in the modern movement by distinguishing his work from its antecedents, Delaunay is confident of having created a body of work that is original, new, expressive, and, as he insisted upon calling it, "inobjective."

These manuscripts—the expository, critical essay of *1939–1940* on the development of his work, the First Large Notebook of *1939–1940* (abridged here), and, finally, assorted comments on pictures that were not discussed in the notebook—are presented separately. Delaunay's notes forming these final selections are comments on and interpretations of pictures illustrated in photographs pasted on facing pages in his notebooks. For further discussion of these selections, see Pierre Francastel, Du Cubisme à l'Art Abstrait [*Bibl. No. 84*], pp. *52, 65–66, 70–71, 86*.

3

Constructionism and Neoclassicism (1924)
Period of Destruction—Period of Construction
The Present Crisis in France and in the World

Regarding the reactionary attempt on behalf of a neoclassicism that seeks to ignore all the innovations of the past few years . . . After the destructive assault against old artistic forms or canons, which can be traced back to the earliest French impressionists, there can be no return to archaic modes. Among some of those who, twelve years ago, undertook a fundamental reconception of the art of painting in France, this attempt to achieve a new style is most strongly felt. One of its leaders, Picasso, tries to return to a classical painting that reached its peak in Renaissance Italy. It is hopeless to attempt to revive a style. . . . One cannot repudiate what one has found to be true in recent years without losing interest in one's own life and the reality of each epoch. The forms one creates to express oneself are, ultimately, the forms of art itself, and true art ceases to exist when this axiom is abandoned.

The present neoclassical reaction indicates a state of weariness in those painters whose day has passed. While others fight for a constructionism that is not purely theoretical[1] . . . that is, in a parallel and nonimitative way—not even as nature is deformed in the so-called fauve and expressionist schools. If the word "expressionist" stood for a true platform, it would define itself in this manner: the quest for, or rather the carrying into effect of absolutely new modes of expression. This would have a universal significance, in the sense that when these methods of control— of measure (which one can qualify by comparing them to those in music concerned principally with harmonics)—become known to the critics and to the public, a great step forward will have been made in the plastic arts where there is currently great confusion among the elements employed; the imitative and the purely creative being in conflict and persistent duality in the best works of the current painters, both European and American. In this regard, the most interesting aspect of

1. The principal text is interrupted by a reference to a distinct development of which the beginning is lacking. [P.F.]

4

current criticism is the definition of this need for a new art with radically new means.

And, furthermore, expressionism did not have the power to define its aim and methods with the audacity that would have triumphed everywhere. For example, this dualism in expressionism, this lack of expressionism, so to speak, is seen in caricature in the film *The Cabinet of Dr. Caligari*, where the compositional elements jar with the actors, who are not treated with the same technique. The breakup of forms (taken, moreover, from the destructive period[2]) is assimilated in this film to a completely impure end, because it is compared to a state of madness, whereas ten years ago this destructive deformation in painting was a desire for force and construction as opposed to the diseased condition and subsequent ambiguity sought by the creator of this film. All these destructive attempts (the *Villes* [Cities], the *Fenêtre sur la Ville* [The Window on the City], the *Tour* [The Tower]) were nothing more than the search for the balance of a new and sound art that does not lend itself to insane deformations. The nightmare aspect pursued in *The Cabinet of Dr. Caligari* shows only the lack of *understanding brought* to modern works—where precisely the qualities of balance and of pure and sound creation are missing.

This great and mysterious process of modern times: from destruction to construction, where the reshaping of a new Europe from every point of view is, in what concerns universal consciousness, the most intriguing current development, and the most necessary. . . . The plastic arts are undergoing a fundamental crisis:

whatever the method, so the Art.[3] . . .

The Savages and the Primitives

Their modes of expression, ever since the linear arabesques of the caves, where line served to lend mobility to color without replacing it by a kind of animated writing on the surface . . . They portray movement that is relative, successive. Color appeared in the earliest civilizations, but stylized in geometric patterns. In the work of particular Chinese,

2. In the art of Robert Delaunay [P.F.]

3. This text is interrupted abruptly, as is that at the beginning, and a third development follows on tribal and primitive art. These three themes—constructivism, expressionism, primitivism—unfold logically. [P.F.]

Persian, Arab, and Byzantine artists, however, the first rhythmic colors appear, though they are always accompanied by a feeling of line and symbol. One could say: their function is more to support, to ornament, or to illustrate than to have importance in themselves. Color is always a costume—an adornment—which has, moreover, the tendency to grow dim, to merge with the Renaissance, which, however, made a cult of colors in a way that was impure as regards color itself.

The sense of surface in the primitives was, so to speak, led astray by the painters of the Renaissance, who abandoned the architectural sense of the picture and lost themselves in the purely descriptive paths of perspective and chiaroscuro—where the role played by color was of secondary importance, as an external property. The picture was designed on the basis of perspective: the objects, figures, and so on, being modeled on a scale of values, so to speak, in black, gray, and white (chiaroscuro); and color was put on afterward—subordinate, as an ornament, and not as an essential and constructive element. In addition, color, in spite of its attraction, loses all its unity and force, the picture becoming meta-phorically a *hole*—all the while retaining an apparent unity and richness. All the elements of color mixed in a structure which is foreign to them become neutralized; they are destroyed and form a mixture that cannot result in a harmonious whole or in a truly pleasing fullness. Also—and in spite of the artists most aware of color, such as Tintoretto and Veronese, in spite of the great expenditure of energy and of surprising imagination on the part of these painters—their paintings always remain below the level of the primitives, who used color with greater refinement even in the method and the craft of painting. But, having discovered the colored surface, in spite of their meticulous and incomparable spirit, the primitives did not develop all the means, all the possibilities that this dis-covery called for. There is in their work a linear and arabesque quality which was the effect of separating the colors and bringing out the life in them: their organic unity.

This is the *cloisonné* of the primitives.

Those who follow will probably want to correct this imperfection and will fall into the error of perspective—which was altogether the fault, the error, of the Renaissance and which perpetuated itself for a long time afterward, even up to modern times, having just died out in the teaching of the school on the Rue Bonaparte[4] and of the official teaching

4. The location of the Académie des Beaux-Arts.

of all so-called "cultivated" countries. The idea of wanting to represent space by a mechanical device—this is what has poisoned hundreds of years of painting.

The contradiction of perspective . . .
Hindu and Asiatic perspective, etc.
representation, horizon . . .

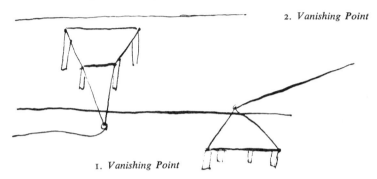

2. *Vanishing Point*

1. *Vanishing Point*

1. Western perspective. Vanishing point: horizon.

The contradictory rules in the use of perspective: for example, in the representation of a table—2, according to the Eastern tradition and—1, the Western.

But if both perspectives are contradictory, insofar as they are perspective they basically share the same quality.

Whether the vanishing point is at the viewer's center or on the horizon line, it is always the idea of description that is central and the methods and ends are the same. Offhand perspective is nothing more than an exception to geometric perspective. But the idea and the methods remain the same.

Thus cubism believed that it was creating a new language—an expressive language—while it did nothing more than create a superficial change in a system that it did not do away with—but which it maintained:[5] the introduction of the technique of seeing an object from many points of view was the result of the same, even if incomplete vision.

The introduction of planes and sections, geometric systems, etc., was

5. At the time of the first appearance of cubism it was hoped that a total revolution would afford totally new modes of expression to art. [R.D.]

not the removal of familiar general rules and the creation of new foundations, merely the revelation of aspects of an idea that was not new. Now we can stand back and see the entire process—and the absence of new foundations for the reshaping of an art which, according to its historians, had the power to create new visions (see the description of quartered cubism by Guillaume Apollinaire, the first formulator of cubism: *Aesthetic Meditations*, 1912) . . .

To create a truly new expression we must have completely new modes of expression.

Cubism used chiaroscuro—which is, basically, constructive—light which, even if it does not fall from a 45-degree angle, is nonetheless light—(white and black) surface forms—fields of vision in section and plane, but represented by the modes of expression of a perspective which, even if it grew out of and away from the so-called "offhand" perspective, still was bound by its laws. Consequently cubism did not create an art with its own foundations, and its construction was only exterior and factitious and enclosed within a system that had been invented long ago. The role of cubism should have been a destructive one. That is to say, after the cubists . . . we should not have been able to return to earlier forms of expression.[6] There are those who, deserting cubism like Picasso to paint reminiscences of Ingres or David, fall into a conventionalism which only proves what has been said, that is, the failure to limn or to articulate a new language, a truth capable of liberating or of expressing oneself completely beyond what has already been seen and thereby proving one's own vital existence.

The two elements which run in parallel development in each period, drawing and color, are nothing but this perpetual dualism in conflict— for example, the case of Ingres and Delacroix has become proverbial. However, this example is not without qualification. Color, desirably, replaces drawing, in the sense that form reaches its fullness when color is at its peak of saturation (Cézanne); drawing, consequently, being in effect a stranger to the problem of volume, not creating real volume as is created by color, volume achieved by the quality and interaction of colors, even without elements of chiaroscuro, by the direct intervention of the simultaneous relations of colors, corresponds to the new art, the

6. After having broken the ancient line, cubism cannot return to it without forfeiting its temporary contribution. [R.D.]

expressive art of color, and can serve as a guide, as a basis, for the study of our times. Cézanne and Renoir were the precursors although their aesthetic was confused with reminiscences of the past, but, nevertheless, Cézanne in particular perceived new horizons, although his troubled and restless life as a painter did not allow him to find the means to approach them. In Cézanne's last watercolors, however, such limpidity tended toward a supernatural beauty beyond what had already been seen—just as the last Renoirs were of an extreme purity, without, however, attaining the major conception of our times, which is to be constructive: to realize composition in all its greatness. With color, Matisse also brought to the fore a new element. Nevertheless, he remained trapped in a kind of impressionism of the color blob [*tache*]. His color was unable to go beyond the scaffolding of the drawing, with the result that its linear aspect always supports color in the picture as a whole. The elements that make up his pictures are both drawing and color in blobs; color does not fulfill its unique and representative function—in the sense of *picture object* [*tableau objet*]—of a picture seen with its *interior* life—after the fashion of a *universe*—where all the formal elements fulfill the demands of *composition*. In Matisse, there is always a sense of something hurried and hasty, an aggrandized sketch from a great sensibility, which is never sustained once the spontaneity has passed. One has no complete and durable satisfaction, only the agreeable impression of a watercolor.

In art a goal must be attained that is more precise, deeper, more durable: to give the likeness of a spectacle of nature with all the brute force of the elements, the variety of materials and of forms. The picture, naturally, is only a synthesis of likenesses, and, above all, of order in the conception and execution of the work.

The more profound a work is, the more soundly constructed it is, the more lasting the pleasure to be derived from it. These three colorists—Cézanne, Renoir, Matisse—lack the fundamental means of expression, the formal means that permit the making of a work truly constructed as a total creation.

For example, Cézanne lingered over the study of the individual object to the detriment of the whole. One feels that in his work he is copying the objective image, and that this prevents him from expressing the great problems of composition that he glimpses from time to time and of which he dreams. And Renoir, preoccupied with the craft, the minutiae of the craft, detail, polarized his color instead of distributing it in large,

compact planes—which would have resolved the composition. . . . In his work it is detail that decides, somewhat haphazardly, impressionistically, upon the direction of the work. One does not feel a great clarity of vision and a directing intelligence which orders the picture, but rather an aspect of nature copied or interpreted by an exquisite sensibility. In addition, no great emotion is felt comparable to the emotion one feels in front of a human work of creation.

It is precisely in these paintings that the dimension of naturalism—in the sense of naturalistic qualities copied or introduced into the picture, of visual qualities arranged with the most subtle taste—is not enough to create a work in the so-called "grand style." A work of art is not the result, directly or indirectly, of gathering aspects of nature, but of the unity of forms, which is the fruit of the creator and of his strength. One does not make a picture with taste, whether it be of French or of African tribal origin; a work is, rather, the synthesis of different forces encountering one another face to face (which can be characterized as the laws of contrast—and these laws are universal). This is also the place to say something concise about the real and envisaged possibilities of inquiry into painting. We are aware of the intentions and intuitions of our precursors—but we cannot live on intuitions. A voluntary responsibility must preside over the area of craft in its bearing on the understanding of the work. And this clarity is the function even of the work's creator. The part played by intuition in creation would take us into the study of psychoanalysis; therefore, let us be content to speak about the role of the elements: the choice of elements or the order that dominates the visual work, particularly, in painting—this work being what is at the same time most simple, most sensitive, and most realistic.

Thus painting must have its means of expression, its expressive laws. Color, which is the fruit of light, as Apollinaire wrote in the poem "Windows,"[7] is fundamentally the material means of painting—and its language. The painter, consequently, works with physical elements that his will must dominate in the unity of the painting. Colors, being measurable, are distributed over the surface of the picture, which is the only referent for the criticism and enjoyment of the work as a whole. The colors determine among themselves other rhythms that are re-created in

7. Guillaume Apollinaire, "Windows," infra, p. 169. The line to which Delaunay refers is undoubtedly: "The window opens like an orange/Fine fruit of light."

the eye of the beholder—and not only on the surface of the picture—in what are commonly called *optical mixtures*.[8]

Consequently, the measurable object called the picture, a surface of two or more dimensions being read simultaneously in the visual radius, becomes an object with multiple dimensions. These multiple dimensions form groups, which oppose or neutralize one another, color being a rhythm in vibration depending on this or that intensity, seen in its surroundings or seen as a surface, in its interaction with all the colors. The vibration of an orange placed in a composition next to a yellow (since these two colors are placed almost side by side in the diagram of colors, their vibrations are consequently neighbors) occurs at a great rate. If in the same composition there is a blue-violet, the blue-violet will vibrate far more slowly against the orange-yellow. All the other colors, according to their distance and their quantitative relationships, vibrate . . . and, depending on either the predominant color or on the balance of colors, the colors vitalize or subdue one another. Thus it is with the help of these methods, which are the foundation of current painting, that the painter finds the elements with which to express forms: their interaction in created, subjective space, which is not space in perspective copied according to antiquated formulas, but the formal, dimensional space of the picture, its new life in reality. . . .[9]

Several further points should be elucidated at this juncture which have to do with the construction or elaboration of the purity of the methods of painting and its physical craft and their interactions with the creative or harmonic meaning of painting.

Pure painting has assimilated the prejudice of not representing things from nature, of making aesthetic works outside of life, etc. It is therefore useful to emphasize that those methods which are antidescriptive and altogether expressive in the true sense of the word do not preclude

8. *mélange optique*: optical mixture or blending, or as M. E. Chevreul (1786–1889) calls it in his important work, which had such a considerable influence on the art of the Delaunays, *De la Loi du Constraste Simultané des Couleurs* (1839; first English edition, 1854), *contraste mixte*, which Faber Birren, who edited the new edition of Chevreul (*Principles of Harmony and Contrast of Color*, New York: Reinhold Publishing Co., 1967, p. 79), explains as the effect of a complementary image of one color on the appearance of another, producing thereby what could be called a "new" color.

9. Repetitive and obscure concluding paragraph omitted from translation. Cf. Francastel, pp. 60 f.

objective representation of things in the universe. Quite the contrary. They favor it, with an objectivity that is much more intense, realistic, and not at all mechanically reproductive; and they approach the most human understanding, which is distinct from the naturalism of the primitives. The difference and the authenticity of this innovation are ensured in their presentation and their strength by the very essence of *expressive control*. In comparison with past descriptive techniques, the result of these methods of pure painting is an amazing profundity, dynamic and full of contrast, produced by the life of colors themselves and their vibrant organization, from which emerges a robust, humane strength, making the old means of expression seem stiff, dead, and conventional.

Between this conventionality and the uncertainty of the impressionists, which was overly hasty and unmethodical, the cubist phase intervened, which was destructive. The passage from *the destructive to the constructive*: we must resolutely pursue the search for positive expressive methods. These methods constitute the goal and the purpose of this book.

Passage from Old Methods to New

This is the first draft of material that constitutes the basic substance of the Notebooks *of 1938.*

Works which, while appearing to be in conflict, heralded the new period, and their influence:

Saint-Séverin, Les Villes, Les Tours, Les Fenêtres sur la Ville, Ville de Paris.

Saint-Séverin—1907 and 1908 Saint-Séverin marks the passage from Cézanne to the confusion that followed and to the destructive patterns of this period; the uncertainty of earlier methods and the search for another aesthetic: the collapse of traditional perspective; light as an element in the disorganization of line; color, trying to find itself in this shakeup, but lacking strength of organization, produces a conflict among the standard elements of painting; the depth achieved by the value of colors, rather than by their real interaction, influenced many painters and influenced expressionism itself.

Cities—1909 In the *Villes* the same things are going on, but sharpened. All spaces are broken up and divided, until infinitesimal dimension in every direction is achieved. It is a dynamism dissolving yet remaining complete. It is the liquidation of familiar methods in art as respects line, color value, volume, chiaroscuro, etc. . . . Influences in America, France, Germany, and Russia.

Towers—1910 CATASTROPHIC ART Dramatics, cataclysm. This is the synthesis of the entire period of destruction: a prophetic vision. Also with social repercussions: the war, the collapse of social foundations. Visions of catastrophic insight, prejudices, neurasthenias, neurosis, sweep the old away; cosmic shakings, desire for the great cleanup, for burying the old, the past, everything is directed toward their entombment. Meanwhile, other visions in the storm point toward new things: the language of the radio, transatlantic communication, nights of nightmare without hopes, nothing horizontal or vertical. Light deforms everything, breaks everything; no more geometry, Europe crumbles. Breath of madness (futurism before the theory): dislocation of the successive object. Planetary waves. Influences on the poetry of Apollinaire: *La Tour*, done in Berlin in 1911; from north to south, etc. . . . on futurism, on patheticism, on expressionism, on the American painters, etc. . . .

A little after the *Ville de Paris*.

Vision of Paris: transition toward constructive color, a state midway between the destructive and the constructive. A baroque totality. A synthesis of *La Ville* and *La Tour*, united by color value and not by color itself. Female nudes are houses, houses are nudes. The ancient grace reappears: Pompeii! But drowned in the desire for new composition.

Fenêtre sur la Ville—1911 and 1912 The first germ of color for the sake of color. Influence: *Du Rouge au Vert, Tout le Jaune se meurt,* G.[uillaume] A.[pollinaire].[10] Speech is color, form is color, depth: toward the greatest realism, but created and living realism. Human realism. Compared with the first musical emotion produced by Bach: the fugues; phrases of color.

Pure poetry—and plastic—lyricism—in opposition to the old succes-

10. Guillaume Apollinaire, "Windows," infra, p. 169. The first line of this celebrated poem which is translated: "The yellow dies down from red to green."

sive monody. Mobility of color, fluidity of form in depth, influence on all current painting: rayonism in Russia, synchromism in America, orphism in France, simultaneism in France, and even on the cubists who were not concerned with color, like Léger, Gleizes, Villon, etc. . . . who were cubists in the sense of chiaroscuro, and who repudiated color as inconsistent with cubism, as something merely *decorative* to form. See the books on cubism of the period by Gleizes and Metzinger.[11] Delaunay was the only one to react against the whole period and was called the first heretic of cubism. The first who gave color a unique and constructive role.

Influence on the Poetry of this period:
Les Fenêtres de ma Poésie sont grandes ouvertes;[12]
The elastic poems of Cendrars.
Influence on posters, decorative art, book bindings, clothes, hats.[13]

L'Equipe de Cardiff—1913 What follows is the first great achieved application of color to a large surface. It is no longer *La Ville de Paris,* which was cut up and shattered. The surface of the picture is living and simultaneous. The whole picture is a unity of rhythms. Modern elements: the poster, the *Grande Roue* [The Large Wheel]. *La Tour* was part of a football game, bodies tangled up with life. Their relations in space, their movement was part of the larger movement of the picture—not dead and descriptive parts, which atrophy the breath of life yielded by the larger vision of the work.

Influence on Roger de la Fresnaye's picture about aviation shown several months afterward at the Salon d'Automne.

Blériot—1914 A simultaneous solar disc. Forms.
Creation of a constructive disc. Solar fireworks. Depth and life of the sun. Constructive mobility of the solar spectrum; dawn, fire, evolution of airplanes.

Everything is roundness, sun, earth, horizons, intense plenitude of life,

11. Albert Gleizes and Jean Metzinger, *Du Cubisme* (Paris: Editions Figuieres, 1912). (English translation: London, 1913.)

12. Blaise Cendrars, "Contrasts," in *Dix-neuf Poèmes Elastiques* (Nineteen Elastic Poems) (Paris: Editions Au Sans Pareil, 1919). The first line of the poem is "The windows of my poetry are wide open."

13. Principally a reference to the work of his wife, Sonia Delaunay, but also to that of Fernand Léger.

a poetry which one cannot render into language—a **Rimbaudism**. The driving force in the picture.
Solar strength and strength of the earth.

Female Nudes—1915 Application of these discoveries to human portraiture.
The nude that is no longer descriptive, drawn, detached from the whole in which it is found. Interpenetration of the figures in the picture by the entangling of all the prominent parts of the picture. The space of objects in fluid relationships.

Still Lifes—1916 The life of the objects is defined by the color which gives them their weight, their true structure. They are no longer dictionary forms or commercial catalogues. The objects have the mobility of life, their place, their relations, which are not regulated according to a known and definite order, but modulated in their most sensual and human individual expression. Objects shown in their relations of sensitivity, as if rendered human. They look at the spectator; the eyes of the spectator live in them.

1917–1919 Color grows more compact, becomes material, more objective, more defined, firmer. Fabric becomes fabric, fruit becomes colored flesh. The construction of color becomes more rigid, always more objective. In the same picture, matter is treated as necessity dictates: in wax, in oil, in paste—depending upon whether the color needs a dry surface (paste) or transparency (wax), or thick and layered material (oil).

1921–22 The human figure regains its rights—portraits.
The *Manège électrique* [The Electric Carousel] is resumed again after fifteen years. Electric dynamism—concentration of form.
etc. . . .
Conclusion. . . .
Color. . . .

Notes on the Development
of Robert Delaunay's Painting (1939–1940)

Born in 1885, began to paint at an early age directly from nature, as did all the painters of the time.

The first canvases that give evidence of a more personal vision were the *Tours de Laon* [The Towers of Laon], 1910 (Luxemburg Museum); the *Saint-Séverin*, 1909 (S. Guggenheim Foundation) and the following: cubist period of 1910 to 1912, which includes *Les Villes*, 1909 to 1910 (S. Guggenheim Foundation); *La Ville de Paris*, 1912 (State Museum, French Section, Paris); *La Grâce* [Grace], 1912; *La Tour*, 1910 (Guggenheim Foundation); *L'Equipe de Cardiff*, 1913 (Collection of the City of Paris, Petit Palais); which are the best-known paintings preceding the period of the first abstract pictures (simultaneous contrasts) in which we see the series called *Fenêtres* (Museum of Living Art, New York University; Peggy Guggenheim Collection, Paris; Ullmann Collection, New York), paintings that move away from a direct vision of nature and exhibit the wish for a renewal of form.

Designation: the *Fenêtres* as a title is still a reminiscence of concrete reality, but from the perspective of the means of expression one can already glimpse a new form of expression. They are windows open upon a new reality. This new reality is nothing less than the ABC of expressive methods that derive from the physical elements of color creating new form. These elements, among others, are contrasts disposed in this or that manner, creating an architecture, the orchestrated composition evolving like phrases in color. In this painting one again finds suggestions that recall nature, but in a general, nonanalytic, descriptive sense, as in the cubist period that preceded it. These canvases mark, moreover, the change in color during the complete evolution of cubism. Guillaume Apollinaire baptized this period orphic cubism. This orphism, this poetry, as the name indicates, concerns color, the formal need for color, and it announces the period of the *formes circulairies* (1912–13–14, Peggy Guggenheim Collection, Paris). This canvas only evokes the subject, the composition, the orchestration, the colors. It is the birth, the appearance in France of the first so-called *inobjective paintings*. Inobjective painting

begins without any external representation or allusion to things—neither to geometric shapes, nor to objects, unlike cubism which revolves around and describes the appearance of objects from all sides and under all forms in a language still dependent upon old ideas of space, more analytic than synthetic. Whatever the complicated perspectives of cubism were, it always began with the representation of nature, a memory, an allusion. (Even in the canvases which appeared at first glance not to depict any traditional form, you recognized, at the end of that moment, an eye, a detachable collar, a volume that constituted a head, and finally a person.) The decisive proof of this is the return, after this passage in cubism, by the cubist painters themselves, to linear figures and chiaroscuro, canvases representing scenes from nature, still lifes, or plastic ideas in literary form.

In the inobjective painting of 1912 there is a formal opposition to even the technique of cubism. The new technique no longer uses chiaroscuro, perspective, or traditional volume, that is, a form drawn and colored after the outline—the teaching of academic tradition. In the painting of *pure color*, it is color itself which, by its play, its ruptures, its contrasts, forms the skeleton, the rhythmic development, without collaboration with old methods like geometry. Color is *form and subject*. It is the sole theme that is developed, and it is transformed beyond all psychological analysis or any other type of analysis. Color is a function of itself, all its action is present at each moment, as in the musical composition of Bach's time or, in our own era, good jazz. It is, truly, the painting that has no need for traditional discursive or literary intervention!

Art never explains itself. It imposes itself.

One can imagine the reactions of the public and the critics about 1912, even in relation to cubism. It took an Apollinaire to take the first steps to recognize the first cells of this new art for which he magisterially supplied the fundamental distinctions between the old paintings and the new, distinctions that still retain *all their value.*

With the first *Formes circulaires* (Paul Viard Collection, Paris)—and afterward, their successors—there are many additions to color themes, despite *Hommage à Blériot* [Homage to Blériot], 1914 (Gazele Collection); *Nu de femme lisant* [Female Nude Reading], 1915 (Girardin Collection); the throwbacks of 1917; the natural allusions in *La Verseuse* [The Coffee-Pot], 1916, which is in the Luxemburg Museum; *Football,*

1922 (Private Collection); the *Coureurs* [The Racers], 1924 (Heim Collection); and the *Tours* (Coutrot Collection) which mark the production and the development of this painting. These *Tours* each being modified according to their period. . . .[1]

Despite throwbacks, what matters in the work of R.D., and what gives it all its novelty at the present time, is the objective clarity of his best canvases, which contain purely pictorial elements. It was in 1913 that Sonia Delaunay, who had not passed through cubism, but who came directly from fauvism, Gauguin, etc., undertook her most important works (*Bullier*, 1913; *Prismes électriques*, 1914), which were also recognized when they appeared by the poet G.[uillaume] A.[pollinaire]. Inobjective painting was born and took its place, with difficulty, amid ridicule and skepticism, especially in painting circles, while imposing itself on the world, affirming itself, purifying itself, developing step by step all the resources glimpsed from its inception, in color. The introduction of time into the structure of the picture gives it new, constructive assertiveness, and imparts force to *this new reality*, which makes it much more effective than even the most talented imitation of nature. The harmonic forces have another human value, a value of fullness as opposed to those that are descriptive or analytic. *The first have in them the affirmation and the decisiveness* of what the human character can produce when most exalted. (The series of *Rythmes colorés* [Colored Rhythms] and *Rythmes sans fin* [Rhythms without End]. This art is completely married to architecture, with which it is able to identify itself. At the International Exposition in Paris in 1937 there were examples of this which, because of their quality and grandeur, remain engraved in the memory. There were certain nonobjective compositions which were not less than 900 square meters, on one surface, in one composition, in the Palais des Chemins de Fer [The Railroad Palace]; another of 780 meters in the Palais de l'Air [The Aeronautics Palace] (an important copy of this is in the Guggenheim Foundation); and besides these, other important panels of smaller scale, but no less representative of this art. The conclusion, even for people who are not completely allied to art of this persuasion, is to nevertheless recognize its significant adaptation to the laws of architecture. They seek to qualify: decorative qualities . . .

1. The *Tours* play a major role in the work of the artist after the discovery of the disc and inobjective painting. During a number of different periods he used this metallic architecture as a vision which shifted with the time. [R.D.]

these paintings. A painting creating an order of architecture, and hanging on the wall, while not making a window—or hole—in the surfaces and proportion of the monument: it is the very definition of the characteristics of art and its use in modern life and its representation in the new architecture. Such a mission could not be accomplished without still lifes. This is because the still life, emblem of the cozy bourgeois life, was made for a sedentary existence and not for our tumultuous and vibrant era.

ROBERT DELAUNAY'S FIRST NOTEBOOK (1939)

The First Notebook *of 1939 is included here. The* Little Notebook *dated 1933, and later changed to 1939, presumably by the artist, has been omitted, as has the* Second Large Notebook. *For an excellent introduction to both the smaller notebook, which is more summary in its discussion of Delaunay's work of this period, and the* Second Notebook, *see Francastel, pp. 70–71.*

Pages

1. A torn photograph with caption: (August, 1913). Shown at the Berlin Salon d'Automne (1913).
4. A torn photograph, with caption.
6. *Tour de Notre-Dame.* (Goetz Collection, United States.)
8. *Portrait de Delaunay.* 1907.
9. *Destructive periods* from impressionism *with cubism included.* Definition of the destruction of the Renaissance tradition: the idea of spectacle, fundamentally a literary subject, which entails perspective as a means; the idea of spaces seen from the outside—rather than a space created from within. The help of technique, of true means: color—which alone can give the dimensional aspect and replace the exterior emptiness surrounding the human. The first cubists are indebted to Cézanne for his investigation of the picture plane.

It is Cézanne who was the precursor and illuminator of cubism. Cézanne's watercolors: the investigation of colored planes . . .

10. or rather luminous planes which destroy the object.[1]

A photograph with caption: *Les Tours de Laon.* (Luxemburg Museum.)

11. Since impressionism, the breaking of the Davidian line: Ingres, etc. . . . The object subsists, but in a state of decomposition [Cézanne's sketch of the fruit dish]. One cannot reassemble.

To destroy the object means the expressive methods used by painters since David—in breaking the fixed line of neoclassicism. The classics were vital for their era, but their canons, their proportions could not survive them. They went to the limits of their expressive methods, which were, in essence, graphic, and led to chiaroscuro.

12. *Saint-Séverin.* (Guggenheim Collection, New York.)

13. In *history* all *ambiguities* exist in relation to cubism; nevertheless, cubism is still very close to us.

Some say that it was Matisse who would have baptized us cubist in the beginning—for others, it's Picasso who would have been its creator, etc. Most often it was paid publicity. This confusion was not disinterested—for, with the forced sale of the German-owned inventories during the 1914–1918 war, didn't we see series of canvases arranged in packages, and very commercially ordered in series? I do not judge here the spirit of copies, for it was the case with many older and modern painters to redo several stages of the same composition, responsive to the necessities of a justified change. This profit-making confusion intervened again when impressionism was born. Renoir and Cézanne were, nevertheless, involved in the confusion, but commercial problems were based on other values, values based on . . .

14. *Les Fenêtres* (1912). (Museum of Living Art, New York University.)

15. a lighter, more superficial understanding among contemporary painters. Many books were written, etc., and the great Cézanne *cursed*, but continued to work profoundly in the south of France.

It was later, much later, that other generations, not his own—naturally—could discover him among all the painters of his time.

1. He preserves chiaroscuro and the light source even in the discs. [R.D.]

It is we who ask to be taught by him, to be initiated into his art that made such a scandal, and with him Renoir, the great Seurat, and van Gogh. All these painters emerged last in the public eye, and yet they were the first. *Cahiers d'Art*, for example, was just a caricature of this industrialization. And all the books and the little quarrels only compounded the fakery. And the false collectors, the poachers, and debunkers, who had the password for undoing this or that piece of business. However, true values are the true commerce—the only commerce. That is why, in spite of all this infighting, false values have collapsed—there was a surfeit of them. Once the surprise had passed, only craft . . .

16. *La Ville.* 1911. (Guggenheim Foundation, New York.)
17. living form remains.

Living form alone is the record of the time. Cubism got no further than analysis, deduction.

And so! analysis is far from synthesis. Synthesis alone remains as a period's summation, as a summation of *all periods*, because a masterpiece of the past still lives.

Analysis is not art. Maybe it is science—but this is what separates us from science with its filing cards.

And our first comrades from the cubist combat have stayed with analysis, or conformism, because of their pictorial craft. For painting is a craft, a manual craft. The expressive mode of this craft includes the means used for its end.

The cubist want to return to the picture plane. Cézanne's fruit bowl, already depicted by him with so much force, cut up by the Cézannian light, is definitely broken by us, the first cubists.

Once the fruit dish had been broken it could not be put together again . . .

18. *La Tour* (1911). (Guggenheim Foundation, New York.)
19. and there alone is the whole process of this period 1909–10–11: the expressive technique of destruction. They all exulted in this state of things, doubtless with a great deal of talent—but ideas were lacking. The pieces of the fruit dish persisted, returning endlessly, presented from every angle like a surgical performance—but life was absent. The object was quite dead—and with it the whole symbol that it represented, despite the abstractions which were now and then quite felicitous and talented.

After having broken the line—a line that is very old—one could

no longer put it together, or adjust it. There were other things to do, to find another spiritual condition. Historically it is very much a change in understanding, of which the technique, the mode of seeing . . .

20. *La Tour aux rideaux* [The Tower with Curtains]. Coutrot Collection, Paris.)

22. the fruit dish no longer being the support, the object, the end of thought. Something more awesome, more adequate to the moment, to our life, more universal through craft itself. . . . This period, this birth amid all this lack of understanding, this analytical division, this shocking commercialization of works of art founded on personal compromises, and traitorous clerks. . . .[2] All this collapse and this rottenness is the enthusiastic result of these new forces.

At the height of cubism—from 1912 to 1913—technically: it consisted of the broken line, chiaroscuro, that is, graded down from black to white with ochers, browns, greens, several clear yellows.[3]

Its forms were essentially traditional, but were presented in an arbitrary order which was related to the traditional logic of a perspective imitative of nature, chiaroscuro volumes being discontinuously superimposed, as if interpenetrating one another, in syncopated order.[4]

These are the major features of my canvases of this period. At that time, even among my old battle friends, those who did not risk public injury profited from the enormous publicity of the time and were never exposed.

23. They had the right to meager payment for their canvases (forty,

2. An allusion to the celebrated work of Julien Benda, *La Trahison des clercs* (The Treason of the Intellectuals), 1928.

3. R.D. describes here the *Tour aux rideaux* which is referred to earlier. [P.F.]

4. This sought-after and longed-for break came (like hair in the soup), hidden perhaps in the depths of good intention, perhaps of instability, but this instability was not obtained by the sensible means of color and it is in this fact, uniquely in this fact, that two human positions are to be found: one, older and putrescent and the other, ready to be created, *inobjective and universal*: A NEW REALISM. This search for the unstable in cubism was more a doctrine of the intellect which already betrays a serious difficulty. I can speak of it since my cubist years have produced some rambunctious works like *Saint-Séverin*, the *Villes*, the *Tours*, and culminated in the *Ville de Paris*. These contortions didn't satisfy me. I saw intuitively, I foresaw something else which would be more torn, mangled, dramatic. These made a scandal: among others the *Ville* and the *Tour* in Room 41 at the Indépendants in 1912 and everywhere else. [R.D.]

fifty—one hundred francs, these were in the prices).[5] But these payments were a bribe in preparation for petty speculation: the game of the postage stamp, of rarity, of the calf with five paws—the golden calf.

At this moment, about 1912 to 1913, I had the idea for a kind of painting that would depend technically only on color and its contrast but would develop in time, simultaneously perceived, at a single moment. I used Chevreul's scientific words: *simultaneous contrasts.* I played with colors as in music one can express oneself through a fugue of colored phrases. Certain canvases were very tall —I called them the *Fenêtres*—the series called *Fenêtres.* The evidence that these colored phrases vivify the surface of the canvas in measured cadences, following one another, going beyond one another cannot be denied.

24. *La Ville de Paris,* 1909–10–11 (State Collection, France), synthesis of *Tours, Villes.*

25. in movements of colored masses—the color acting this time almost as a function of itself, by contrasts. Later I will define for you, in terms of craft, professionally, what these functions are, these laws of colors.

In this period of the first *Fenêtres*, there were still thirteen canvases that were titled, containing abstract and concrete elements— like bits of curtain, Eiffel Towers, nudes, cities, etc.—and participating in a grammar, dare I say it, that was classical—with words become images. We were quivering at that time! These images, even treated abstractly, were memories of old habits, based more on an old spirit than on one that has been saturated and vivified by a new craft, a spirit of our time—clear and creative—incontestable by the craft itself: the expressive mode which is its method. But I soon reached the goal. I was obliged to show weakness and strength, conformism and truth in struggle. This bit of the fruit dish, in my work,

26. took on the architectural proportions of an Eiffel Tower (my barometer, which will serve me as a fruit dish). This epic battle was full of backsliding, of contradictions in its weaknesses and the regrets, the sense that one is alone (I almost was). . . . A restless

5. A franc at that time was valued at about twenty cents.

period everywhere—we were not far from war. There was something in the air. This happened in 1912. Cubism was in full force. I made pictures which seemed like prisms compared to the cubism my fellow artists were producing. I was the *heretic* of cubism. Great arguments with my comrades who banned color from their palette, depriving it of all of its elemental mobility. I was accused of returning to impressionism, of making decorative paintings, etc. . . . And meanwhile, I felt I had almost reached my goal. Apollinaire, who was writing his book on cubism, and therefore wanted to assemble all its varieties to justify . . .

27. his intentions, who wanted to form a united front against enemy number one—the public—one fine day invented a word for my art: orphic. The hand was played. Quartered cubism is the gathering together of all the elements that fight one another in painting. The word "quartered" would indicate itself that cubism is crossed by various intersecting forces.

And, however, the reminiscence of objects, the scraps of objects in my paintings, appeared to me to be harmful elements. I certainly intended to melt these objective images into the rhythms of color, but these images were of a different nature. The integrity of the concrete forms is not of the same nature; therefore there is dissociation. In cubism, objects were not annoying, because cubism is graphic: the arrangements of the composition are linear; but in color—which is dynamic and of a different nature than the linear—there was conflict.

28. *La Ville de Paris*, commissioned copy. (Coutrot Collection, Paris.)

29. Then the idea came to me of suppressing images seen in reality: the objects which entered to interrupt and corrupt the colored work. I applied myself to the problem of formal color. My first circular colored forms were being produced between 1912 and 1913—and this entire period is a technical re-search of painting. Never in doubt, as Gleizes wrote and said many times, I laid the foundations of a new painting.

Never in doubt is an exaggeration, because everything I have just said clearly explains, I hope, the passage from figurative (traditional) to inobjective (pure painting, reality), with all the uncertainties of its development, all the doubts in facing a completely new problem, a technique to be found, to be discovered so that the form could emerge.

And it is from that time on that I elaborated the plastic methods by which to arrive . . .

31. at what, to my mind, I glimpsed as really living in pictorial art. Writings of the period exist (I have saved them). I have some of Apollinaire's manuscripts which bear witness to the preoccupation of setting a new energetic reality, vital according to its expressive craft, in opposition to the dead end of cubism, which was the consummation of Renaissance painting. These writings spoke already to the spirit, because their title said it explicitly: *Pure painting, Reality.*

Their titles augured a radical change in the art of painting.

There will be, it seems, those insensitive people who will deny that to make a living, present, instructive, intuitive, constructed art, one must go beyond technique. Every great period has had expressive methods, adequate to its goal—that which formed its style. And *the style is always synthetic.*[6]

6. The balance of the *First Notebook* and the entire *Second Notebook* have been eliminated since both consist essentially of a listing of pictures, their dates, size, and ownership without comment. Cf. Francastel pp. 83–85.

COMMENTS ON THE BACKS
OF PHOTOGRAPHS (1938–1939)

[*Consisting primarily of fragmented, repetitive material not relevant to Delaunay's historical analysis of his paintings, the opening passages of this section have been deleted. Deletions of this nature are indicated by an asterisk (*).*]

La Ville de Paris (1910–11–12). (Paris Collection.) Period of passage from old painting to *new*, of which the *Fenêtres* are a ray of hope pointing toward something other than still life, toward a modern dynamism.

Les Fenêtres (1912).

Belongs to a whole series which truly began my life as an artist. It goes beyond me in the sense that, once discovered, it had many developments and was applied to many things. We will see in what follows that through the purely physical principles which are essential to the *Fenêtres*, we can arrive at an art of visual movement . . . that does not have the photograph as its origin and as its death, but is a sensuously grounded representation of laws of contrast.

This principle, absolutely new in every possible development (poster, fashion, fabric, furniture, architecture, *city planning*), will regenerate or give life to everything visual. It is for this reason that I say it goes beyond my personality, my own talent, but I claim, modestly, only a date, because this cost me a great deal in every way (family, too). It is a *language of space* (which perspective was), a sensuous and *rhythmic* language (which early perspective was not), *born of a wish* after periods of destruction of the old methods of conventional painting, drawing, perspective, etc. . . .

It is a new order which, perhaps, justifies the evolution of impressionism and the shattering of cubism, but all the while sustaining *formal methods*. I articulated these formal methods for the first time in *Les Fenêtres*. I was at that time the "heresiarch" of cubism (see *quartered cubism . . . constructivism, neoplasticism*).

Les Coureurs* In these pictures, only color, without chiaroscuro, forms the life itself of the picture.

26

Antidestructive, *analytic.*

Color is a function of space. In Picasso it is decorative—*it colors.* There is, therefore, no true life. It is a chameleon. But the critics do not criticize. Dealers pay for reviews in *Art de Paris* and form a Picasso offensive. He has found everything in *others.* But he has the talent . . .*

Le Football (postwar picture). Old 1913 theme is taken up again in a desire for greater objectivity of movement. It is less descriptive than *L'Equipe de Cardiff.* The actions of the colors are sharper, physically more pure, more suited to the representation of action in movement. Painting is not a symbol. It is a harmony of rhythms, in the spirit of a representation. Painting is a complete art, a whole, which represents in all its purity a plastic act, not an effect (impressionism), not an allusion (cubism and symbolism), not an anecdote (realism, naturalism), but a living act—human, creative, lyrical—with *pure methods* which are painting.

After the rupturing of early cubism one could not return to the *old methods* (Ingrism, etc.). It was necessary to go right to the end, even if it meant marking time. Ingres used the methods of his time. Delacroix went to the depths. Delacroix humanized himself and brought forth Cézanne. Cézanne failed in his own work, but passed the torch. All of us have bathed in the light of Cézanne. Cézanne did not escape, but he has his line. Picasso does not have it because he is restless, eclectic, decadent.[1] He always shattered with lightning and talent. (See Picassoism.) In art, one must pass through and not fall into the traps of tradition, one must be oneself.

Manège électrique. This is a picture I did three times. Once in 1907 (refused by the Salon d'Automne), then destroyed. Once in 1912 (refused by "Artistes Françaises"), then destroyed. Once more after the war (at the Indépendants). Electric prism; dissonances and concordances of colors; an orchestrated movement striving for a great flash; inspired by a vision of a popular fair, striving for the sort of violent rhythm that African music achieves instinctively; cold and warm colors dissect each other, redissect each other violently, creating ruptures, harmonics in comparison with traditional academic harmony.

1. See the chapter on speculation. [R.D.]

II.
Robert Delaunay's
Historical Observations
on Painting

*T*he previous section documented Robert Delaunay's historical exegesis of his work, his interpretation of the differences between his achievement and the precursors of inobjective art (impressionism, cubism). His concern was to separate his conception of craft and constructivity from what he took to be the technical constriction of the impressionist vision of nature and the cubist deformation of nature. The whole point of Delaunay's autobiography of his oeuvre is to ensure that the pictures are read correctly, are seen as he conceived them.

This second and more extensive section of his writings is dramatic, polemical, immediate. Here Delaunay undertakes to write a history and wherever possible to guide and to lead those whom he takes under his aesthetic tutelage. What is clear is that his influence was enormous—considerably more impressive than is generally recognized. His polemic against cubism, which will be found somewhat churlish and competitive, was nonetheless considered indispensable by him, lest he be considered only "the heresiarch of cubism." He wanted and deserved more than Apollinaire had accorded him and he is at pains therefore to make clear that his art was not simply a divergent employment of cubist impulses (although his Ville de Paris certainly betrays cubist technique of composition), but a new art, an art of color, light, and simultaneity. The simultaneous craft, which Apollinaire accused Delaunay of having borrowed from the futurists, was actually derived from different sources. There is little doubt that Delaunay had responded to the dynamist rendering of motion, which was a hallmark of the futurists Boccioni, Severini, Balla, etc., but Delaunay's impetus to the simultaneous craft was less futurism than his reading of M. E. Chevreul's color theories, which depend upon the vibrancy and tension that arise out of the complementarity and dissonance of color. Delaunay was not interested in displaying objects moving within a plane, in which the object's motion is suggested by replication of form and differentiation in color and light. His goal was to penetrate the very core of painting, as a craft and as an art, as becomes clear in this section of his writing. Delaunay found that color, along with the internal relations among colors suggested by their simultaneous contrast, generated the true motion and rhythm of reality. And, as Delaunay's art from the end of the war and thereafter makes increasingly clear, the reality depicted in his work is without literary or descriptive significance. It is abstract, inobjective art.

Cubism and Pure Painting

CONCERNING IMPRESSIONISM (1934)

If impressionism is also the result of a gesture of revolt and of defiance from artists who had nothing but very limited contacts among themselves, as G. Besson writes in *La Peinture Française au XIX^e Siècle* (Braun editions), cubism, so justly quartered by G. Apollinaire, was a gesture of revolt against this same impressionism. In cubism, one finds artists who are diametrically opposed—in ethics as well as in technique. The analytic phase of early cubism, derived from Cézanne and Seurat, gave way to the spirit of synthesis—which gives birth to *abstract art*. This transformation of the spirit of analysis born in primitive cubism gives way to a new conception in painting and arises from synthetic researches begun about 1912 to 1913—it is at this time that it became necessary to go back to understand the whole import of so-called abstract works. Purely pictorial elements such as circular forms and colored rhythms derive from these first embryonic gropings to evolve uniquely toward a new understanding of painting, which defines clearly its limit in comparison with past periods. Painting totally conceptual in its essence, having its proper harmonic laws. A purely human universe. Certain people believed they saw an esoteric art in cubism, indeed limited

to a public of cultivated aesthetes. After the initial shock of heroic times, which had their repercussions even in Parliament[1] (this about the years 1910 and 1911), cubism passed into every phase of architectural production, furniture, fabric, etc . . . which proves its historical importance as well as its importance in its own time. Abstract art is the representation of its time and in very strong reaction to that which illuminated it. It is the complement of the true wall of modern architecture, the wall no longer being a symbol, but a reality living and constructed in space.

The element of circular movement is appropriate to this new art even in its construction of color relations outside of the academic puerility of the figurative or the nonfigurative, because it alone takes into account the spirit of the man who created the pictorial methods and whose life alone is given to the work through the purity of the means employed. The synthetic result is the only one that counts. Abstract, living painting is not made up of geometric elements, because the novelty does not consist in the distribution of geometric shapes, but in the movement of the rhythmically constitutive elements of the colored parts of the work. A geometric shape is a shape that is the equivalent of an ordinary shape in the universe. A circle or a square, an essentially geometric shape, does not constitute a composition, any more than the reproduction of human figure or other figure constitutes the work of the painter. The lyric state of the artist and his visionary power with organic and rhythmic laws of color-form are the guarantee of an abstract living work. This work can join itself intimately with architecture, being itself constructed completely architectonically. It becomes in this moment the living representation of its epoch. It is human: it becomes social.

1. Reference to questions asked in the Chamber of Deputies about the putatively decadent effect on French morals of cubist "distortions."

To Sam Halpert(?) (1924)

Draft of a letter to the American painter that was never sent, which Francastel believes Delaunay kept to use in his book on his own work. The book was never completed. See Francastel, pp. 93–94.

In order for you to reply to the American woman as you ask in your letter, here are the answers in the order of your questions:

There are several beginnings to cubism. All these pass through Cézanne. Simplification of the volumes seen directly in nature, of landscapes, figures, and still lifes, the colors are nonetheless still chiaroscuro. The specific technique is derived from Cézanne. Cézanne more broadly handled: (*Saint-Séverin*) the colors emerald green, the blues, the yellows, the ochers, etc. . . .

A very short time afterward, the elements of the volumes break up more and more, the color becomes more simple, the lines more shattered, the palette reduced to white, black, ocher, emerald green—natural earth colors—some reddish browns.

The usual form of nature disarticulates itself; that is to say, the viewpoint of perspective ís modified.

For example, in representing a house, it's already no longer this house, seen with everybody's eyes, it is a house analyzed in several of its aspects simultaneously—reconstructed not from a directly visual point of view, but from a conceptual one. The line is then cut, broken—and what justifies the break here are the light-dark relationships—a luminous framework—which interpose themselves or contrast with one another. The general view does not express tranquillity. It is the analytic epoch of cubism. The objects are dissected. It is the transitory state between impressionism and abstract art. With analysis, one does not construct. It is the jolting, dramatic epoch of cubism. Its poetry is not abstract. There are relations between this pictorial era and the poetry of Mallarmé (*Sadly a mandola sleeps in the hollow of musical void*).[2]

2. Stephane Mallarmé. *Autre Poèmes et Sonnets*, No. 3, beginning, *"Une dentalle s'abolit."* Cf. *Selected Poems*, translated by C. F. MacIntyre (Los Angeles: University of California Press, 1959), p. 102.

This cubist era, already completed, bears within it its own pathos. (*Villes*, Room 41 of the Indépendants. The first *Tours*, cubist exhibition, 1911.) There is a legend about cubism's beginning.

It is even contradictory in the literature, because the commercialization and speculation in art have already made themselves felt. The proof, the auction of confiscated German property, where one saw certain pictures painted in series without variations among them, but, as it were, stock in reserve, preferred stock: There were interests at stake; the legends were prepared. This is what explains the lack of clarity as to its origins. The great cubist movement is not yet reduced to essentials. So, for impressionism, one saw at its end its great values emerge as a result of the sheer force of things—outside the clan—examples: Cézanne and Renoir.

In order to return to the expressive technique of the analysis of objects or of shapes, the habitual perspective plane is turned around in certain deformed representations of the same object on the same canvas. One sees, for example, a part of the fruit dish from above, another in profile, another from the other side, reassembled by the animation of the planes; planes flattened out and forming a certain liaison through their juxtaposition, justified through a certain link with chiaroscuro.

There is nothing novel from the point of view of technique. There is, however, a revolution with respect to form. A broken form, decomposed, cannot create a pure language, but it was a poetic element of high inspiration. The revolution is in the shattering, already seen in Cézanne's fruit dish and in his watercolors. This is the intention, the desire for a change. It is a transitory state. Science needs analysis, but art does not.

The copy from nature, the possession of the object, has made for bankruptcy. The broken object cannot be reassembled. There is nothing to be done if one begins with the object: with the quartered cubism of Apollinaire.

1911— . . .

1912—the *Fenêtres*—the title is only evocative, surrealist. It is a completely new technique. The contrasts of simultaneous colors are in relation to moving colors. That is to say, color is a function of form in itself and form is not descriptive. It carries its own laws.

No more copying from nature—supernaturalism of Guillaume Apollinaire if you wish—rather, *abstract painting in color*. Color, colors with their laws, their contrasts, their slow vibrations in relation to the fast or

extra-fast colors. Their interval. All these relations form the foundation of a painting that is no longer imitative, but creative through the technique itself. Concerning this, Apollinaire has spoken of orphism, but orphism is literature. In reality, it was the birth of an art that has no more to do with interpretation or description of forms of nature. In its place. As in music, an auditory art, this was a visual art whose forms, rhythms, developments all start from painting as music, which has no sonority in nature, but only in musical relations.

Painting becomes painting.

In this period, about 1912, it was called pure painting.

After the vertical contrasts and the horizontal contrasts of colors in the *Fenêtres* that gave an appearance of prisms and that, at this time, contrasted with the chiaroscuro of black, white, gray, ocher, and brown cubism—which followed the era of the *Disques* and the *Soleils*, that is, the circular phase.

Where the color is used in its gyratory sense, form is developed in a dynamic circular rhythm of color.

All representation other than of objects or natural forms is abstract art.

This does not mean that I did not use allusions to natural forms— portrait, figure, objects, etc. . . . but when I did, it was in a completely re-created form.

A form that is no longer analytic, descriptive, or psychological; a purely plastic form, with relations of colors as the scaffolding.

What properly distinguishes the period of the *Ville de Paris* where the lines have been shattered? Their shattering, as the word says, does away with the sense of continuity. In the period of the *Ville de Paris*, I wanted to create rhythmical relations among the elements of the composition—landscape, woman, and tower—but the break stops this rhythm, this movement, this dynamism. The result is abrupt, the passages of the chiaroscuro tones, the ensemble is gray.

The woman of the *Ville de Paris* sums up the cubist period. In its ensemble, this picture belongs to classical painting. Only in certain formal passages does it prophesy the abstract period of the *Fenêtres*. The *Equipe de Cardiff*, 1913, is more significant in the expression of color, less shattered. The yellow poster in the complete picture contrasts with the blues, the greens, the orange. It is the extent of color that counts in color. In the *Ville de Paris*, there are no longer contrasts as

emphatic or as consciously willed as in *Equipe de Cardiff*, of which I later made a variant that is more dynamic, more colored.

In the domain of the plastic, I have attempted an architecture in color, in the hope of realizing the enthusiasms, the states of dynamic poetry, while remaining . . . uniquely within the plastic means themselves, stripped of all literature, all the anecdotal, the descriptive, etc. . . . But this effort depends totally upon technique.

It is only in technique that one can avoid the *déjà vu* and the conventional.

This is not to say that there will no longer be nature, that there will be no longer objects, figures, etc. . . .

One must begin with the simple, with the living form, with the germ of the moment.

Miscellaneous Observations (1919–1920)

These notes were written on scraps of paper as aide-mémoire *to the artist. See Francastel, p. 94.*

Era of destruction of the old methods in the plastic arts which the press has superficially called *catastrophic art*[1] (the *Villes*, the *Tours*, *Saint-Séverin*, etc. . . .)[2]

The universal language of color, plastic sensibility, plenitude of vital form is the sense of being the total expression of the picture.

The indispensable anarchy of impressionism has excluded the return to the conventional methods of earlier painting.

In the same way, cubism, with its constructive intention for which, nevertheless, it had not established the means (witness its impressionism of volume), still prevents return to conventional drawing, tints, forms, and lighting. Since cubism had shattered the traditionally conventional line . . . one could not return to archaic methods. Cubism has not succeeded, despite its wish, in creating volume, because it was within its destructive transition. It issues from the old (and with the old, one cannot make the new); cubism is the shattering of the old. Cubism historically marks that phase of art which in its desire for a purely pictorial reality thrusts heroically toward novel (means) and a universal goal.

We discover ourselves in front of the most audacious plastic achievements of our time. After having traversed the public domain of all old and modern comparisons, we find ourselves before the most objective creation since plastic art began.[3] It is necessary to locate in its proper womb, 1909–10–11–12 among the cubist precursors (Apollinaire's book: *Aesthetic Meditations*, the Berlin lectures on cubism, etc. . . .), the

1. Presenting in a prophetic manner the great catastrophes on another historial plane. [R.D.]

2. *Peintre de Paris*, through *Villes, Tours, Ville de Paris*, influences Léger (Paris), M. Weber (New York), Meisner (Berlin), Boccioni (Milan) (PATHETICISM) [R.D.]

3. The influence of color, badly directed by the whole group of cubists, in reaction to the black and gray period of Braque, Picasso, Metzinger, Gleizes, Le Fauconnier, Gris, Herbin, etc. . . . coloring in the style of the primitives. Color does not fulfill its primary formal function. Influence on the synchromists. On Macke, the German expressionist painter. On Vianna, Cardozzo, Negrei[r]os (Portugal), Halpert (New York), Bruce, Frost, Loeb (Vienna), Yagovlev (Moscow). [R.D.]

birth of this art, which seemed to be the logical fruit of the researches of a whole generation toward constructive materialization—making its foster-brother look like a still-born mutation.

From its beginnings it developed with vital clarity, which was at heart the cubist dream, although *cubists had no inkling* of its methods. We are everywhere indebted to this initiation that has had incalculable consequences on perspectives whose laws are elaborated each day in a transformation of the very methods that conscious sensibility introduces into the actual womb of this aesthetic, which is *moving, vital,* and *anti-neo,* and vice-versa.[4]

(Comparison of the cubists, who are equivocal about returning to the old methods—traditional [neoprimitivists] geometry of space—or others, who, like Picasso, simply derive from Bouguereau, not being able to obtain the purity of an Ingres [Ingres being already of the "neo," there is no further serious development possible] or the Michelangelesque or neobaroque deformations, etc.)

The cubists have marked time because they made an art of camouflage and not agreeable constructive creation in the full sense of that word. The group owes its apparent unity only to the implicit hold of a little momentary speculation which can ultimately lead only to disagreement and to suicide. Actually . . . to take up the challenge and supply true and clear proofs in a plastic language to such refutations, based on the reality of art in its fulfilled essence (we have before us all the apologias, the manifestos, the books, works cited—critiques—of cubism and its contradictions, its attacks, its enemies, etc.) [is our task].

In summation: cubism had its noble goal for a moment. All the youth of the world believed in the new language (with its construction and all that makes an art . . . its tangled and confused appearance attracted many spirits hoping to find in it an end other than the classical, new means of expressing concrete relativities).

Cubism's true masters abandoned it to itself, to oblivion, and, not having received fecundity from this ordeal, they returned to traditional methods instead of coming to the tradition through the new, vital, and constructive means which are the true and logical traditions.[5]

4. One could push this paradox and discover in its development what is perhaps the ideal cubist—in real manifestation—real from the point of view of technique, of form—and its single clear constructive realization: what Apollinaire in his first cubist book wanted to prove by a political sense of the group (quartered cubism, orphic cubism). [R.D.]

5. Neo-Egyptian, neo-Italian, neo-Negro, neo-Raphaeliste, neo, neo, neo, neo, neo, neo. [R.D.]

Fragments, Notes (1923–1924)

These notes and fragments, which resemble in content the opening essay, "Constructionism and Neoclassicism," pp. 4–15, are dated about the same time by Francastel.

New spirit . . . exaggerated individualism leads to plundering. The need for instant glory prevents certain artists from drawing the form of their art spontaneously from fundamental laws and prompts them, consequently, to seek in the work of others—that which is easier and quicker —the kind of art that is useful. They appropriate one—or successively several—of those styles which have succumbed to the empty habit of being afflicted with notoriety. This continuity in looting is what individualists dare to call "tradition."

One can apply this epithet of Rosenberg to many of the painters and the masters of cubism. Example: Picasso with his periods. Steinlen, Lautrec, van Gogh, Daumier, Corot, Negro art, Braque, Derain, Cézanne, Renoir, Ingres, etc. . . . Puvis de Chavannes, neo-Italians.[1] These influences prove how little seriousness there is from the point of view of making art and the confidence of artists who change in order to accommodate methods learned from someone else. I offer as an example the Douanier Rousseau, who, up to the end of his work, had developed in his craft, but who always remained Rousseau. This proves his great personality, continuity, and sincerity in comparison with the superficiality of others and their habitual snobbism. *It's already a commonplace.* This touches *on a chapter: the commercialization of art*—an attack on false values.

False values—to which, after similar cataclysms, destroyers try to ascribe a fictive value. The truly creative spirit must live far from this decay. Space is vivifying. Its life is a constant dedication. . . . At the risk of its life . . . freed from all constraint. There are artists who are proud of external results, like money. Cézanne lived far away—so did Renoir, van Gogh, etc. . . . and they were the true speculations, that is to say, they were the true values, those which were not inflated. Also, there is an interesting question in the profiteering spirit in art, which

1. Neo-Italian is often used by Delaunay to mean "in the style of the Renaissance."

can help to *purify* and clarify a good number of the actual preconceptions of the artist who seeks immediate profit through intrigue, politics, and other deceptions of quotidian life in European art centers. The intrigues, the calumnies, etc. Painting for merchandise and painting for art. A band of nonentities, even while falling into the apparent obscurity of the researches of some artists . . . have adopted and vulgarized these procedures of obscurity, as previously they had been the vulgarizers of the classics, since death comes from repetition. An artist truly capable of bearing that appellation escapes constantly into himself, if one can say this, and into the little tangibilities of life, while skirting other artists. The artist needs the equilibrium of the collective and the personal. He must work, therefore, with this plenitude. This effective plenitude, as for example in the mention of Rousseau, whose work is all *one*, is the sure mark of the value of his work.

If one examines Cézanne, one finds alterations in his work. Naturally, in the case of Cézanne, these alterations have also provoked movement in the line of tradition. There have been germs of destruction, research into more novel means of expression in order to reach the sought-after plenitude. From our own point of view, this is an imperfection, given the representative quality of his work—what we seek naturally in this sense of plenitude can only come as a result of means employed in his work and its selection of subject matter: this creative selection originates in the confidence of the work before the universal.

It was impossible for Rousseau to understand Cézanne. The genial quality in the work of Rousseau is at one with the *genial qualities of the man. . . .*

They recognize the necessity of a new language, but their wish is far from reality. They confine themselves because they have not ventured forth and created the syntax, the vocabulary of this language.

Comparison with the evolution of the *Fenêtres*—first stammering toward the new architecture of the picture—establishing, in 1912, at the center of cubism, the necessity for formal color in opposition to all cubism. First step toward architecture of new art (the cubist dream) . . . Has influenced all the cubisms toward color, but they have used coloring like decalcomania. Comparison of the first of the *Fenêtres* with the last—the first thing during the time of Apollinaire's poem—and the last with the disc of Blériot—the suns. At this time, there were no longer any curves or discs in the pictures of the cubists. Little by little, one can see these discs appear, used in an arbitrary or accidental way

(Léger, etc.)—similar to a milliner who hoards her ornaments. She puts them on a hat with all possible imaginative taste, choosing, for example, a cockade created separately and affixed to another form, etc. . . .

Important chapter:

Painting is the means[2] and the end, indivisibly! (R.D.)

To create is to produce new unities with the help of new laws. (R.D.) The error of the greatest of the neos, in general, is to believe that one can rediscover looking backward while forgoing the precious present. It is necessary to seek in the present. There are no lies, there are false values.

To take French painters, called real masters: Matisse, Braque, Delaunay—to make a comparative study of their aesthetic oeuvres—and their personalities—to recapture . . . that which is profoundly constructive in their craft . . . to rediscover in such a comparison their vital, dynamic brightness . . . the work. To look for their *relative novelty . . . in its true sense.* If one wants to compare them . . . and false savants of all the constructive tendencies from the stone age up to the age of the *T[ours] S[oleils] F[enêtres]* C. Q. F. D. to those who have their eyes in their feet—eyes with preservatives—eyes cut like those of sea-breams *—pedanticism and false science* having come from Germany. *Herr* critic who cannot see anything across his lorgnette—puritan, purism, academicism (false interpretation of genius).[3]

We have come to a time in art where all the isms have lost their value through vulgarization. In the plastic arts, truly strong work cannot be vulgarized. An equilibrium based upon living styles cannot[4] be made

2. Among living artists, we have to clarify what is intangible and what is genuinely innovative in every point of view. [R.D.]

3. The independence of the creative artist (which does not mean that one attaches the grappling hook, to use the celebrated phrase of that individualist, Cézanne) is the only guarantee of creativity. Constant audacity outside of convention—that is neither romanticism nor anarchy. On the contrary, rule and order are the basis of audacity, but understood outside the usage that tends to classify and immobilize these new laws by putting them, for example, into hermetic sequestration. No longer does the expression "to paint like a singing bird" appear emptied of meaning. Genius is the balance of mobility within immobility in the greatest relations, that of the mundane to the universal and cosmic. (Relation of Einstein and the plastic as regards the relations of light and the curve.) [R.D.]

4. Synthesis	{	from the stone age to the age of T.[ours] S.[oleils] F.[enêtres]	{	character of art creator fashion	{	modes of expression and modulation

[R.D.]

to come out on the expressive side of plastic sensibility, taken in the most objective sense, in relation to other arts. Comparing the forces that result and that can be compared to nature: for example, a picture that has all the exterior forces of the natural as realism and its natural strength . . . is used in the sense that man wishes to obtain the most from art possible—that is to say, the most subjective dimension through forcefully realist means, rivaling nature.

Therefore, in comparison with nature, this expressive side takes on the necessity of the material—as respects quality and impact—and the material itself orders quality. The necessity for a painter to take account of what alters a particular material when mixed with a color pigment, whether it is oil, wax, or gum, making it accordingly more or less dark or striking. This is the scientific part of the business of painting, the part that plays one of the most important roles in art, since it touches upon the very objectivity which expresses all conception and building toward the universal. Plastic language, therefore, has its birth on the material side and this material side assumes all its significance, and one of its most important functions in the highest, most humane conception of visual sensibility (*an example in the art of the Cosmas*). This quality of the material is the basis of all the plastic arts, of all conception—since it is assisted by purely material elements that are set alongside all the more human projects: architecture, fashion . . . furniture, etc. The aesthetic either takes root in the mode of use or else has a speculative origin. The craft side is fundamental.

Comparisons with Expressionism

Means of expression?

Expressionism (exasperated and destructive individualism not contenting itself any longer with formulae—the first move toward construction).

Description of *Villes*, while detouring through the *Fenêtres* of three periods. *Their interrelations.* Transformation of the deformation of the retinal image (Cézanne) to the first laws that change the picture in all its internal and external structure—where the picture appears for itself, in its mass (*Fenêtres*, 1910, exhibited at the Indépendants, Room 42, black and white, the curtains, the broken lines)—which was completely cubist—opposed to Picasso already by the opposition of white and black—this was understood by Léger the following year in *La Noce* [The

Wedding]. The blacks and the whites were already a mark of vibrationism in the sense of a dynamic mechanism of thought. (Critique of Metzinger.)

In this great stage of 1910–11–12 where all the fundamental problems are under study, the destructive era—those forces are constructive which, during most centuries, would have constituted every possible evolution of art (*Aesthetic Meditations*, dimension of construction). We live, during this era, with all the forebodings of a period that breaks the tablets of the law. The Old Testament of painting. French and world painting fought, in Paris, in a catastrophic convulsion which should give birth to this new understanding of pure painting.⁵

We have come to the moment that is *the most palpitating and living in modern art*, to immeasurable horizons. What does the word "classic" matter where the etiquettes of the cubists are concerned, the neo-Greek, the neoplatonic . . . not to go beyond the *petty limits* of the craft of expression . . . Explication of divine necessity . . . of work under the beautiful sun of Spain, far . . . *from a functionalism* that is the ancient slavery under the pretext of . . . and which from day to day repeats itself without diminishing.

The necessity for the painter to travel: Universality—examples: Rubens, Greco, Cézanne—and to recapture in his personality and strength, in man before nature, a kind of nourishment: to eat horizons, spaces, lights. *Paradox is not art.* That is demonstrated (from the era of Oscar Wilde). Unable to realize a new creation, the opportunists hurry to achieve the retrieval of a backbone from antiquity—but even the marble is broken!!!

We can prepare a *graphic picture* of modern art in all its directions and the *unities* that order those directions. To abandon cubism in order

5. That is, to make images out of the external cataclysm of war (the broken line): destroyed cities, camouflaged ships and houses, etc. . . . The deforming of the image in Cézanne. The need to condense space indispensable to the cubists. The word "cube," geometric investigation (the fourth dimension). Study the books of the time . . . concerning *antidescriptive* and formal simultaneity in its meaning as a dynamic plastic art which has fulfilled within the sphere—"spherism" and "roundism" in opposition to the old cube and Euclidean geometry. . . . The foregoing considerations must take into account the ultramodern Einsteinian era. Curves—from the deforming of *Saint-Séverin* to the *Disques*. I must study broken curves in all the paintings. Recall the contradictions in the histories of cubism written by Salmon and Apollinaire. Where is the truth? We uproot ourselves, for what? For a rottenness, for the exploitation of a precursor who no longer exists. We fight, we eat, we politic, we intrigue in order to write history without direct means which are the only means of the plastic. [R.D.]

to return to academicism (without having discovered) is not [the same as] abandoning [it] in order to super-extend the "conceptionist" and clear new spirit.

> The proofs are supported—Tear the Veil
> My Rainbow
> Laugh at the sun*

* The remainder of the notes in this section, consisting of a list of Delaunay's paintings and exhibitions between 1906 and 1913, have been deleted due to their summary, fragmentary text.

The Discovery of the Simultaneous Craft

Notes Drawn Up by Robert Delaunay
at the Request of Félix Fénéon (October 1913)

*Although references in this and the following sections abound in De-
launay's relations with the poets, the Notes are included in this section
on the Simultaneous Craft because the concern is the emergence of
métier.*

Simultaneism was discovered in 1912 in the *Fenêtres* for which Apol-
linaire wrote his famous poem. It was in formation or transition in
La Ville de Paris (1911), the *Tours* (1910), *Les Villes* (1909), which
influenced Cendrars in his poem "La Tour."[1]

In the aesthetic meditations of Guillaume Apollinaire, the first book
on cubism, these pictures are classified as cubism's the second direction,
the color reaction to the chiaroscuro of cubism. These works were the
first manifestation within cubism of color for the sake of color that
Cendrars called "simultaneous"—a specifically pictorial craft that cor-
responds to the condition of sensibility which is opposed to all retreats
in art, to all imitation of nature or styles. Cendrars writes on this subject:

1. Blaise Cendrars, *Dix-neuf Poèmes Elastiques* (Paris: Editions Au Sans Pareil, 1919).

Our eyes go up to the sun. . . . The contrast isn't black and white, on the contrary (an unlikeness), the contrast is a resemblance. The art of today is an art of depth. The word "simultaneous" is a term of craft (*métier*). Delaunay uses it when he works with everything: harbor, home, man, woman, plaything, eye, window, book; when he is in Paris, New York, Moscow, in bed, or outdoors.

The "simultaneous" is a technique. Simultaneous contrast is the newest perfection of this craft, this technique. Simultaneous contrast is depth seen—Reality—Form—construction, representation. The depth is a new inspiration. One sees in this depth, one travels in this depth. I follow. The senses are there in it. And the spirit!

A great many of the painters called cubists crystallize themselves, turning their backs on life. Too bad or too good for Bouguereau. I find painting nudes or nude machines in the Pompeian or the Chaldean manner neither curious nor lively after having indirectly revolutionized the world. The schools have never served anyone except the junior masters. Too bad. That doesn't make me gloomy. I ought to stay alone with my life of painting—that is what makes it all worth enduring!

SIMULTANEISM IN CONTEMPORARY MODERN ART, PAINTING, POETRY (OCTOBER 1913)

Our simultaneous craft in painting (not the simultaneous vision that has always existed in art). These investigations date from the *Manèges* [Carousels], the *Saint-Séverin*, from the *Villes*, the *Tours*, the *Fenêtres*, and the *Soleils*.

[*There follows a list of Delaunay's paintings from 1907 to 1911 which illustrate the origins of the simultaneist crafts.*]

Art and image in contrast to the descriptive or the illustrative. Art is not conventional serial writing (note on "Light," which appeared in *Der Sturm* in 1913).

The sequential in design, in geometry, etc. . . . Example: the railway train is the image of the sequential that approaches the parallel: the evenness of railroad tracks.

But an art of simultaneous contrasts consists in *the forms of color.* (*Aesthetic Meditations* by Guillaume Apollinaire, October 1912. "The works of the orphic artists must simultaneously present a pure aesthetic agreement, a construction that makes sense and a sublime significance, which is to say the subject. It is pure art.")

Orphism is a designation given by Apollinaire to one of the four tendencies of cubism as he has quartered it, but the *simultaneism* under discussion here is actually universal. It does not link up with cubism. In fact it is sufficient in itself and originates earlier than he has discerned. In impressionism there already were symphonies of construction through color that are not yet formal, but complementary.

Simultaneism in color creates a total formal construction, an aesthetic of all the crafts: furnishings, dresses, books, posters, sculpture, etc. . . .

The simultaneous: my eyes see up to the stars.

The line is the limit. Color gives depth (not perspective, *nonsequential,* but *simultaneous*) *and form and movement.*

The simultaneous vision of the futurists is of a completely different kind. Consider, for example, a title of one of their pictures: *Simultaneity.* This word is etymological in literature, thus classical, and passé. Sequential dynamism is the mechanical in painting and that is the scope of their manifestos. Futurism is a machinist movement. It is not vital. The first simultaneous representation: The *Fenêtres simultanées sur la Ville* [Simultaneous Windows on the City] (April 1912, exhibited in Zurich, June 1912, article by Paul Klee in *Die Alpen,* exhibited in 1912 in New York).

Color-construction, discovered in 1911, December to January 1912, is the key to these images.

And regarding this, a Smirnoff-Delaunay conversation[1] during the summer of 1912 at La Madeleine.

Beginnings of synchromism.

Notes published in *Soirées de Paris* and *Der Sturm.*

Birth of an art of color (article in *Le Temps,* October 14, 1913, by Apollinaire).

1. During the summer of 1912, Smirnoff, an old friend of Sonia Delaunay who was a young Russian university professor, visited the Delaunays for two months at La Madeleine. Later Smirnoff gave a lecture entitled "The Simultaneous" in a St. Petersburg cabaret called the Brodyatchaya Sobaka (Stray Dog). The cabaret was decorated with posters by Sonia Delaunay. Cf. Vriesen, Imdahl, *Robert Delaunay: Light and Color.* [Bibl. No. 101.]

Delaunay quietly invented an Art of color or synchromist image.[2]

The necessity for a new subject has inspired poets to set off on a new road and their poetry about *La Tour*, which communicates with the whole world, shows it. Rays of light, symphonic auditory waves.

The factories, the bridges, the ironworks, dirigibles, the incalculable movement of airplanes, windows simultaneously seen by crowds.

These modern sensibilities converge simultaneously.

Cendrars (April 1912), "Easter," written in New York—while walking one Easter night through the districts of New York, under the suspension bridges, in the Chinese section, among the skyscrapers, in the subway (appeared in October 1912). On his return to Paris he went to see Apollinaire in all sincerity of art. This meeting inspired Apollinaire who published "Zone" (November 1912 in *Soirées de Paris*, republished in *Der Sturm* and then in *Alcools*).

At this time Cendrars met Delaunay. He was impressed by the beauty of the *Tour* and *Saint-Séverin* and by Madame Delaunay's colors and book bindings.

This is what gave birth to the *Premier Livre Simultané* [First Simultaneous Book] (February 1913).[3] The movement was established. In December 1912 the beautiful poem "Windows" by Guillaume Apollinaire appeared (December 1912, on the first page of the Delaunay album where there was a very beautiful play of colors. The window opened like an orange, that beautiful fruit of light), a poem inspired by the *Fenêtres simultanées* of Robert Delaunay, 1911.[4]

2. A reference to a school of painting more commonly associated with Macdonald-Wright and Morgan Russell who claim its founding in 1913. See statement of Macdonald-Wright, *The Art of Stanton Macdonald-Wright* (Washington: Smithsonian Institution, 1967), p. 13.

3. Reference to the poem *La Prose du Transsibérien et de la petite Jehanne de France* [Prose of the Trans-Siberian and of Little Jeanne of France], by Blaise Cendrars, which together with Sonia Delaunay's color impressions form the *Premier Livre Simultané*.

4. The literary controversy engendered by Robert Delaunay's justifiable claim that Apollinaire's poem, "Windows," was composed while Apollinaire was living with the Delaunays during the last six weeks of 1912 is both amusing and instructive. André Billy claims that the poem was written at a café with a group of friends supplying lines to enable Apollinaire to meet the deadline for publication of the poem as a preface to an exhibition catalogue of Delaunay's work in Berlin at Walden's *Der Sturm* (January–February 1913). This version gained currency and was promptly challenged by the Delaunays. Cf. Discussion by Francis Steegmuller, *Apollinaire: Poet Among Painters* (New York: Farrar, Straus and Company, 1963) pp. 236–239. "Without boasting," Delaunay commented later, "I think I can say that *Les Fenêtres* had a great—I don't want to say descriptive—influence on a certain part of his poetry of that period." Quoted from *Art Documents, éléments pour l'historire du cubisme*, n.d. (after 1935) in Vriesen, Imdahl, *Robert Delaunay: Light and Color*.

This is one of the first documents of the simultaneous poem and the first poem without punctuation.

Apollinaire's and Cendrars's art are completely different. Apollinaire, a sensitive man, was always curious about any new contribution. . . . Cendrars belongs to a younger generation that is new. Other young men like Arthur Cravan, nephew of Oscar Wilde, published "Sifflet" [Whistle] in *Maintenant*.[5]

Barzun, [with his] sound and song, appeared during the month of June 1912, perhaps it was May. Attracted by Delaunay's paintings, Barzun came one Sunday evening to his house. Cendrars, Smirnoff, and Minsky were there, and Barzun spoke enthusiastically about the *Tour* which he connected with dramaturgy. He spoke to us about his *Poème et Drame* [Poem and Drama], a work on which he had been working for ten years, which was to be for the modern world what tragedy had been for the Greeks (he cited Euripides and Aeschylus). He told us about the imminent publication of a theoretical tract on modern art which defined his theory of dramaturgy.

The latter book appeared six weeks later under an unexpected title. The awaited *Dramatisme* [Dramatism] was entitled: *Voix, Chant et Rythme simultané* [Simultaneous Voice, Song, and Rhythm], which provoked in some informed circles a clear reaction. The book was not "simultaneous" at all. M. Barzun had enlisted and exploited a word that he had not understood and that he developed only in its etymological dimension.

Now, in October 1913, he announces the impending appearance of his first simultaneous poem.

This announcement is made at a time when a fortnight earlier the newspapers had been talking about the *Premier Livre Simultané* that had been exhibited at Berlin and about which the world press had been informed through a color prospectus of simultaneous contrasts, and about which the French, English, American, and German press had commented.

5. Arthur Cravan, questionably identified by Robert Delaunay as a nephew of Oscar Wilde, was a boxer, outrageous *poseur*, and founder and editor of the journal *Maintenant* (1913–1916) in which he published a scandalously personal attack on the Delaunays in his review of the 1914 Salon des Indépendants. He was sued by Mme. Delaunay and lost. Cf. *The Dada Painters and Poets*, edited by Robert Motherwell, New York, Wittenborn Inc., 1951, pp. 10–12. Also Cecily Mackworth, *Guillaume Apollinaire and Cubist Life*, London: John Murray, 1961, p. 135.

Article by Cendrars on the *Premier Livre Simultané* in *Der Sturm.*

Poem by Cendrars called "Contrastes."

Article by Rubiner on the *Premier Livre Simultané, Der Aktion,* Berlin.

Simultaneism in literature only expresses itself, as conceived by Barzun and his imitators, through the voice (of the masses) parallel or divergent, harmonized or discordant, speaking together at the same time. This conception is not new. It is practiced in all operas, and above all in Greek tragedy. This is no longer simultaneism, but literary counterpoint.

Literary simultaneism is perhaps achieved by contrasts of words.

[*La Prose du*] *Transsibérien* [*et de la petite*] *Jehanne de France* is a simple contrast (a continuous contrast which is the only one that can reveal the profundity of living form).

[*La Prose du*] *Transsibérien* [*et da la petite*] *Jehanne de France* permits a latitude to sensibility to substitute one or more words, a movement of words, which forms the form, the life of the poem, the simultaneity.

In the same way visuality is achieved through colors in simultaneous contrast.

In a movement a new depth.

The simultaneous word . . . through simultaneous color and through contrast of simultaneous words there comes forth . . . a new aesthetic, an aesthetic representative of the times.

Historical Notes on Painting: Color and the Simultaneous (1913?)

Undoubtedly written during 1913, although undated.

First Collective Manifestation, 1910.

Room 41 at the Indépendants surprised everybody. The painters understood nothing about the tempest that they had unreflectively released. They were not provocative other than hanging some already completed pictures, with much conviction and anxiety, on the wooden partitions of the Indépendants. The designation "cubist" dates from this exhibition (Albert Gleizes, *Arts Plastiques,* No. 1).

A photographic image, but not an image in the pure sense of the word —that is to say, the *plastic, organic element, the plastic organization,* etc. . . .

Image in the pure sense of the word means the plastic, organic element, plastic organization in the vital sense of rhythm. It is human and it is *natural*. It is the childhood of all art. Robert Delaunay and Sonia Delaunay after the break with cubism—the beginning of all modern anxiety—search for a plastic image through the most sensual element: color. Breaking with everything that had been done in art in means and in form, they made the first simultaneous pictures. And concerning this, G. Apollinaire in his famous article in *Le Temps* 1912—"The Beginning of Cubism"—said in substance and literally that Robert Delaunay had silently invented an art of pure color. This was an allusion to the first *Fenêtres*, windows that open to new plastic horizons.

It was the inspired Chevreul who observed *the laws of simultaneous colors in his theoretical studies.* Seurat was aware of them, but Seurat did not have the audacity to push composition to the point of breaking with all the conventional methods of painting. In his work there is the *retinal* image, the image in the popular sense of imagery. Line and chiaroscuro are still the plastic basis of his art.

LETTER TO AN UNIDENTIFIED COLLEAGUE (1913)

Dear Colleague:

We ask you to augment your thoughtful investigation of the first *simultaneous book* with some clarifications of issues of craft.

This book is not an invention but a simultaneous image.

This book has already appeared and was exhibited simultaneously in London and in Berlin. Next it will be in Paris.

La Prose du Transsibérien is, reassure your colleagues, armed with periods and commas. We will not remove them as has our friend Apollinaire in his last poems.[1]

The inspiration for this poem came to me naturally and is—think about it—far from the commercial flurries of M. Marinetti.

Since there are no longer heads of schools, we attend to those signs that oblige us to elaborate certain things which clarify this *new craft*.

The simultaneism of this book rests in its simultaneous and illustrative presentation. The *simultaneous contrasts* of colors and of text form depths and movements of colors which are the new inspiration. Let M. Martin Barzun be reassured that this does not resemble in any way his cold and pedantic dogmatism which derives from badly digested sequential conversations.

Regarding this, I recall some words of Delaunay on the new craft:

There is no question about the simultaneous vision in Art, for that has always existed.

It has to do with a new representative and simultaneous craft: painting, sculpture, furnishing, architecture, books, posters, dresses, etc. . . .

Our sensibility responds immediately to a work of art that, as in nature, to which one instinctively compares it, imports a sense of depth.

Our eyes see the sun. There is movement.

All is color in movement, depth.

We find a craft which must serve for a new aesthetic, one that is representative and not descriptive, such as simultaneous contrasts, complementaries, and dissonances. The constructive color is the craft in all new images of Modern Art.

1. Reference to the elimination of punctuation marks from Apollinaire's *Alcools*, published in April 1913.

IMAGE AND CRAFT (1938–1939?)

From purely internal evidence—the summary rehearsal of points made earlier in his writings—this brief essay would appear to be from the period of summation and reprise before World War II. Francastel does not date this essay.

In painting the simultaneous is adequate to the image and to the craft [*métier*].

The real means [*moyens*] must reinforce the representative function.

The real means are colors in their contrasts, in their movements.

Their movements exist really only in the functions of simultaneous surfaces, with depths (depths of material, which is the beginning of methodology) obtained by the creator with simultaneous contrasts.

Simultaneous contrasts are absolute in the direction that actual painting takes.

And it is here that the initial difference, beyond the sundry schools of painting, is to be located in the craft of simultaneous contrasts. Simultaneity—say certain painters oriented to a dynamic sense—is but a word which has no representative value and they end (futurism) presently in their fatal position: geometry, mechanics, geometric dance, etc. . . .

There is no geometry in the simultaneous craft (*Fenêtres*, 1909–1910–1911–1912, *Saint-Séverin*)—no longer an abstract object as in cubism.

The world is not our image re-created through reason (cubism). The world is our *métier*.

From this start a new inspiration works through towers, bridges, houses, man, women, playthings, eyes, windows, books, New York, Berlin, Moscow. I am at St. Petersburg, in my bed, in Paris, my eyes see the sun.

Everything has its value through contrast. There is no fixed color. All is color through contrast. All is color in movement. All is depth.

Contrasts, assuredly, appear in all painting up to our own times, in Venetian paintings, in Persian, Chinese, Hindu, African, in modern French painters, and in those from every country.

These contrasts are on sequential or geometric surfaces (of the sequential: the essay on light, synchronized movement, a note that appeared in the *Soirées de Paris* and translated in *Der Sturm,* the lecture in St. Petersburg, simultaneous contrast).

Masterpieces attest to a definite movement of surfaces. Veronese's *Wedding at Cana* shows mastery even in the authoritative use of color on surface planes.

Depth, however, is absent. Since colors are employed by him in a linear manner, sequentially, when Veronese wants to seek depth, he has recourse to perspective (sequential mechanism).

Three Notes on the Differences between Delaunay's Art and Impressionism and Expressionism (1920s?)

An undated work, perhaps from the early twenties, when all the terms and polemics were still fresh and energetic.

I

If you have read the life of Seurat you are *au courant* with the definition of this whole group: neoimpressionism. Nonetheless! As you write me, they have not arrived at *real substance.*

Why?

However, they have had, in comparison with other tendencies of their time (P. Gauguin, a species of symbolism in painting, etc. . . .), the most reality; but Seurat, their principal force, is dead in the midst of his work, perhaps at the moment when he would have frankly broken with everything physical as well as with reminiscenses of the museums of the past, which are full of ongoing impurities, in *the construction of his Art* (it endures in his pictures from the Greek, Hindu, Japanese, Italian). . . .

Inquiry into reality demands real means.

We no longer borrow from any style. We search everywhere before nature with our own means. We believe we see *"Haystacks, Towers, fields, skies, Cities."* We see only *light,* because when the light changes even for an instant, the haystacks, etc. . . . are changed in line or shape, or even more the direct image evaporates according to the *effect of light.* In these first findings is *impressionism.*

It is already a great victory when one compares to these poor linear constructions, recovered from chiaroscuro, the static imitation of nature by the great Italians (see the poet G.A.).[1]

Impressionism is exuberance. It is very often irreverent and unsuccessful, as you write me, but that nevertheless separates us from *all this Italian second-hand dealing* which is decaying in the academies world-

1. Variant: And these impoverished perspectives overlaid with chiaroscuro and beastly and factitious imitations of nature done by the most virtuoso of Italian masters. [R.D.]

wide and which is more detestable than primary observations in front of nature.

Impressionism has already provoked some reactions that were interpreted by the first *Theoreticians of Color.*

The struggle of the cubists to ally themselves, through the luminous effect of their design, with the great movement of impressionism is a further demolition and destruction of the Italian academy, of the linear construction of the design, which goes back to the earliest artistic expressions of the caves and of all the arts.

One of these first theoreticians was Seurat. Seurat struggled against the exuberance of his time with the search for true constructive means. He goes back to nature as the source of reality: light. He had more restraint than his peers. He almost touched the great reality. His accidental death prevented him *perhaps* from creating for us true Beauty.[2]

Reality of Art. What you call *substance* must be suitable to its means.[3] Its vital functioning: *light.* The colored waves which follow one another, which are self-moving, are the key to the mystery. It is necessary to get rid of the sequential measures (see Rood: the simultaneous contrast). The first method is *simultaneity of color.* The movement of color is the fundamental dynamism of all modern art in *painting.*[4]

First *Synchromism*: unevenly colored construction (see Princet).[5] These first *measures* and proportional dimensions give an infinite boost to our sensibility and to our psyche, which is always an attentive (see Princet), impersonal, and inexhaustible source.

2. Seurat appears to me to be the greatest figure of impressionism. But recall that the impurities noted above persist. His composition in drawing constrained color that was underdeveloped, submerged, diffused. An overly great preoccupation with *light* was harmful to reality in his art. I insist, after reading their theories on the fundamental aspects of their art, that this was the initial error. They have not sufficiently sought to define real techniques. They worked on a compromise between old-fashioned composition and the immediate imitation of nature (a hodgepodge). They confused technique and composition and arrived at approximate *images,* but not at the *reality of art.* [Variant and addition of R.D.]

3. The means are the measure of color based upon simultaneous contrast (see Rood). [Variant of R.D.]

4. We must oppose to the reality of art the propositions of the cubists who are to drawing what color was, as used in the painting of the Italian Renaissance. . . . They have done with drawing what the impressionists did with colors. . . . [Variant and addition of R.D.]

5. Maurice Princet, mathematician, aesthetician, friend and admirer of the Delaunays, is discussed in Cendrars's essay, "The Eiffel Tower," infra, pp. 171–76. Princet wrote the preface to the joint exhibition of R. Delaunay-M. Laurencin at the Galerie Barbazanges, Paris, 1912.

All discussion of the objective, subjective, object, figure, nude, design, anatomy, literature, geometry, metaphysics is useless and the verbiage of false aesthetes must be banished from all aesthetic language in painting now that we have come to the pure means that serve inspiration. *Inspiration and craft* [*métier*] are intimately joined and their proportion always just.

The impressionists have had an effect. Monet, Cézanne, etc. . . . have in several series of pictures translated a series of effects of colored light. Thus, if one looks in a room, for example, at identical landscapes under different effects of light (a haystack in the sun, the sun changes according to different light effects) the series of pictures will be a succession of differently colored effects. Among such identical landscapes (haystack in the sun) there will be a simultaneity of color. With the impressionists this simultaneity was accidental, but it truly existed in nature and it became a question of their seeing it and of finding the means and the construction for it and of grasping it in *unity and reality.* . . . These are, moreover, unprecedented relations, but how enriched is the picture that is no longer a simulacrum of natural colors but *is* "color"—that modulates while shifting its new proportions, which imply movement and the translation of the most supply plastic states. This movement follows the causal impulse and the mastery of the painter (according to such-and-such a proportion in height, length, depth) must be adequate to the grandeur of his work. Simultaneity has its proportional dimension. We have reached an art of pure reality that follows European impressionism, in which is contained all the painting of the past century with precursors such as El Greco, who began to break up drawing in order to look for color, and then our great revolutionary Delacroix. However, in the analysis of their works, one sees only that there is too little light in them and that however they will lead us to our freedom, to wake ourselves to the need to be energetic in seeking to become purer in our craft. . . .

2

If I . . . a little late, it is because I have just dealt with the articles . . . concerning the expressionist movement. Expressionism is synonymous with realism. Realism is, for all the arts, the eternal quality that must determine the strength, the beauty, of its duration and that must, therefore, be adequate to it. In the domain of painting we seek the purity of means [*la pureté des moyens*] or the most pure means to *assure*

the functioning of this reality which has to be *the expression of the purest beauty*. In painting, impressionism (I tie together all the little reactionary manifestations such as neoimpressionism, cubism . . . all that is technique, scientific process . . .) has shown that light was the source of *these pure means*. In impressionism, we found ourselves directly in front of nature stripped of all the baggage used by the Italians or others such as the Gothic, the Byzantine . . . in a word, all styles. Impressionism is in this way a beautiful victory, but an incomplete one. It is the first stammerings of souls exuberant in the face of nature and somewhat embarrassed to confront chaos, reality. This exuberance has destroyed all false ideas, archaic methods of painting (the science of drawing, geometry, perspective . . . the agonizing academy, the neoclassical . . .). This liberating movement, impressionism, can be dated to its precursor, El Greco, several Englishmen, and our great revolutionary Delacroix. It is a great era of preparation in search of the reality, *light*. The search for light encompasses *all of impressionism* understood as I have said above (Seurat, neoimpressionism; Picasso, cubism).

The functioning of color, which must necessarily be vital to every *expression of beauty*, has remained the problem of modern painting. Seurat alone has extricated something from light: contrast (as a means of expression). *His premature death* has perhaps prevented the realization of his creations. (One can cite him in the history of impressionism as having reached the highest point in the search for means.) His originality lies in the contrast of colors: the optical mixture [*mélange*] applied by him and his colleagues; but, being nothing more than a technique, it doesn't have the importance of contrast as a means of composition and expression or pure beauty. . . . Simultaneous contrast (see Rood) was not discovered or developed by the impressionists, and nevertheless it has to be at the very root of all pure expression in modern painting. Simultaneous contrast assures the dynamism of colors and their *composition in the picture* and the reality of expression.

3

The great contemporary movement in painting, in Europe as in America —that is to say, the liberation, through universal impressionism, of pictorial means—finds form, several forms, multiple forms in simultaneism or rather in the new simultaneous craft.

After numerous past schools of art and the efforts of their creators

to return art to life (if it can be put this way), it did not do to begin still another school.

All the great painters, artists, and poets have, after having destroyed old molds, applied their gift of sensibility—some to destruction, others to the building of a new craft.

Let it be clearly understood that we remain within the realm of form—of craft—and abstain from philosophizing about art. The activity, the movement, the shocks, the plastic achievements alone interest us in this study—to tell all that there is to tell about the new art that has been brought forth by new creators, young geniuses in plastic achievement (painting, the art of space; what is generally called sculpture, books, dresses, posters, etc., everything that falls under the visual sense).

These are visionaries, endowed in craft, with a new knowledge of material, who change the appearance of the universe through the realization of new "realities-form." Through their constantly attentive sensibility they bring into being new artistic wholes. It is in painting that the new art has made the greatest progress, the new synthesis that glorifies modern life in its spirit, in its sense of the beautiful, its taste above all for movement, for many movements. . . .

The effort of the first impressionist masters having been acquired by the mass, we are no longer held back. The search for light was their tangible act and their pictorial achievements have given a new dimension to the picture. . . .

Simultaneity has pushed further in the search for Reality. The desire for humanized forms, a knowledge of their movement in space, has upset all the concepts known from impressionism, fauvism, cubism, futurism, orphism, etc. . . .

Movement in the rhythms of absolute colors is nothing but a preoccupation with light, but a knowledge of the material itself which changes according to personal sensibilities, directs the ongoing investigations of these painters. Some have been involved for a time in destroying the old craft of painting: perspective, geometry, drawing, etc.—having found new means that help them to the realization of new works.

These means, as others, have come to them and they have adapted them to their sensibility, transformed continually by their relations with materials, etc.

From this beginning new wholes are born that have in turn transformed the understanding of already-existing crafts, such as poster, the dress, so-called decorative objects, etc. . . .

And this has come about through the need for an order in the use of simultaneous contrasts, which are one of the many means employed by these painters.

As we have noted, the need to eliminate drawing, to break with the old formal methods, chiaroscuro, line, etc., has given birth to a more profound inquiry into color that is more involved in space and is more absolute.

For all the primitives, color was seen either as symbolic or surface. It was not employed as self-sufficient, but as an instrument or method for constructing the represented subject.

The new art aims at the formal representation of space continuously in movement—real volumes. . . .

And colors are, in their simultaneous contrasts, the marvelous means of expression for constructing movement—which they produce by their material. . . .

A portion of the photographs that are in my possession[6] represent the destruction . . . of the craft, of earlier means (which, in relation to the present, is a descriptive sequential craft) and the other part . . . truly presents color used with the new craft . . . that has already transformed and vivified artists and artisans from different countries. They are accounted a considerable influence in Germany. On one side the tumult of the *Villes*, the *Tours* has led to destruction, and from this destruction a new vision of the world is born through the new craft—from 1904 to 1914.

6. The archives of Robert Delaunay (no less those of Sonia Delaunay) consist of looseleaf volumes with photographs of his work alongside and on the backs of which comments and interpretations have been written. Unfortunately, many of Robert's photographs are missing. Mme. Delaunay's archives are much more comprehensive and complete.

Draft of a Letter to Nicolas Maximovitch Minsky (1912; 1918?)

This letter to Delaunay's Russian friend Minsky was begun in 1912, but concludes with the sentence: "It is a painting, a real painting, and it has been a long time since we have seen anything like it." The letter was then taken up by Delaunay after the war and completed.

The Laws of Color Real French art, completely clear and absolute representation, constructed according to the laws of light, or rather, of color, that is to say, purely visual, with a new craft, as was great Italian painting with its old craft; in reaction against all the *cerebral* incoherences of the cubists, the futurists, centrists, rayonists, integrists, cerebrists, abstractionists, expressionists, dynamists, patheticism (to the exclusion of some directions in the research of color: fauvism, orphists, synchronists).[1]

Wave of Incoherence and Worthless Idealism Furthermore, the importers of these bluffs were foreigners, that species vulgarly called profiteers, not recognized in their own country, nor fundamentally and truly in Paris either. And so it was that certain people tried to smuggle in as French art (made in Paris) some pastiched lucubrations from old primitive sculpture, while others introduced the newspaper, nails, broken glass bottles—all the way to Italian futurism, which has framed bologna sausage, hair, and all sorts of eccentric objects. . . . All of these apparent fantasies conceal a hoax which, happily, sincere spirits and true innovators from the very first disdained as an insult to the public.

These incoherent trends had Picasso, Boccioni as their leaders. Truthfully, there were no French futurists. The pictures of these foreigners, apparently bizarre, had a profound *pomposity* in which there was nothing the least bit new.

To make this art it was necessary, above all, not to be a painter: humorists, snobs, literary types overran spurious modern painting—trying

1. In the 1912 version of this text, Delaunay limits the enumeration to "cubists, futurists, centrists, rayonists, integrists, abstractionists. . . ." [P.F.]

to prop up certain shady dealers who proclaimed this dubious art as French art.

The New Construction / Observation of Nature as Objective Representation / First Step: New Means During these facile, loud, and hollow eccentricities, which vied for public attention, a new work was being prepared, acquired at the price of a labor of days, months, and years of slow evolution, but which could now be objectified. In your article of 1913, you noted this effort directed toward *the new construction of color*[2] at once mysterious and profound. These efforts date from 1909 and even earlier. It is one long series of *studies of form expressed in light or lights (prism) of the sun, moon, gas, electricity, etc., by means of simultaneous contrasts of color.* The point of departure for these painters is the objective study of color, of the laws that govern colors—as in music there are laws of sounds. Each creator, each discoverer carries in him the innovations that come to augment the universal patrimony of Art.

First Refutation of the Old Means These investigations were begun by the observation of the action of light on objects which led to the discovery that the line, according to the old laws of painting, no longer existed, but was deformed, broken by luminous rays (Robert Delaunay: *La Ville*, 1909, *Saint-Séverin*, 1909–1910, *La Tour*, 1910–11).

There followed an exact study of color in itself: *simultaneous contrast*,[3] *creation of profundity by means of complementary and dissonant colors*, which give volume direction. A more objective vision, but one still insufficiently representative, with poetic inspiration derived from the play of pure color. Depth of color replaces the linear perspective of the old craft. This discovery was the object of elaborate studies, various articles appearing in Germany, Russia, and in Paris.

Simultaneous Roles, Decorative Objects—R.D. The important pictures of this period are R.D.'s *Ville de Paris* and S.D.-T.'s[4] simultaneous

2. Variant of 1912: "which brought to life construction with a new force." [P.F.]

3. Variant of 1912: "is still an abstract vision of color with the poetic inspiration of the play of pure colors (the *Seine*, the *Fenêtres simultanées*, *Ville de Paris* of 1911, simultaneous book bindings, and the simultaneous book). The simultaneous contrast of colors is realized by dissonances, that is, by the exaltation of one color by another. The new life of colors and their simultaneous vibration: the *Disques* (1913). The study of color itself stops here and becomes the matter of art itself." [P.F.]

4. Sonia Delaunay-Terk.

book bindings of 1912. First simultaneous book 1913. *Equipe de Cardiff.*
Bal Bullier [The Bullier Ball] of S.D.-T.

Third Investigation into Unities. Simultaneous contrast created depth.
The *Disque,* the stage following the study of pure color, created *the*
simultaneous movement, the vibration of color which imparts to form
the depth of light without the chiaroscuro of the old craft (R.D.: *Les*
Soleils, 1913. *Le Manège de cochons* [Carousel with Pigs], 1907–1913.
Hommage à Blériot, 1914. S.D.-T.: *Prismes électriques,* 1914. *Prepu-*
scule étude de lumières [Twilight, Study of Lights], 1913; the poem
"Zenith," 1913).

The study of color ends here and becomes the substance of art which,
in the last pictures of these young painters, is objectified according to
laws. . . .

The foundation of the work of these painters is wholly directed toward
the laws of the relationships between colors. For the laws of the contrasts
of colors are physical laws which it would be possible to formulate, and
the painters worthy of the name have always felt them. In a sketch of
Rubens that I have before me, one touch of carmine, which is completely
useless from the point of view of the image, is there only to counter-
balance the influence of a particular blue. It is interesting to study *The*
Wedding at Cana in the Louvre from the same viewpoint (Marc
Vromant, June 2nd, 1914 on R.D. *Comœdia*).

The laws of color objectify themselves in the last works of these
painters, *simultaneously objectifying the relations of space,* that is to say
the objects between them, the image, the subject matter. Those old topsy-
turvy painters who represented objects, for example, in an interior, creat-
ing relief through a modulation of white into black and deducing lines
which gave perspective. The color was only a coloring, a luminous acces-
sory sufficient to their sensibility to represent nature at the moment. This
atmosphere does not satisfy *our modern eye; the optical laws of painters*
have been perfected and *new expression has imposed itself.* The first
attempts at this kind of painting were too synthetic for the public (which
was accustomed to conventional painting that described nature) because,
thanks to the use of more real means, there was simply no longer an
object, no longer description. It was necessary to extract a new whole
from rhythmical rules before filling in the old structure, that is to say,
the drawing through study and the direct observation of nature through
the eye. The first forms obtained in authentic novelty of expression

carried with them a certain stiffness derived from the poverty of the emerging means. It was necessary for many years to keep on struggling to augment and enrich continually through the variety of discovered contrasts and to observe all of nature ceaselessly in order to arrive at the first true conceptions **[First Unity]** of unity, that is to say: the image: the picture. G. Apollinaire in *L'Intransigeant* speaks of the *Ville de Paris* in the following terms:

> The great event of this Salon is undoubtedly the rapprochement between R.D. and the neoimpressionists exhibiting in the back rooms. Delaunay's painting is definitely the most important picture in the Salon. The *Ville de Paris* is more than an artistic manifestation. This painting marks the advent of a conception of art that seemed to have been lost perhaps since the great Italian painters. And if it epitomizes all the efforts of the painter who composed it, it also epitomizes, without any scientific paraphernalia, all the efforts of modern painting. It is broadly executed. Its composition is simple and noble. And nothing that anyone can find wrong with it can detract from this truth: It is a painting, a real painting, and it has been a long time since we have seen anything like it.[5]

The methods are wholly new: the action of light on objects; all the color one can impart by simultaneously complementary contrasts and dissonances; the form created by the movement of colors in their illuminated depths, imposing the study of objective lights, of objects, of people who move within the various lights of different countries: harmonies of colors, prisms, and infinitely various, new forms. The last pictures made in Paris: *Prismes électriques, Crépuscule*, election posters, etc., of S.D.-T. were studies of different lights and their prisms. The illumination of Paris evenings that created this mysterious life of new forms when all its lights are lit.

Last Works: Form in the Light, Humanizing Itself in Modernism, the Representation of Absolutely New Spectacles—the Heroism of the Aviator, the Conquest of the Air, the New Architecture of the Eiffel Tower, etc. . . . *Hommage à Blériot*, the *Soleils* of R.D. Analysis of the

5. Cf. *Apollinaire on Art: Essays and Review, 1902–1918.* [Bibl. No. 106.]

solar disc setting in a limpid, lowering sky and near the multiplied prismatic discs which inundate the earth from which airplanes depart. In the flashing and transparent light of Madrid without fog, without gray, nothing but a song of colors that interlock and clash, the *Nu* of R.D. is born, transparent, iridescent, almost a rainbow, but vigorous and solid in its realist composition. Antidescriptive, this nude reflects the prism of the country in more than the blond coloring of flesh. The nudes of Rubens must be luminous color patches from another craft, but with a similar given effect, the hot and somber paintings of his time.

Another picture in Madrid: *Chanteurs flamenco* [Flamenco Singers] of S.D.-T. These sharp and oriental songs of Andalusian women whose eyes are still astonished from no longer being veiled, in the enveloping light of a small theater, giving off an atmosphere of vibration of sound along with the light's vibration. The construction of the picture is based upon the great contrasts which become tangled with one another and are enclosed like the flamenco songs themselves, in dissonant vibrations. Two people seated with a guitar—the center of the color movement— and, as in nature, their heads do not assume any more importance than that which is imposed upon them by the rhythm following the laws uniquely appropriate to the color-form of the picture.

In the cold and transparent light of Madrid a whole series of pictures followed—studies made under the sun's rays that were more humane, closer to those of Portugal. This country, where as soon as one arrives one feels enclosed in an atmosphere of dreaminess, of slowness; where rhythmic movements are as indifferent as oxen with their big horns in their archaic yokes, led by a little girl clothed in multicolored rags. Other sights were savage and strange. Colors clash and are exalted with dizzying speed. Some violent contrasts of patches of color: women's clothes, their shawls blazing with lush, metallic greens; watermelons. The forms of colors: women disappearing into mountains of pumpkins, vegetables in fairy-tale markets, in the sunlight, interrupted by a tall woman carrying on her head a vase of simple and irregular shape, as an old vase. The costumes of the region, rich with rare color. All the exciting round shapes of women's bodies broken by the severe blacks and scintillating whites of the men's attire, contributing severity, angles in this moving sea of diffused color.

Femmes aux Pastèques [Women with Watermelons] S.D.-T., 1915; *Scènes de Marché* [Scenes of the Marketplace] R.D., 1915. Numerous

studies for the great market in the Minho of S.D.-T, 1915–16. *La Verseuse* [The Coffee-Pot] of R.D., 1915–16–27. Some of these studies and pictures of S.D.-T were exhibited at Stockholm, Christiana, spring, 1916.

The apotheosis of Portuguese expression, in which one finds elements of all the studies and pictures of S.D.-T. in dimensions greater than those of *The Wedding at Cana* in the Louvre, is in this picture, which is also complicated and rich with elements like an old master painting, but with craft that entailed a wholly new and completely representative composition.

It is called: *La Misericordia au peuple du Minho par Apollinario, le donateur* [The Misericordia (given) to the People of Minho by the Donor, Apollinario].

Apollinario had had built a refuge for children where they were brought up. The peasants came with their wives and children from the mountains of the valley.

The donor is in the middle of the picture. Behind him the background of the mountains of the country and, closer, two sister hills: Valenca, the Portuguese, and Tuy, the Spanish, with their villages perched high up. He receives in his arms the children who come to him and places them in the Brotherhood of Misericordia which will bring them up. The men, dressed completely in black, are there. They have descended from the limpid blue-green sky of this country. On each side of the donor, groups of thoughtful peasants help—women in beautiful tessellated costumes of all colors, like birds in a bustling, bouncy group—and on the other side, directly in front of the Brotherhood, the men, serious, leaning on their tall mountain staffs. And above all this, in the transparent sky, an iridescent vision of the Virgin, with a sparkling cross, which, with hands joined, she uses to bless the charitable gesture of the donor.

Behind, or, rather, lower than the group of women, the lemonade vendor leans, matter-of-factly, on her table covered with a white cloth, with glasses and lemons, unaware of the apparition.

This large composition unfolds into eight smaller panels where fruit, vegetables, toys, jars, and all the objects which are familiar in the life of the people (and which surround them) are depicted. The picture—a great monumental conception—is conceived in contrasts to the form of the building for which it was destined. Nothing descriptive, nothing chiaroscuro, but everything form in light.

In *The Wedding at Cana,* the multitude of people at the bottom of the picture is seen and lit by studio illumination in perspectival composition. They are detached from the sky. But this sky, a vast, inexpressive surface, does not connect with the rest of the picture. The sky even hinders it, detracting from the unity of this very beautiful expression at the bottom of the picture. The old master painters described objects and tied them together successively by means of chiaroscuro.

In the *Misericordia,* the form is expressed through the light. The picture is the simultaneous representation of forms: contrasts of forms expressed through the color contrasts, simultaneous movements of the most profound color, without lines, without perspective.

The picture: a conscious balance of forms submitted to monumental expression in architectural harmony with the edifice. The overriding contrast of the sky to the group of men and the luminous form of the Virgin is, in turn, opposed to the deep and warm blackness of the Brotherhood. The large contrasts of forms: groups of men and groups of women subordinate to the general composition. As a consequence of these contrasts the women stand out in these great oppositions and vibrate simultaneously in the general movement of color. The disc. The tall staffs of the peasants, the banners of the Brotherhod interrupt and oppose the masses of colors, forming an architectural element which exalts the soaring ovals of the windows that frame the picture's base. These new techniques create pictures with *the formal and objective power* of nature through the very fact of their conception which is greater, more realistic, and, above all, anticonventional.

Painters began by demolition—the period of the *Villes,* of the *Tours,* of the studies of Paris. This entailed the methodical destruction of the old craft, which was no longer sufficient, and then there occurred a completely human miracle. There was always some connection with actual events. The modernist drama of cities, blimps, airplanes, towers, windows, is the arduous course of long meditations on form. The search for the new craft, for the most part, was not understood in its true sense. In contrast with these last, one sees the results clearly, completely surprising since so unexpected. After such a storm—a human storm, conscious and unconscious destruction—at the end a constructive, clear, great, and universal concept, which places modern painting in the leadership of world art, as the Italian masters were.

These are simple works, clear and sharp, truly radiating from the

torments of questioning. The *Misericordia*, a human feast to immortalize dead man's beautiful gesture, enveloped by his great tranquillity and contemplated religiously as before nature.

The art of R.D.—from a modernism that is no longer destructive but constructive—spontaneous and precise, bears visions of the new life: skies filled with cities, blimps, towers, airplanes. All the poetry of modern life is in his art.

LETTER (1917)

Dated 1917, this letter was written in reply to the book of Joan Sacs: La pintura moderna francesca fina al intiame, *published in the Catalan review* Vell I Nou *(Old and New), December 15, 1917.*

July 6, 1917

Dear Sir,

It is a pleasure to reply to your invitation to appear in your review by sending you some photographs of some early paintings of mine.

These earlier works reproduce better because they employ the old device of chiaroscuro and a photograph renders such works best.

These works are from my destructive period that you have cited in your book (variant of the second draft, which you have spiritually called: *sigmatique*) and that the mania for names has prompted journalists to call simultaneism. On this subject, the controversy remains open regarding the investigation of the simultaneous before the war (simultaneism—don't know what it means). It is not yet clear to the public. Some people—I think them sincere—have confused the question due to the quantity of articles and mountains of paper. Is it because of a failure of intelligence? I think so. (On this subject—the Apollinaire polemic—Barzun—the cubists, the futurists, etc.) Everybody speaks about simultaneity as a metaphysical thing instead of *the craft itself. The constructive period of the new laws of color-form.* Unfortunately the last photos, the most recent, *Disque solaire simultané-forme* called

Hommage à Blériot, does not have an impact unless one has seen the picture in Paris.

This picture, naturally, from an earlier period, interests one the most and is lost in reproduction. The photo is not even what musical notation is to hearing.

After your letter, all my objections were dissipated. I am certain that specific things in your book have escaped us, not knowing Catalan. One free evening, Mme. S. D.-Terk, who speaks Spanish and Portuguese, amused herself by translating [your book] for me aloud without knowledge of the construction of the Catalan language, but rather by *deductive instinct.* We have followed the general direction of your work and it is at her suggestion that I have written you the preceding letter which you wish to honor by reproducing.

I reread it.

I find it alive but confused, particularly for the public. I am not a writer; my discipline is my pictures. [I am] too much in my craft of an art-worker. I am sending you, however, these notes which will give you more, I hope, of the evolving movement in which I believe.

As I wrote you in my earlier letter regarding your book, I like it because it shows the public and amateurs alike, not the path of specialization, but the great moral obligations of art. It doesn't specialize. It doesn't close. Perhaps it doesn't speak enough of the dimension of craft, of the role of material, of the direction one should give to the material. But this is the fault of the age in which painters are false literary men, false reasoners, instead of those seeking to realize form.

This is not your fault . . . it's a time of poor, hysterical, convulsive, destructive painting, an era of intellectuals who make paintings like dilettantes, and above all a time of reasoners misconstruing the goal of painting, which is to represent the Universe. All these hoaxes, futurists, cubists, all those so-called aesthetic meditations, these paintings of soul-states, these fourth dimensions, were neither painting nor Art. All this explains the apparent need of these painters to change their style every year—they who seemed laughable or puerile to those who everyday seek to evolve in their craft. Thus these painters pass from the *greatest eccentricities* to the most banal and *impoverished* pomposity without sequence, without lucidity, without spirit. This is what the masses forget or to what they remain insensible: life, observation, vision, eye, evolve and the only evolution in painting is that of craft, which renews itself in

balance with our faculties. This is far from the work-play and the intellectual games to which the painters and literary men have reduced painting in recent years.

There are some painters who, in 1917, having discovered the unintelligible, made drawings such as those we see in the scrapbooks of our grandmothers. As for myself, I no longer see as one did—it was a half-century ago, in the chiaroscuro of pomposity. Is is so far from our beautiful time of heroism, movement, and innovation.

I do not go backward. There is nothing there. Everything is rot, deterioration.

I know all the old techniques.
I want the new, the living, the unprecedented.
The pictorial idea—what has never been done.
I have struggled against the old craft:

	perspective	
	geometry	
	chiaroscuro	
mechanism	drawing	symbolism
primitivism	decorative	nonrepresentational
	illustrative	and form
	descriptive	
	literary	
	divisionism	

I want representation—simultaneous continuity of forms.
The whole.
Depth through an adequate craft, through relationships between color contrasts—form that is depth. (Depth that is *color and not chiaroscuro.*)

I have innovated in the use of contrasts. See, in the destruction and construction photographs numbered 1, 2, 3, 4, 5, 6, 7, 8, and 9.

I pursue this unexplored development, in order to find the form-color.
Form-color—inseparably.
The complexity of color rays used simultaneously in relation to the material.

vibrations going at speeds	in gum	of the same
which in scale would give	in wax	pigment
squares of 100 x 100	in oil	
	in metals, etc.	

The angular contrasts—not in a geometric sense as it seems to be in photos 1, 2, 3, 4, 5, 6, 7, 8—but in the disc contrasts—photo 9 and the last one that I sent you on the 7th of June.[1]

Since the *Villes, Saint-Séverin*, the *Fenêtres*, too rudimentary, too archaic, where the old is mixed in.

I have not yet found a language in which to write about colors.

I prefer form that is reconciled with nature.

Expression of a tangible craft.

Visual.

Painting is above all a visual art
in depth
Without mechanical elements.

laws of the contrasts
of the
movement of color
{ the movement of the colors which determines the forms between themselves, ourselves, and the Universe.

You can choose in this group what you judge is good, representative, persuasive, if you see reality in it. You, more than I, have the sense of what the public can understand. Above all, I have spoken with you, which has been diverting. Quote parts, if you want, but above all, interpret, because it will have more unity, since I do not know how to write. These words are perhaps too far from reality, too abstract.

I would like you to see our recent work. I believe they will be a surprise. Photography is a criminal art.

Painting is the universal and ideal language. One is compelled to love it. I believe that my words are nothing compared with the pictures. That is why I would love you to see my pictures.

1. The evolution of the eye in photographs 1 2 3 4 5 6 7 8 9 toward the ball rather than the circle and in this bad linear scheme before representing the placement of colors, the distributive quantities of contrasts, their distance before creating form in the movement of the whole.

Soon your news. I expect that you will return the last photo when you have seen it. I don't know if it suggests anything to you, if it inspires you.

Looking forward to reading [your letter]; accept, dear sir, my warmest greetings. . . .[2]

ON THE BACK OF A PHOTOGRAPH OF THE SIMULTANEOUS BOUTIQUE (C. 1924)

This short text was written on the verso of a photograph of the Simultaneous Boutique set up for the Salon d'Automne in 1924. It could have been included in the section of Robert's writing on Sonia Delaunay, but we have chosen to follow Francastel's arrangement, which includes this note in Delaunay's exposition of simultaneous craft. (Francastel, p. 133–34.)

As love is not a simple amusement, but the gesture of love a natural creation for the perpetuation of man, art is, in the spiritual domain, the quintessence of the image man makes of himself, in the happiest rhythm. This is why we are still moved by the primitives who have employed technique of the purest and sparest order (the Middle Ages). Those of our generation who will have found eternal elements above the petty turmoils and evils of the century will have a chance to survive. Therefore, we cannot adapt from the old to the new. It is necessary to be in a state of grace to discover the eternal truth. We cannot work one day in one manner and another day climb on another bandwagon without having to suffer for it (chapter on fashion). Where there is turmoil there is no belief—only decadence—or, even more simply, swindling with talent (the Stock Exchange). Actually, it's very fashionable. Those who provide a little sensation, amusement, will fall quickly out of

2. A postscript has been deleted because it is of a personal nature not germane to this selection. See Francastel, p. 133.

fashion. Only the eternal truth leads to candor and impassioned con-
science and can be itself. There is no way back. If one calls cubism a
period of painting, one will see how little it takes to trump up a craft
(Craft chapter). After the initial collective shock of the break that I
observed above, how many have been able to endure? The fear of the
road that is too long. The retarded wanted to amaze, to stay behind
with the rebus of the first moments (Picasso). The impressionist era
had these weaknesses, but the strongest of the impressionists knew how
to triumph in the end by releasing their personality through a craft
adequate to their strongest reality (see the vulgarizers of cubism). In our
own time where it was necessary to question everything again, to entirely
re-create the elements, a certain amount of time was and still is necessary
to build the house before living comfortably in it, and arriving at the
modern age in all the plenitude of its certainty of life (life is beautiful).

SIMULTANEISM: AN ISM OF ART (1925)

From Hans Arp and El Lissitzky, Die Kunstismen *(Erlenbach-Zürich,
München, Leipzig: Eugen Rentsch Verlag, 1925). This rare work of
twentieth-century art history contains brief statements by the principal
exponents of the "isms" of modern art or else statements by the editors
on their behalf, accompanied by photographs of works by the artists. The
entire volume is presented in three languages.*

Simultanismus *Die Gleichzeitigkeit der Farben, die gleichzeitigen
Kontraste und alle aus der Farbe sich ergebenden ungeraden Masse,
entsprechen ihrem Ausdrück in ihrer darstellenden Bewegung: dies ist
die einzige Realität zum Aufbau des Bildes.*

Simultanisme *La simultaneité des couleurs, les contrastes simultanés
et toutes les mesures impaires issues de la couleur, selon leur expression
dans leur mouvement représentatif: voila la seule réalité pour construire
la peinture.*

Simultaneism[1] Simultaneousness of color, simultaneous contrasts and all uneven measures issuing out of colour, conform to their expression in their representative movement: this is the only reality to construct a picture.

1. The English translations are all eccentric or inaccurate and the translation of Robert Delaunay's statement is no exception. We have presented it as it appears. However, it might be rendered more fluently and accurately as: Simultaneity of color, simultaneous contrasts and every uneven proportion that results from color, as they are expressed in their representative movement: this is the only reality with which to construct a picture.

Delaunay and the Futurists

Delaunay's controversies with the futurists, set off by Boccioni's attack on Delaunay in Der Sturm *(no. 190–191, December 15, 1913) under the title: "Futurist Simultaneity—A Vigorous Attack Against Delaunay." "This attack," Boccioni's title continues, "relies on an essay of Apollinaire recently published in* Soirées de Paris *(No. 18, November 15, 1913)."*

Actually, Boccioni's accusation against Delaunay was less astringent to Delaunay than Apollinaire's first general notation on the importance of futurism and his subsequent review of the Herbstsalon in Berlin at the Der Sturm gallery where he writes, "Through his persistence and talent, Delaunay has made the term 'simultaneous' (originally borrowed from the futurists' vocabulary) his own . . ." (Apollinaire on Art: Essays and Reviews, *1902–1918, op cit., p. 337.)*

This comment outraged Delaunay. No less, Apollinaire's later description of Delaunay's Hommage à Blériot *as an example of "spiralling futurism," to which Delaunay heatedly replied in an open letter in* Intransigeant, *March 4, 1913. As Francastel indicates in his illuminating discussion of this issue, Delaunay thought that by 1913 he had revealed his sources to Apollinaire and converted him to an understanding of his art. Not so. Apollinaire, always on the lookout for the new, and frequently imprecise in his assessments of it, had not realized that Delaunay —far from being an epigone of futurism—had developed his basic aesthetic even earlier than Boccioni's* Manifesto of the Futurist Painters *(Milan: March 8, 1910), and certainly earlier than the famous exhibition*

of futurist art at Bernheim-Jeune in Paris on February 5, 1912. For useful, but often contentious discussion of this matter, cf. Raffaele Carrieri, Futurism (Milan: Edizioni del Milione, 1963). Also Francastel's excellent discussion, pp. 135–38.

LIKE NATURE, ART HAS A HORROR OF CONSTRAINT (C. 1933)

The text included here, dating from the 1930s, is a summary riposte to the futurist claim against Delaunay's originality and is, curiously, literary, imagist, and passionately "simultaneist" in spirit.

First of Aesthetic Conversations

First Sir . . .

Dear Friend, as far as I'm concerned, I know no other movements than those of my own sensibility. . . .

Here is an object, the eye leaps to it and through my reasoning, "I dissect it as a surgeon dissects a corpse."

Then I taste it as a gourmet digests a choice dish.

Inside me, the object begins its true life.

It is a fact that it disappeared the moment my sensibility caught hold of it.

My sensibility elaborates and re-creates it. I am struck by the imperfections which were forced upon the object, which distracted it from its true meaning. It is necessary, then, that I undertake a new work from which all useless elements will be completely eliminated, a work in which particular reliefs and planes will be emphasized as my sensibility dictates, that is, a new geometry.

Second Sir . . .

Life is movement! Forget the past! It is crucial that everything be in motion, that images move one after another. We have to substitute

for the embalmed corpses of the Museum and the library modern life
with its automobiles, airplanes, cannons, machine guns, dreadnoughts.

Nothing must remain asleep. Repose is death. Let us suppress every-
thing that opposes our expansion:
antiquity, capitals, adverbs, participles.
Let a Universal whirlwind transport us, so
that the thousand thoughts which swarm in us may be set in motion
at the same time, on canvas and let their sequence of images
scream and clash to give back into the brain
something which perceives the tumult of the Universe.

First Sir . . .

Your Art has Speed for its expression and the film for its means. . . .
Your future is already past. . . . Struggle, do sports, travel, wage wars,
but, above all, do not fall back into the philosophy that we already
know too well: the simulacrum of the movement of uniformly successive
mobs. Your means are dynamic, mechanical, that is to say, against the
rhythmical. . . .

Your personages are merely conventional signs, academic and funda-
mentally archaic. When your compositions simulate more of life it is the
ideal of the engineer that you follow. You remain within the Object
which moves itself in the manner of all simulacra, which must then be
animated with sensibility.

You are really marching toward death.

Yes, we have enough of this sentimental, descriptive, static psychology
with which you put us to sleep. You are, you say, good boys, sur-
geons, thinkers, philologists. You divide the Universe beginning with
the object.

What's that?

You say sensibility. You retreat behind this big word. This conception
of jumping an object successively is called futurism. Can one conceive
through sensibility a movement that nobody sees? The personal move-
ment of our unique reasoning. You see, your sensibility is a special case
for you alone. You do not build anything. You play on words and that
leads inexorably to divisionism. This is the last state of the cadaver,
which is already in a state of decomposition. . . . You are the antonym
of life.

All these human things are already dated for mankind and are simply curiosities for us and our children in the houses specially reserved for them. They appeared in the distant contours of a past drama of former illusions.

God appears in all kinds of forms which make us smile sadly. But we pass by the churches, the museums, the obscure catacombs where so many men wanted to die, and the dust continues its work. From time to time a thief undresses a God *à la mode*.[1] This affords a simulacrum of movement, a tremor in the logic of the cemetery and its inhabitants.

Everyone nonetheless retains their convictions that have led them to this lovely place, this beautiful labyrinth which represents centuries of humanity, history, literature.

We exit. Ah! The light is pure. We have doubts, we are afraid. Everything is so dramatic! But these gestures, this beautiful sweet smile, this deceitful smile, this hideous laughter, this idiot laughter, this melancholy laughter. Is this God?

I am a collector. Have you noticed, quickly, under glass, in the amphitheater room, the corpse awaiting interment? The lighting was splendid under the blue sky, the corpse glittered and appeared incessantly in the prism.

Useless now—that psychology. Death is no more? But is it beautiful, and all the work surrounding us useless? Little student habits seem useless and the master . . . Ah! the lighting has changed. It is going to rain, no, it's day's end; however, it's always necessary to work. Turn on the gas. Wait a minute! What a beautiful effect: the cadaver is gilded. One slices, one cuts up, one embroiders the corpse with gold; one piece, three pieces, how much in the head? All the pieces of the corpse are golden. What wealth!

The sensible hour of six o'clock is going to strike. Let's hurry, let's cut, let's divide, let's cut, let's divide, let's dismember this thing. Gentlemen, six o'clock. The boy arrives. All the pieces are good for tomorrow. He counts them, tests them. Melon hats. The people go away. Everybody. He closes the school, extinguishes the gas, lights a cigarette. Psychology, the golden slices, the proof . . . I leave proof to Art. Oh, always that.

1. An allusion to the theft in 1911 of *The Mona Lisa* from the Louvre in which Apollinaire was unjustly implicated.

I love Art today because I love above all the light and all men love light above all.

They invented Fire.[2]

2. Added in pencil: "The impressionists are the primitives of light. The light. Simultaneity. Harmony. Inequality." In the margin of the last paragraph of the text: "Guillaume." This text is the echo of a conversation in the form of a dialogue with the sculptor Pevsner, the architect Nelson, and a Hungarian painter, Lux. [P.F.]

Delaunay, Klee, Apollinaire

LIGHT (1912)

An article written by Robert Delaunay in 1912, translated into German by Paul Klee, and published in Der Sturm *(No. 144–145, February 1913). Written while the Delaunays were at La Madeleine in the Chevreuse valley during the summer and fall of 1912, the essay is in poetic form, recalling the characteristic devices familiar to Delaunay from Cendrars's "Easter in New York" (which Delaunay had called the first simultaneous poem) and Apollinaire's* Alcools. *Cf. Francastel's discussion, pp. 144–45.*

Impressionism is the birth of Light in painting.
Light reaches us through our perception.
Without visual perception, there is no light, no movement.
Light in Nature creates color-movement.
Movement is provided by relationships of *uneven measures,*
of color contrasts among themselves that make up *Reality.*
This reality is endowed with *Depth* (we see as far as the stars) and thus
becomes *rhythmic simultaneity.*
Simultaneity in light is the *harmony,* the *color rhythms* which
give birth to *Man's sight.*

Human sight is endowed with the greatest Reality since it comes to us
directly from the contemplation of the Universe.

The Eye is our highest sense, the one which communicates most closely
with our *brain and consciousness*, the idea of the living movement of
the world, and its movement *is simultaneity*.

Our understanding is *correlative* with our *perception*.

Let us seek to see.

Auditory perception is insufficient for our knowledge of the Universe.
It lacks depth.[1]

Its movement is *successive*. It is a species of mechanism; its
principle is the *time of mechanical* clocks which, like them, has
no relation to our perception of the visual movement in the Universe.
This is the evenness of things in geometry.

Its character makes it resemble *the Object conceived geometrically.*

The *Object* is not endowed with *Life or movement.*

When it has the *appearance of movement,* it becomes *successive, dynamic.*

Its greatest limitation is of a *practical order.* Vehicles.

The railroad is the image of this successiveness which resembles
parallels: *the track's evenness.*

So with Architecture, so with Sculpture.

The most powerful object on Earth is bound by these same laws.

It will become the illusion of height:

The Eiffel Tower

of breadth:

Cities

length:

Tracks.

Art in nature *is rhythmic and abhors constraint.*

If Art is attached *to the Object,* it becomes *descriptive, divisive, literary.*

It stoops to imperfect modes of expression, it condemns itself of
its own free will, it is its own negation, *it does not liberate
itself from mimesis.*

If in the same way it represents *the visual relationships*
of an object or *between objects* without *light playing the role
of governing the representation.*

It is conventional. It does not achieve *plastic purity.* It is

1. Variant: "since it lacks duration." [R.D.]

a weakness. It is life's negation and the negation of *the
sublimity of the art of painting.*
For art to attain the limits of sublimity, it must approach our
harmonic vision: clarity.
Clarity will be color, proportions; these proportions are composed
of various simultaneous measures within an action.
This action must be representative harmony, *the synchromatic
movement (simultaneity) of light,* which is the *only reality.*
This synchromatic action will thus be the Subject which is the
representative harmony.

[*On the back*]
Auditory perception is insufficient for our knowledge of the
Universe since it lacks duration.
Its successiveness fatally commands evenness;
it is a kind of mechanism where depth, and therefore rhythm,
become impossible.
It is a mathematics where there is no space.
Its law is the time of mechanical clocks, where there is no
relationship at all to the movement of the Universe.
It is the evenness of things of this kind that condemns them to
nothingness.
Its quality resembles the Object.
The object is not endowed with life.
When the object is . . . there is the successive dynamic, but no
rhythm. It becomes a similitude of movement.[2]
Its greatest limitation is of a practical order. Vehicles.
The railroad track is the image of the successive approaching
the parallel: the tracks.
Thus Architecture.
These are only appearances.
The greatest object on Earth is subject to the very same laws:
it will become a record appearance of height or breadth or length, etc.
Art is rhythmic as Nature, that is to say, eternal.
If it begins with an object, Art is descriptive, stooping to
assume weak functions.

2. Variant: The object is not endowed with life or movement. When the object has an appearance of motion, it becomes successive, dynamic, but not rhythmic. Its greatest limitation is of a practical order. [R.D.]

It condemns itself freely—it is its own negation. Its most
representative mode is wax sculpture.

If Art is the visual relations of an object or between objects
themselves, without light playing the role of *governing the
representation*, it is conventional, and turns out to be a
language like any other, and by consequence, successive. Thus
literature, which has no plastic purity.

It is a weakness of Plastic Art. It is the negation of life, a
negation of the sublimity of art.

Art comes from the most perfect organ of Man
The Eye. The eyes are the windows of our soul.

It can become the living harmony of Nature
and it is then a fundamental element of our judgment toward
purity. To see becomes the comprehension [of the] good.

[*in pencil*]
The idea of the living movement of the world which
passes judgment upon our soul.

Our understanding is thus adequate to our sight. It is necessary
to look in order to see.

An auditory perception is not sufficient in our judgment to
know the universe, because it does not abide within duration.
Its successiveness leads fatally to its death.

It is a species of mechanism where there is no depth, and
therefore no rhythm. It is a mathematics that lacks space.

It is evenness of this sort that is condemned to death
Its quality resembles the Object. The Object is eternally
committed to death and its greatest limitation is of a practical order.
So with Architecture. These are only appearances.
The greatest object on earth is obliged by the same law.[3]

3. The drafts of this text have at the head of the page the following:
Art as nature abhors constraint.
I love the art of today because
I love Light, above all and all men
love light above all
They have invented Fire
 Aesthetic meditations
 G.A.
Light comes to us from perception, etc.
[This is Delaunay's rhapsodizing of the closing sentence of Apollinaire's essay, "Modern
Painting," infra, p. 98.]

The following is a variant of preceding text, dated 1912.

Auditory perception is insufficient for our *understanding of the Universe* since it is a mode that lacks duration.

Its motion is one of successiveness and it thus fatally orders an evenness and a kind of mechanism that lacks depth. It is a mathematics where there is no *space*, and consequently *no rhythm, no movement.*

Its law is the time of mechanical clocks which, like them, have no relationship at all with the *movement of the Universe.*

It's the evenness of things that condemns them to nothingness. Its quality resembles the *object.*

The object is not endowed with life or movement. When the object is a pretense of motion, it becomes *successive, dynamic,* but not *rhythmic.*

Its greatest limitation is of a practical order. Vehicles, railroad tracks are the image of the successive verging upon the parallel: *the evenness of the tracks.*

Thus Architecture.

These are only appearances.

The greatest object on the earth is likewise bound by the same law. It becomes an appearance. The Eiffel Tower: a record in height; the tracks: in length, etc.

Art, like nature, is rhythmic, that is to say, eternal. If art is connected with the object it becomes *descriptive.* It stoops toward imperfect instrumentalities, condemning itself of its own free will. It is its own negation. Its most representative mode is in sculpture in wax where it becomes an art of mimesis. Light does not impart life rhythmic to it. In the same way, if it represents the visual relations of an object or of objects among themselves, without light playing the *role of ordering the representation,* it is conventional and does not culminate in *poetic purity.* It is a weakness. It is the negation of life and of *the sublimity of art.*

Art arises from the most perfect organ of man, the eye. *The eyes are the windows of our soul and our eyes see the light.* Art can become the living harmony of nature and is thus *a fundamental element of our view of Reality. Representation.*

It is the voice that the Light causes to be heard and of which Hermes Trismegistus speaks in his Pimander.

"Soon"—one reads in the *Pimander*—"the shadows will descend . . .

and from them came an inarticulate cry which seemed to be the Voice of light."

This voice of light, is it not drawing, that is to say, line? And when light expresses itself completely, all is color. Painting is in fact a luminous language.

GUILLAUME APOLLINAIRE:
THE BEGINNINGS OF CUBISM
REALITY, PURE PAINTING (1912)

A slightly different version of this essay, written in two parts, appeared in Le Temps *(October 1912) and is published in* Apollinaire on Art: Essays and Reviews 1902–1918, *pp. 259–61. The second part, entitled* Pure Painting, *was translated into German and published in* Der Sturm *138–139 (December 1912).*

The Beginnings of Cubism

In the early autumn of 1902, a young man set up his easel on the isle of La Grenouillère. He was painting the Pont de Châtou. He painted rapidly, using pure colors. His brightly colored painting was almost finished when, hearing someone cough behind him, the young artist, whose name was Maurice de Vlaminck, quickly turned around and saw a tall young man examining his work with interest.

The newcomer, whose name was André Derain, apologized for his curiosity and explained that he was a painter. The ice had been broken. They began to talk about painting. Maurice de Vlaminck was familiar with the works of the impressionists: Manet, Monet, Sisley, Cézanne, of whom Derain was as yet quite unaware. They also spoke of van Gogh and of Gauguin. Night came and amidst the fog that now rose from the Seine, the two artists went on talking until midnight when finally, recrossing the bridge, they made their way home.

Maurice de Vlaminck in Reuil, Derain in Châtou. They saw each other every day and their passion for innovations in painting steadily increased. Maurice de Vlaminck was always on the lookout for artistic oddities. During his many trips through the villages that border along the Seine he had bought from pawnbrokers various sculptures, masks, and fetishes carved in wood by Negro artists of French Africa which had been brought back by sailors or explorers. Doubtlessly he found analogies in these grotesque and boldly mystical works with Gauguin's paintings, engravings, and sculptures that had been inspired either by the Breton Calvaries or by the primitive sculptures of the South Sea islands where he sought refuge from European civilization.

Whatever their source, these singular African images made a deep impression upon André Derain, who drew great satisfaction from them, particularly admiring the ways in which the Guinean or Congolese image-makers were able to reproduce the human figure without actually using a single element borrowed from direct perception.

Maurice de Vlaminck's taste for Negro sculpture together with André Derain's thoughts on these bizarre objects at a time when the impressionists had at last freed painting from its academic bondage were to have a decisive effect on the future of French art.

At about the same time, an apprehensive-looking young man was living in Montmartre; his face recalled at once Raphael's and Forain's. Pablo Picasso, who from the age of sixteen had had some fame with paintings that, in fact, recalled those cruel works of Forain, had suddenly abandoned this style to paint some mysterious works in dark blue. He was living in that strange wooden house at 13 Rue Ravignan where so many artists once lived—artists who have achieved fame or else are in the process of achieving it.

I met him there in 1905. His fame had not yet gone beyond Montmartre. He was wearing the blue overalls of an apprentice electrician and his words were at times quite harsh; such words, along with his somewhat strange art, were well known throughout Montmartre. His studio was flooded with canvases that portrayed mystical harlequins, and with drawings on which people would walk and that anyone could take away with him. This studio was the meeting place of all the young artists and poets: André Salmon, Harry Baur (the future Sherlock Holmes of the Antoine theater), Max Jacob, Guillaume Jeanneau (later one of the collaborators of *Le Temps*), Alfred Jarry, Maurice Raynal, etc.

That year André Derain met Henri Matisse. This encounter gave birth to the famous fauve school to which a large number of young artists belonged, artists who would some day become cubists and in whom the public is now so interested. I mention this meeting because I think it is important to make explicit the role that André Derain, originally from Picardy, played in the evolution of French art. The following year, Derain became friendly with Picasso. Their friendship resulted almost immediately in the birth of cubism, which in the beginning was above all a sort of impressionism of forms that Cézanne had had a glimpse of toward the end of his life.

By the end of the year cubism had ceased to be a mere exaggeration of fauvist painting, whose violent colorings were no more than an *irritating* impressionism. The new meditations of Picasso, Derain, and Georges Braque, another young painter, led to the true cubism, which was above all the art of creating new compositions from elements taken not from the reality of sight but from the reality of thought. Every man has the sense of this inner reality. You don't have to be particularly cultured to understand, for example, that a chair, no matter how you look at it, never ceases to have four legs, a seat, and a back.

In 1908, Georges Braque exhibited a cubist painting at the Salon des Indépendants. It provoked the wit of Henry Matisse, who, deeply struck by the geometrical appearance of this painting—in which the artist had sought to render essential reality, with the greatest simplicity—uttered the mocking words of cubism, which was soon to receive such wide acclaim. The young painters accepted it, because, by representing reality as it is conceived, the artist could give a three-dimensional appearance to his subject—could, in a way, "cubize." Were he simply to depict reality as it is perceived, he would not be able to achieve this three-dimensional quality, unless, of course, he created a *trompe-l'oeil* effect through foreshortening or perspective, which would falsify the character of the conceived form.

The young school grew, however, and by 1910 it included Jean Metzinger, who was the first theorist of cubism, Albert Gleizes, Marie Laurencin, Le Fauconnier, Robert Delaunay, and Fernand Léger.

It was at this time that André Derain, shocked by the result of his ideas, or perhaps preparing a new aesthetic revolution, cut himself off from the cubist school and went to live in seclusion. With new artists now in its midst, cubism was soon filled with new trends. Breaking with the conceptualist formula, Francis Picabia, Robert Delaunay, and Marcel Duchamp all turned to an art no longer restricted by any rules.

We are thus heading toward an entirely new art, one which will be to painting—such as we have considered it until now—what music is to literature.

This art will have as many relationships to music as any art that is the opposite of music can have. It will be pure painting. Whatever might be thought of such a daring attempt, it cannot be denied that we are dealing with artists who are sure of themselves and worthy of respect.

Recently a large number of very talented cubists have appeared, such

as August Agéro, Juan Gris, Roger de la Fresnaye, Louis Marcoussis, Pierre Dumont, and others. The following anecdote is authentic: the wife of a young impressionist painter gave her husband a year to become a cubist, and, if during that year he didn't exhibit at the Section d'Or, she would seek a divorce.

I should mention, by way of conclusion, that when people accuse the most recent cubists of painting pictures without any real subject, the artists often quote the anecdote of Apelles and Protogenes from Pliny. It really makes clear what aesthetic pleasure is.

Reality, Pure Painting

In the midst of the battle that is being waged in France against the young French artists who, as proof of the profundity of their art, proudly bear the name cubist—a name originally used to ridicule them—I felt a personal obligation to organize the defense of a group of artists whom I was the first to discuss in the major French newspapers *Le Temps* and *L'Intransigeant* and in my book *Aesthetic Meditations* (Figuière, 1913) [which contains] some definitions of cubism as well as an attempt to pinpoint the differences that must be established between the traditional art of imitation and the art in which a well-known painter such as Picasso has distinguished himself.

The diversity of opinion among these artists reassured me about the future of an art that is not a technique but represents, rather, the enthusiasm of a whole generation for a sublime aesthetic that rejects the traditional rules of perspective and other conventions.

It so happens that at that time I often saw a young painter whose work has provoked a great deal of discussion over the past few years, both in France and abroad. His name is Robert Delaunay, and he is one of the most gifted and daring artists of his generation.

His conception of colored volumes, his sudden break with perspective, and his notion of surfaces have influenced a great many of his friends. I also came to know of his experiments with pure painting, which I reported in *Le Temps*.

Delaunay had never completely explained his theories to me, however, and recently I had the pleasure of being shown his latest works, in which reality is as full of movement as living light; furthermore, Delaunay decided to explain to me, for my own edification, the principles of his

discovery, which will exert a greater influence on the arts than the sudden changes provoked by his most famous painting, *La Ville de Paris.* I believe I shall be rendering a service to everyone by quoting his aesthetic declaration on the construction of reality in pure painting:

Realism is the eternal quality in art; without it there can be no permanent beauty, because it is the very essence of beauty.

Let us seek purity of means in painting, the clearest expression of beauty.

In impressionism—and I include in that term all the tendencies that reacted to it: neoimpressionism, precubism, cubism, neo-cubism, in other words, everything that represents technique and scientific procedure—we find ourselves face-to-face with nature, far from all the correctness of "styles," whether Italian, Gothic, African, or any other.

From this point of view, impressionism is undeniably a victory, but an incomplete one. The first stammer of souls brimming over in the face of nature, and still somewhat awed by this great Realist. Their enthusiasm has done away with all the false ideas and archaic procedures of traditional painting (draftsmanship, geometry, perspective) and has dealt a death-blow to the neo-classical, pseudointellectual, and moribund Academy.

This movement of liberation began with the impressionists. They had had precursors: El Greco, a few English painters, and our own revolutionary Delacroix. It was a great period of preparation in the search for the only reality: "light," which finally brought all these experiments and reactions together in impressionism.

One of the major problems of modern painting today is still the way the light that is necessary to all vital expressions of beauty functions. It was Seurat who discovered the "contrast of com-plementaries" in light.

Seurat was the first theoretician of light. Contrast became a means of expression. His premature death broke the continuity of his discoveries. Among the impressionists, he may be considered the one who attained the ultimate in means of expression.

His creation remains the discovery of the contrast of com-plementary colors. (Optical blending by means of dots, used by Seurat and his associates, was only a technique; it did not yet have

the importance of contrasts used as a means of construction in order to arrive at pure expression.)

He used this first means to arrive at a specific representation of nature. His paintings are kinds of fleeting images.

Simultaneous contrast was not discovered, that is to say, achieved, by the most daring impressionists; yet it is the only basis of pure expression in painting today.

Simultaneous contrast ensures the dynamism of colors and their construction in the painting, it is the most powerful means to express reality.

Means of expression must not be personal; on the contrary, they must be within the comprehension of every intuition of the beautiful, and an artist's *métier* must be of the same nature as his creative conception.

The simultaneity of colors through simultaneous contrasts and through all the (uneven) quantities that emanate from the colors, in accordance with the way they are expressed in the movement represented—that is the only reality one can construct through painting.

We are no longer dealing here either with effects (neoimpressionism within impressionism), or with objects (cubism within impressionism), or with images (the physics of cubism within impressionism).

We are attaining a purely expressive art, one that excludes all the styles of the past (archaic, geometric) and is becoming a plastic art with only one purpose: to inspire human nature toward beauty. Light is not a method, it slides toward us, it is communicated to us by our sensibility. Without the perception of light—the eye— there can be no movement. In fact, it is our eyes that transmit the sensations perceived in nature to our soul. Our eyes are the receptacles of the present and, therefore, of our sensibility. Without sensibility, that is, without light, we can do nothing. Consequently, our soul finds its most perfect sensation of life in harmony, and this harmony results only from the simultaneity with which the quantities and conditions of light reach the soul (the supreme sense) by the intermediary of the eyes.

And the soul judges the forms of the image of nature by comparison with nature itself—a pure criticism—and it governs the

creator. The creator takes note of everything that exists in the universe through entity, succession, imagination, and simultaneity.

Nature, therefore, engenders the science of painting.

The first paintings were simply a line encircling the shadow of a man made by the sun on the surface of the earth.

But how far removed we are, with our contemporary means, from these effigies—we who possess light (light colors, dark colors, their complementaries, their intervals, and their simultaneity) and all the quantities of colors emanating from the intellect to create harmony.

Harmony is sensibility ordered by the creator, who must try to render the greatest degree of realistic expression, or what might be called the subject; the subject is harmonic proportion, and this proportion is composed of various simultaneous elements in a single action. The subject is eternal in the work of art, and it must be apparent to the initiated in all its order, all its science.

Without the subject, there are no possibilities. This does not, however, mean a literary and, therefore, anecdotal subject; the subject of painting is exclusively plastic, and it results from vision. It must be the pure expression of human nature.

The eternal subject is to be found in nature itself; the inspiration and clear vision characteristic of the wise man, who discovers the most beautiful and powerful boundaries.

Such words do not require commentary. They seek to be understood directly and to arouse the simultaneity that alone is creation. All else is notation, contemplation, and study. Simultaneity is life itself, and in whatever order the elements of a work succeed each other, it leads to an ineluctable end, which is death; but the creator knows only eternity. Artists have for too long strained toward death by assembling the sterile elements of art, and it is time they attained fecundity, trinity, simultaneity.

And Delaunay has attained them, not only in words, but also in his works—pure painting, reality.

A Note on the Construction of Reality in Pure Painting (1913)

These are the manuscripts that Delaunay gave to Apollinaire for his article in Der Sturm; *the latter put them in order. Variants exist.*

Realism is, for all the Arts, the Eternal quality that must determine Beauty and its duration. It is that quality which is equal to Beauty.

In the realm of painting, let us strive for purity of means, the purest means for the purest expression of Beauty.

Impressionism (to which I would link all reactionary phenomena: neoimpressionism, precubism, cubism, neocubism, everything that is technique, scientific process) proved that light was the source of Beauty. Impressionism brings you into direct contact with nature, far from all the worn-out devices of Italian, Gothic, African tribal styles.

Impressionism is, for this reason, a substantial though incomplete victory; here we find the first babblings of exuberant souls before nature, somewhat awed by this great Realist. This exuberance has destroyed all the false ideas, all the archaic methods of the old school of painting (the science of drawing, geometry, perspective, etc., the whole agonizing, intellectualist, neoclassical academy).

It is clearly possible, then, to ascertain the beginning of this liberating impressionist movement, with its precursors: El Greco, a few Englishmen, and our own revolutionary Delacroix. These artists belong to a great era of preparation in search of the one and only Reality: "Light," which includes all the studies I mentioned above, as well as the reactions to them.[1]

The functioning of Light,[2] necessarily vital to all expression of Beauty, has remained the problem of modern painting. Seurat (and only Seurat) was able to release something from light: "the contrast of complementary colors."

Seurat was one of the first theoreticians of Light. With him contrast became a means of expression. His premature death interrupted the

1. The study of light as a whole, including impressionism, as I said above (neoimpressionism, cubism . . .). [Variant by R.D.]
2. Variant: color. [P.F.]

94

continuation of his work. He can be cited as the impressionist who went furthest into the study of method.

His enduring achievement is the contrast of complementary colors. (Since the combining of different optical planes by dots, which he and his colleagues all used, is no more than a technique, it has not the same importance as contrast, which is a pure expressive means of composition belonging to pure expression.)

He uses this first method for the scenic transposition of nature. His paintings are like so many fleeting images.

"Simultaneous contrast" (see Rood) was not discovered, or, I should say, realized, by even the most daring of the impressionists, and yet it is the only basis of pure expression in contemporary painting.

"Simultaneous contrast" assures the dynamism of colors and their arrangement on the canvas; it is the most effective means of expressing Reality.

Means of expression should not be personal; on the contrary, they should be accessible to all those who aspire toward beauty: and the technique should be equal to its plastic representation.

"Simultaneity of colors"—through simultaneous contrast and all the uneven shades that result from colors according to the way they are expressed in their figurative movement—represents in painting the only reality to be used for composition.

It is no longer a question of Effect (impressionism and neoimpressionism, Claude Monet, Sisley, Renoir, Pissarro, etc.), of Object (impressionism, cubism, Derain, Picasso, Braque, Metzinger, etc.), or of Image (impressionism, neocubism, Gleizes, Fauconnier, Herbin, H. Rousseau, Seurat, Cézanne, P. Gauguin, Signac. H. Matisse, etc. . . .).

We are approaching an art of painting that is purely expressive, beyond the limits of all past styles—archaic, geometric, . . . an art that is becoming plastic, whose sole purpose is to translate human nature with more flexibility as it is inspired toward beauty (neither literature, nor technique, nor process).

Light is not a process. It comes to us through perception.

Without perception (the eye), no movement. Our Eyes are the windows of our being and of our soul. It is in our eyes that the present unfolds, the "mathematical science," along with our perception. We can do nothing without perception, hence without light. Consequently, our soul establishes its life on harmony, and harmony is born only from

simultaneity, whereby the measures and proportions of light enter the soul through our eyes, the supreme sense.

And the soul judges the forms of the natural work in comparison with the artifice of painting.[3]

The inventor takes into account what is in the Universe with regard to essence, frequency, imagination, and simultaneity.

Nature therefore engenders the science of painting.

The first painting ever made was simply a line drawn around the shadow of a man cast by the sun against the ground.

But consider how far removed we are, with modern-day methods, from this "Simulacrum"; for we have light (light colors, dark colors, their complementary colors, their intervals, and their simultaneity) and all the possible shades of color that have been conceived to create harmony.

Harmony is, on the one hand, perception; on the other, harmony is ordered by the creator who must strive to render his perception with a maximum of realistic expression: which may be called the subject.

The subject is the harmonic proportion and this proportion is composed of the different simultaneous members contained within one action.

The "subject" is eternal in the work of art and must appear to the enlightened in all its order, in all its science.

There is no resource except subject. This does not necessarily mean, however, a literary, hence anecdotal subject: the subject in painting is entirely plastic; it springs from vision; and it must be the pure expression of human nature.

The eternal subject is found in nature itself: the inspiration and clear vision that belong to the sage who discovers the strongest and most beautiful limits.

3. Variant: (pure criticism) with nature. Another variant: harmonic proportion in painting is composed of the different members contained within one action; this action, in competition with nature, is dictated by invention and technique. [P.F.]

LETTER TO APOLLINAIRE (1913)

April 17, 1913

I'm thinking about your letter which I received the day before yesterday.

But could you possibly have doubts about the vision of the Subject? Haven't I spoken and written about impressionism, apropos an answer that I gave and that you read?

I have spoken and written on impressionism, on all its aspects, on color and on form.

You have a good example of this in the *Blue Rider* or the *Girl with a Mandolin*.[1] Look for the subject, you won't find any. Then there's Rousseau, the visionary—totally visual—his tendency toward the popular, in the most representative, the *noblest*, the *clearest* sense. What is happening is that now there's a new group on the scene to defeat intellectualism, taste. Technique now plays an important role, which is not one of vulgarization. Cézanne, the apprehensive, humble Cézanne, had foreseen this, but was afraid; he wasn't ready; he had trouble with his museum. He was stifled by his own bourgeois character and by his taste. Rousseau was luckier, richer. He is not just a museum. He takes his place in tradition through vision, through movement—which is modern in his work. I wish he were even more modern. I am too difficult, because I have no taste. I am surrounded only by people who have taste. But my mind is on the move.

Right now I am painting the sun, which is itself pure painting—and a New York series.

1. Delaunay somewhat contemptuously refers to Kandinsky's *Blue Rider* and Picasso's *Girl with a Mandolin* (1910) without capitalizing them or giving any indication that they are the titles of world-renowned pictures. Our capitals and italics do not appear in the original text.

GUILLAUME APOLLINAIRE: PURE PAINTING (1913)

An unpublished manuscript which Francastel dates from early 1913.

It's over a year ago now that I wrote, in an essay that appeared in *Soirées de Paris*, the words "pure painting," a phrase that the painters were very soon to justify.

Based on harmony, such painting can come alive only by means of asymmetrical form. Being intellectual to an extreme, it is, as a result, also realistic to an extreme, and its very purity demands that marvelous plastic Trinity without which there can be no modern art.

Perhaps pure painting signifies pure light, and those illuminated ads that ennoble our streets at the same time that they industrialize them are to my mind an imperfect yet clear image of the most significant kind of painting, one toward which the efforts of our young artists are currently directed.

But let's not get ahead of ourselves; these new methods are not yet those of painters.

GUILLAUME APOLLINAIRE: MODERN PAINTING (1913)

An article published in Der Sturm, *No. 148–149 (February 1913), p. 272. This translation is taken from* Apollinaire on Art: Essays and Reviews *1902–1918 pp. 267–71. The original manuscript, translated into German by Jean-Jacques, was lost and so, at the request of Delaunay, it was translated into French by Anatole Delagrave (A. Jakowsky) and published in 1939 in a limited edition under the title* La Peinture Pure. *It is a central document in the history of modern art, establishing as it does the distinction between cubism and orphism and defining light as the principal foundation of the latter. It is an echo of the text translated into German by Klee and thus clarifies the link which Delaunay's "Light" had both to German and French practitioners of abstract art. Cf. Francastel, pp. 145–46.*

France in the nineteenth century produced the most varied and most innovative artistic movements, all of which together constitute impressionism. This tendency is the opposite of the old Italian painting based on perspective. If this movement, whose origins can be discerned back in the eighteenth century, seems to have been confined to France, that is because in the nineteenth century Paris was the capital of art. Actually, this movement was not exclusively French, but European. Englishmen like Constable and Turner, a German like Marées, a Dutchman like Van Gogh, and a Spaniard like Picasso have all played major roles in this movement, which is a manifestation not so much of the French genius as of universal culture.

Nevertheless, this movement first took hold in France, and French artists expressed themselves in this art more felicitously and in greater numbers than the painters of other nations. The greatest names in modern painting, from Courbet to Cézanne and from Delacroix to Matisse, are French.

From the point of view of artistic culture, one can say that France played the same role that Italy played in earlier painting. Later, this movement was studied in Germany almost as ardently as in France before the fauves. At that time, impressionism began to be refracted into individual tendencies, each of which, after a period of groping, has now taken its own road in order to arrive at a living expression of the sublime.

The same thing has happened in French literature; each new movement includes several different tendencies. The name "dramatism" does not express the rejection of description that dominates the works of certain poets and prose writers, among whom are Barzun, Mercereau, Georges Polti, and myself.

Similarly, new tendencies can be found in modern painting; the most important of these seem to me to be, on the one hand, Picasso's cubism, on the other, Delaunay's orphism. Orphism is a direct outgrowth of Matisse and of the fauve movement, especially of their luminous and anti-academic tendencies.

Picasso's cubism is the outgrowth of a movement originating with André Derain.

André Derain, a restless personality enamored of form and color, gave, once he had awakened to art, more than mere promises, for he revealed their own personality to all those he encountered: to Matisse, he revealed his feelings for symbolic colors; to Picasso, his feeling for

sublime new forms. After that, Derain retired to live in solitude and, for a while, failed to participate in the art of his time. His most important works are the calm and profound canvases (up to 1910) whose influence has been so considerable and the woodcuts that he did for my book *L'Enchanteur pourrissant.* The latter gave rise to a renaissance of the woodcut, thanks to a technique that is broader and more flexible than, for example, Gauguin's; the effects of this renaissance were felt all over Europe.

Let us return to the major tendencies in modern painting. Authentic cubism—if one wishes to be categorical about it—might be defined as the art of painting new compositions using formal elements borrowed, not from visual, but from conceptual reality.

This tendency leads to a poetic painting independent of all visual perception; for even in the case of simple cubism, the artist who wished to achieve the complete representation of an object—especially of objects with a more than elementary form—would be obliged by the need to disclose all the facets of the geometric surface to render it in such a way that, even if one took the trouble to understand the resultant image, one would find it far different from the object itself, that is, from its objective reality.

The legitimacy of such a method cannot be doubted. Everyone must admit that a chair, from whatever angle one looks at it, will always have four legs, a seat, and a back, and that if one takes away one of these elements, one takes away something essential. The primitives painted a city not as it would appear to someone looking at it from the foreground, but as it was in reality, that is to say, whole, with its gates, streets, and towers. A great number of innovations introduced into this kind of painting confirm its human and poetic characteristic every day.

Picasso and Braque introduced elements such as letters from signboards and other inscriptions into their works of art, because in a modern city inscriptions, signboards, and advertising posters play a very important artistic role and are easily adapted to that end. Picasso sometimes abandoned customary paints in order to compose three-dimensional pictures of cardboard or collages; in these instances, he was obeying a plastic inspiration, and these strange, rough, and disparate materials became ennobled because the artist endowed them with his own strong and sensitive personality.

To this movement belong Georges Braque, Jean Metzinger, Albert Gleizes, Juan Gris, and certain works by Marie Laurencin.

Another minor current can be distinguished within this major current: physical cubism, which consists in the creation of new combination with elements borrowed from visual reality. This is not a pure art, and the movement is related to cubism only in its constructive aspects.

Another wing of impressionism soars toward the sublime, toward light. The efforts of the impressionists had led them to paint the appearance of light. Then came Seurat; he discovered the contrast of complementary colors but he could not detach himself from the image, for a contrast can exist only through itself. But Seurat's investigations were of considerable importance, particularly because they paved the way for many other seekers.

Delaunay believed that if a simple color really determines its complement, it does so not by breaking up light into its components but by evoking all the colors of the prism at once. This tendency can be called orphism. This movement, I believe, comes closer than the others to the sensibility of several modern German painters.

This dramatic movement in art and poetry is becoming stronger and stronger in France; it is represented particularly by the works of Fernand Léger, whose investigations are esteemed very highly by the young painters; also, in some of Mlle. Laurencin's painting; in Picabia's recent works, whose smashing violence is shocking the public at the Salon d'Automne and the Section d'Or; and, finally, in the strange paintings of Marcel Duchamp, who is attempting to symbolize the movement of life, etc.

The most interesting German painters also instinctively belong to this movement: Kandinsky, Marc, Meidner, Macke, Jawlensky, Münter, Otto Freundlich, etc. To orphism likewise belong the Italian futurists, who developed from fauvism and cubism, like all those who also rebelled against the conventional forms of psychology and perspective.

These two movements are movements of pure art, because they determine only the pleasure of our visual faculty. They are movements of pure art because they attain the sublime without depending on any artistic, literary, or scientific conventions. Here begins inspirations. We are soaring here toward plastic lyricism.

In the same way, the new poetic movement known in France as "dramatism" soars toward the concrete, direct lyricism that descriptive writers can never attain.

This creative tendency is now spreading throughout the universe. Painting is an art not of reproduction but of creation. With these move-

ments, orphism and cubism, we are attaining the fullness of poetry in the bright light.

I love the art of these young painters because I love light more than anything else.

And all men love light more than anything else because they invented fire.

Painting Is, by Nature, a Luminous Language (The Orphic Group) (1924?)

This text, an extension of the dialogue between Delaunay and Apollinaire, was written about 1924, after Apollinaire's death. It is an effort to make clear the sense in which painting is different from poetry, since Apollinaire's baptism of Delaunay as orphic was as much an effort to supply a definition of Apollinaire's new verse as it was to provide a role for Delaunay in the history of cubist "heresies." Delaunay's annoyance with Apollinaire's categorizing is clear here as it is elsewhere, but he never turned his back on Apollinaire nor did he deny the fructifying role their friendship played in the developing of his artistic sensibility. See Francastel, p. 167.

Clear, live, visual French art—not mystic. The rhythmic representation of colors, which is not dynamic, successive movement, or even movement of visual perception, but is rather the harmonic simultaneity of colors. The movement of colors that creates art in painting. In this art it is no longer a question of perspective or geometry—methods painters presently still use.

Geometry is an abstraction that demands the application of literary as well as descriptive means to the primitive representation of art, since, in geometrical art, color is not a structural element—it is only a coloring, an added factor. It has no active part in light since it is superimposed on a system that has nothing to do with colors in light.

This is where the great originality and genius of the painter lies. No longer satisfied with the mere arrangement of forms and objects, he will strive for the sublimity of representation. He must create rhythm, different rhythms, a movement that will bring the subject into being— the side of painting which is poetic and sublime. This painting also has a popular dimension in that it acts directly on one's senses [*la sensibilité du spectateur*]. It is not stasis; it is movement, perpetual, always *perfectible* movement. We are approaching a pure *Dramatic* work, for all the elements that go into it are visual elements—the colors, the light. The relationships between the different contrasting colors, simultaneous contrast, create a depth, a movement more effective than all the Euro-

pean, Hindu, Chinese perspectives, since they are determined solely by the creator's vision. Objects are all clearer since there can be no confusion between them, nor are they symbolic in color (as in the works of the symbolist painters), for these are not mere spots of color, successive and flat, which contribute only to the taste for color—the decorative side. In the new art it is a question of the most varied, free, profound, and elevated representation that man's vision has ever attained in its most intense moments.

TWO NOTES ON ORPHISM (1930; 1928–1930)

This text was composed about 1930 when Delaunay was concerned with fixing his historical perspective on the problems of simultaneism, color, and light. Cf. Francastel, p. 167.

Orphism

The intent of the word "orphic," used by G. Apollinaire, was to align with cubism every manifestation of the art of that era, in order to thereby create a homogenous group with which to rally artistic youth to a single aesthetic movement. Also, when Apollinaire saw that an art of color was being born—whose whole importance he himself had not foreseen— he assimilated it to the poetic, musical, and plastic Games (to whatever fantasy struck him). Alone he, the poet, does not see the incredibly important constructive essence of this new art. He baptised with the name of orphism all these colored manifestations which, right at the heart of cubism, were the first hope of a transformation from the monotonous black, gray, beige, green era toward a first deliverance from the plastic academicism. That importance, he saw immediately, since it was he who created theoretical cubism, quartered it, and located there constrasting tendencies—in opposition to a politico-plastic contrast. This tendency of the young toward a deliverance from the monotony of the times and an

enthusiasm for vital realization (his Berlin lecture at *Der Sturm*, opening the Delaunay exhibition) he announced to the press of the entire world. . . . Era of gestation of the effervescence of youth, of the research for a new art.[1]

Antagonism, confirmed by Raynal's study of Picasso (Delphin Publishers, Munich), between line, drawing, and color.[2] There appeared already during the previous five years a purity of modern criticism in the midst of all these manifestations of art, which could be seen, understood—from the phenomenon of Cézanne to that of Delaunay by:

1. The study in depth of the means that in plastic arts are expressive sensibility itself—which structures and forms the reality *by means of which one compares and deduces* and we express, above all, a philosophy of art that is purely *organic* and objective. The measure, if one can call it that, the exact evaluation of criticism—which must be *the understanding stripped and cleared* of *the anarchy* above all, of the confusion of the period of productivity. . . .
Finally:

a comparative scale of visual evolution according to the created—after the copies and comparison of periods according to copies.

1. Two directions of this era: the "neo" direction and the ultraconservative; sensibility. [R.D.]

2. Orphism after G. A. [Apollinaire.]
Criticism of this poetic designation. Pure painting would be reflected better than a word which carried with it the symbolic past and expressed opposition to contemporary realist errors which persist in the formal means of certain cubists.

$$\text{orphism} \left\{ \begin{array}{l} \text{plastic} \\ \text{verbal} \\ \text{musical} \end{array} \right.$$

The meaning of the word orphism is *creation with reference to G.A.* This *creative direction of color toward pure painting*—an art that is entirely new, having its own laws of creation—and appearing to be detached from any image in the *objective, visual dimension of nature*—develops on the contrary—in the most profound sense, perfecting itself—toward an objective construction that is equal to nature, with a legibility comparable to the spectacle of nature. And we have helped in recent times to justify what we propose—a materialism of expression arising from the *organic juxtaposition of colors,* the law of sensibility and order, forms which only a poorly educated eye would confuse at first glance with impressionism, with that which impressionism expressed instantaneously and by contrast to nature. Contrast with nature is all the more accentuated when the craft itself is pure and expressive and subjectively reinforces form—while imparting to it the unique life and breath of art. [R.D.]

Pictures of pure criticism:[3]
in order of years and development

Pure criticism	destructive		
	intermediary		
		creation	
	construction		

This longer text, found among Delaunay's unpublished papers, dates from the period 1928–1930.

Simultaneity was discovered, in a total manner, for the first time in 1912, which was expressed in its entirety in the picture *Les Fenêtres* for which Apollinaire wrote his famous poem (about which there are other relevant anecdotes).

In 1910, in a picture of the destructive era, *La Tour*, there were intuitions of simultaneity. This picture was exhibited in Paris in 1911, in Berlin in 1912. Apollinaire wrote another poem that accompanied a postcard reproduction of this picture published in Berlin.

Cendrars also wrote dedicatory poem for *La Tour*, collected in *Dix-neuf Poèmes Elastiques* [Editions Au Sans Pareil].[4]

These two poets were influenced by this picture (which is very well known throughout the world) but the picture is less important from the point of view of fundamental novelty. One can find its analogues in other works and it had a great influence on the German expressionists, as well as in Russia, America, etc. . . .

Les Fenêtres was a great deal more significant as plastic and poetic sensibility and novelty. If we compare it with the past at the moment of its actual making, it stands as a real creation. I want to say here that there is nothing like it within the tradition and at the present time I think that it is misunderstood. In comparing it with other works, I have

3. *Pure Criticism.*—Such criticism should take into account even the reality of works which result from the ideologies that lead them, that means, *vis-à-vis cubism*—which is recognized as *a destruction*—the return of cubism to old formulas proves the ineffectualness of cubism insofar as it is regarded as an expressive plenitude! ! ! The return to old formulas augurs for those who practice it a detour—for those who mark time, a denial of life—for those who have gone further toward an evolution of technique, a victory: *supercubism*. [R.D.]

4. See "The Eiffel Tower," p. 171.

not found the least trace, in its intention or physical aspect, of any other painting or artist, even among the mosaicists where a completely super-ficial comparison could be made about its exterior aspect. The first time that I picked up a trace of this thought was in the notebooks of Leonardo da Vinci where he writes on the differentiation between the art of paint-ing and of literature, but his evaluation deals only with the functional dimension of the eye. He seeks to prove the intellectual superiority afforded by simultaneity through our eyes, *windows of the soul*, superior to hearing and the successiveness of hearing.

It was a question for him—as you see it in *Les Fenêtres*—of color for the sake of color.

It is not my intention to repudiate the colorists I like, such as the glass painters of the Middle Ages, or the Arabs or the Cosmas, etc. . . . But I wish to prove that the role of color as used by the ancients and moderns was, in one sense, not absolutely pure. The use of color was stained by a descriptive or literary usage or by chiaroscuro. It wasn't unique, a universal language.

I think that *Les Fenêtres* marks the beginning of what Apollinaire called *pure painting* in the same respect as "Les Fenêtres" marks the beginning he sought for pure poetry: *it has a date of origin.*

At this time, the movement toward color was assimilated by cubism. Why? Do not forget that it is Apollinaire who first publicized cubism. As Cocteau has written in his *Feuilles Libres*, the word *cubism* is very different and cannot be compared with the word *impressionism, impres-sion* being a word given by a painter to designate his wish to paint what he feels about the spectacle of nature in the manner of a Kodak—ideal and individual.

The reason that Apollinaire brought together all the tendencies known at that time under a single rubric was that he wanted to mold the turmoils and inquiries of artists into a solid mass, a single front before the in-comprehension of art lovers and the general public. He assimilated, in a sense more political than artistic, this birth of color. He gave it the designation orphic—the second branch of the new religion of cubism. For him it was a poetic designation.

But Cendrars was more precise. He compared simultaneity to a material like reinforced concrete, which was a very perceptive observa-tion.

Certainly Apollinaire saw it as a surrealist poetry, as he called it.

In the poem "Windows" there is more than a new technique. The

poem is rumored to have been composed of conversations of his café friends.[5] This anecdote (or rather this gross foolishness) was picked up in a magazine by I don't know who; it says that Apollinaire, before making a preface for the catalogue of a painter (the catalogue in which this poem is reproduced before reproductions of my pictures, 1909–1913), suddenly remembered in the midst of a crowd of friends that the form had to be delivered the same evening, and he began to write what was called for in verse *(du rouge au vert tout le jaune se meurt)*. It is recounted that he asked his friends to help him since he was lacking inspiration. Some dictated a newly minted passage to him, and Apollinaire wrote it down; another offered still another passage and thus the whole poem was finished.

I have the manuscript of this admirable poem and I defy the journalists who fabricated this so-called collaboration to tell me in what color this poem is truly written, for it marks one of the best periods of the poet, his most sharply original period.

At this time we were very close to Apollinaire, who was virtually abandoned by his friends upon his return from the Santé prison following the theft of some Phoenician statues by his secretary.[6] We found him at his house in Auteuil completely withdrawn and neurasthenic as a result of the publicity that had momentarily snarled him in a nefarious adventure harmful to his reputation as a man of letters in the avant-garde. It was at this time that we invited him to live with us at 3 Rue des Grands-Augustins for about a month and a half until he was ready to move into his new lodgings on the Boulevard Saint-Germain.

This was the moment when our intimacy began and I remember discussions and letters written on the subject of the new painting where I disclosed to him the definitions that I had established for this period of my painting and where I laid the foundations of a possible new painting. I have a horror of theories, however modern, of any doctrine of a poetic plastic, even if it is the most rudimentary. The most elemental is a negation of the whole a priori problem in painting, and I think the same about poetry.

5. What follows is Delaunay's account of the controversy discussed earlier.

6. See accounts of the theft of the Phoenician statues and Apollinaire's unfortunate involvement in Steegmuller, *Apollinaire: Poet Among the Painters* pp. 182–89, 191–193, 210–211, 217–18. Also Mackworth, *Guillaume Apollinaire and the Cubist Life*, pp. 132–42. [Biblio. No. 88.]

The sense of the poetic life imparted to material is translated through the material itself, that is, through color.

Simultaneous contrasts are naturally the essence of this same living organism, as is already apparent from the earliest works in *form-color. Form-color is inseparably* opposed to traditional color, where color is tied to chiaroscuro.

These artists have understood that color should not represent insofar as it is *pure painting*; otherwise nothing can be perceived in these new works and nothing of its *meaning* can be grasped.

To represent is nonetheless the foundation of the plastic, however, *to represent* does not mean to copy or to imitate but to *create*. Naturally this creative style must develop. *The first simultaneous works* lacked the requisite mobility and variety.

With the early cubists, the first revolutionary period in which all the *pictorial elements* were disordered, the critics had a most difficult task. The painters represented their chaotic and turbulent condition. To this early phase one can ascribe *Les Villes* (1908), *Saint-Séverin* (1909), *La Tour* (1910), *La Ville de Paris* (1911). But we can see the vindication of my dicta that when the majority of those painters called cubist, obeying a need for objectivity, wished to represent natural objects such as figures, objects, they used the same means as academic painters before impressionism, because *impressionism* was already an impulse toward liberation that lacked expressive means. Why revert to means from which impressionism had made a liberating and anarchic act?

In reaction to this first cubist era, there was Ingrism, and the whole clique of precursors who were regressing. After the neo-Renaissance, neoprimitivism, neobyzantinism, neochaldeanism, there came machinism, totally confused, and I regard machinism as a retrogression. For to *represent a machine* or a *human figure* with an expression that lifts its means, for example, from the *chiaroscuro* of earlier painting is not introducing a novelty. Photographically a machine or a figure is the same thing. It is exactly there that one touches on the reality of the work, on its artistic value above all, on its vital quality. It was more than an intermission when these artists, who had worked at first with such heroic enthusiasm in 1910–1912, regressed into the neo. I speak only of those things which specifically make up the craft of painting. I attribute the cause of this state of things to an insufficiency of craft, of genius also, perhaps even more to an industrialism arising at a moment when

there had not been *sufficient preparation* for production. There was demand, speculation, and the necessity of selling.

The time for perfection was lacking; the old and known means were the most facile to offer themselves—and then the war came. Four years of not working, followed by a great wave of reaction, which has led us to this hybrid painting of *neo-Corot*, neo . . . neo . . . neo . . . the trademark of manufacture.

In the meantime, *color* was more and more clearly comprehended, became *perceptible* and explicit and not formal as the old academic codes had understood it.

The more lively color-form develops, the more humanly it continues its unfolding from its beginnings, for it is a movement still in its infancy, still in formation.

Color specifically and not considered as *coloring* is still to be acknowledged, to be discovered, but it is on the way. This new art of perception is opposed to all retrogression, to symbolism, to traditions. It is endowed with movement, with life, and not with the stasis of a *crystal*, or known archaisms. We see a wave of *simultaneous fashion* mounting that corresponds to a real wish.

Fabrics, advertisements, furniture are undeniably moving toward living color.

We will be present at a totally visual transformation in the appearance of dress, architecture, and cities in general, in fact, *every dimension of the visual order*, through a pure and new creation that will be truly expressive of our desire to live.

Robert Delaunay and the Origins of Abstract Art

Letter to Kandinsky (1912)

Delaunay became acquainted with Wassily Kandinsky through the good offices of Sonia Delaunay's old friend, Elisabeth Epstein, who after Delaunay's exhibition at the Indépendants in 1911 wrote enthusiastically to Kandinsky. At the time, Kandisnky was occupied with Franz Marc and August Macke in preparing for the first publication of Der Blaue Reiter. Kandinsky responded warmly in a letter to Delaunay dated October 28, 1911. Kandinsky, having resigned shortly thereafter from the New Artist's Association of Munich (the Neue Kunstlervereinigung München) formed the first Blaue Reiter exhibition at Galerie Thannhauser in Munich on December 18, 1911, and requested pictures from Delaunay for it. The paintings included Saint-Séverin No. 1 *(1910), which was sold, and* La Ville *(1911), which Jawlensky bought. The only letter from Delaunay to Kandinsky that has survived is the one included here. It is dated during the early spring of 1912. However, Kandinsky and Delaunay actually met in Paris a quarter century later.*

Paul Klee visited Delaunay at Kandinsky's suggestion in April 1912, and although Delaunay was important—particularly his series Les Fenêtres—*for the development of Klee's art, their relationship was exceedingly formal. It was different with Kandinsky's colleagues, August Macke and Franz Marc, who were awaiting the Delaunays after their*

return from La Chevreuse in the fall of 1912. The two painters visited him on October 2 and were deeply moved by his work. A profound, warm, and affectionate correspondence developed between Delaunay and each of them. Cf. Francastel pp. 176–77; Vriesen, Imdahl, Robert Delaunay: Light and Color, *pp. 38–39, 42, 50–51. [Biblio. No. 101.]*

In the first paragraph Delaunay is referring to Kandinsky's famous Volume, Über das Geistige in der Kunst *(Munich: Piper Verlag, 1912). English edition: London: Constable & Co. Ltd., London 1914; most recent translation,* Concerning the Spiritual in Art, *with Kandinsky's own correction, by Ralph Mannheim, in* The Documents of Modern Art *(New York: Wittenborn & Co., 1947). Cf. bibliographic note from this edition, p. 6.*

Dear Sir:

I have seen the book about which you spoke at the house of Mme. Epstein. Unfortunately it is impossible for me to read a line of it; but I will ask her to translate it for me. It is a large task!

I have looked several more times and at length at your canvases and if I have been pleased with them it is because certain things were comprehensible to me. I have not analyzed these things: a principal reason is that I have found a more genuine interpretation, a very perceptible progress in your latest canvases over the one last year. My personal attention to your works has led me to state this above all: your latest pictures brought me right back to an inquiry I had undertaken last year at the Indépendants where I had also seen your canvases that I do not now remember.

Therefore, I find it very useful that you have sent these this year. As regards what is central to our works, I think the public must become acclimated. The effort that must be made is necessarily slow because the public flounders in old habits. On the other hand, the artist has a lot to do in the little-explored and obscure domain of color composition that is hardly traceable any earlier than the beginning of impressionism. Seurat sought the first laws. Cézanne demolished all painting since its inception, that is to say, *chiaroscuro* adapted to a linear composition which predominates in all the known schools. . . . This inquiry into pure painting is the actual problem. I do not know any painters in Paris who are truly seeking this ideal world. The cubist group about which you speak

looks only within the line, reserving a secondary and nonconstructive place for color.

I have not yet figured out how to transpose into words my investigations in this new area that has been my sole effort for a long time.

I am still waiting for a loosening up of the laws comparable to musical notes I have discovered, based on research into the transparency of color, which have forced me to find *color movement*. These things, which I believe are generally unknown, are still in an embryonic stage. I am sending you a photograph of these attempts that date back some time already and that were quite a surprise and an astonishment to my friends since they communicate with only a very few connoisseurs whose understanding is completely detached from impressionism. I remember that you have asked me, but I do not know anyone who can write about these things at the present time. However, I already have some definitive essays. Even my friend Princet[1] has not seen them, since they were finished very recently; however, I am confident in the judgment of his sensibility and it seems to me that he will react strongly to their implications. I think that he will be able to develop these ideas in the course of work that he began several years ago and which I have already called to your attention. I will speak to you again about all that.

Also, I am no longer surprised by people who do not see: these are unintelligible realities for them at the present time. I am certain as well that it is my fault. As far as the public is concerned, the primitive stiffness of the system is not yet a lodestone to its need for pleasure. I often ask myself whether there is any need for such things! I am content with those rare connoisseurs and friends. I will speak to you some time about the subject in painting, about an exciting conversation at the home of Apollinaire, who has begun to believe in our search. This conversation coincided with your letter and underscores everything, which is still so frail but so vital . . .

I will be happy if I understand your article in the *Blaue Reiter* and I will also ask Mme. Epstein to undertake the hard work of translating your book for me.

The futurists are more successful, but perhaps they will disappear when we have found the right means, for as the French expression goes, they all throw away "the handle before the ax."

1. Cf. note 5, p. 57.

As for the cubists, the leading ones deny that they are representatives of that school, feeling, perhaps, that their certainty is problematic and of short duration! . . .[2]

LETTER TO AUGUST MACKE (1912)

Written while in Berlin in 1912.

Believe me, I am not a spoil-sport.

I love to dance in the light, and I love particularly the spirit that is freed in this act, because I love synchronized movement, which is the image of the drama of the universe. I do not seek beyond that, beyond the essential *or the representative*.

I know some young men in Paris who admire the way I see images. You speak to me of geometry. I do not see geometry. If you told me a single thing relevant to representative movement . . .

Your set idea is to begin with form—that's very cubist—but you have no right to say that I do not represent objects. Undoubtedly I use the means, the gifts of my perception, but I assure you that I do not depend in the least upon geometry, for my conviction is completely different.

It isn't my task to speak about my conviction since I make images of it. My works alone communicate my vision of men, women, and children, since all of us can so easily look as far as the stars. Didn't my old friend Rousseau distribute the stars in the sky exactly as he wanted in his *La Charmeuse de Serpents* [The Snake Charmer].

We can see as far as the stars. We can see a *simultaneous universe*. Every other simulacrum is foreign to me.

2. Conclusion of the letter appears, with textual variants, in Francastel, pp. 179–80.

LETTER TO FRANZ MARC (1912)

Written from Paris in 1912.

Dear Friend,

Perhaps I will come, perhaps I won't. I would be very interested to see a group of your pictures. As my last card told you, I have begun two big pictures that absorb me completely and I can commit myself to nothing else on account of my work.

It is unfortunate for Germany that the publishers do not take advantage of the beautiful opportunity afforded by [Maurice] Raynal. In France we have already produced one book and there is another in the wind, but not as useful.

I was very surprised by what you wrote about the article of Guillaume Apollinaire.

You do philosophical meditations on questions of craft.

You say you love my works.

My works are the result of my exertions in the craft that lead me toward purity. Everything is intimately connected. How can one understand or even love one part of this whole, this synthesis. . . . On the one hand you tell me that I try to reconcile the mysterious laws of art, and on the other hand in your letter you write: "I know nothing but pictures, the *work* and the *effort* and the mysterious fantasy of art." I have no philosophy. How can one conceive of the techniques of refining a work or a method that dates from the Middle Ages in works of the twentieth century.

Clarity is the quality of the French race, but it is a quality that helps only French inventors. . . . I have to be satisfied with this heritage.

In Art I am the enemy of disorder. The word "art" means harmony for me. I never speak of *mathematics* and never bother with Spirit. Everything that I say is relevant to my craft and is consequently connected to results.

You say again: "Why doesn't your perception issue from light?" As if to say that without light there is no perception.

It is true that *without light the eye cannot perceive.*

"Movement of colors? What is that?"

A word from physics. Everything is movement. A pencil line is only movement. Nothing can be explained about art with words like that.

I find (and I am terribly sorry about it after reading your letter) that you have understood absolutely nothing of my views about the worker who elucidates the personal techniques of his craft alongside his works.

I am not speaking of a mechanical, but of a *harmonic* movement since it is simultaneity, which means *depth*. "We can see as far as the stars." *There is movement*. My visual perception makes me aware of the depth of the universe. In the universe of simultaneity there is nothing that resembles this insight.

This unity is not divisible.

Your method of reasoning (philosophical) that you allow me to grasp in your letter is divisionist. I do not conceive of a philosophy of Art. I see only an aesthetic criticism which is adequate to *representative* means. "I am crazy about the forms of colors but I do not seek their scholastic explication."

Nevertheless, everything that you say is scholastic since you do not allow for any alternatives. You only confuse with words and abstractions. You have no clarity. What does it mean to be "crazy about drawing"? Such madness is pathological and has nothing to do with me. And I say that you are mistaken when you speak about forms. "Forms" is a prehistoric, scholastic word, found in every academic drawing manual. This kind of thing is related to geometry, which is a *professorial invention*.

I no longer like definitions of points like two plus two since I have nothing formally to do with mathematics or geometry and I am horrified by *music and noise*.

None of the finite sciences have anything to do with my passion for light. My only science is the choice of impressions that the light in the universe furnishes to my consciousness as an artisan, which I try, by imposing an *Order*, an *Art*, an appropriate representative life, to organize.

I exist only in my work and I cannot separate my means from my end.

I have an end, an artistic belief that is unique and that cannot be classified without risking becoming ponderous. I love poetry because it is higher than psychology. But I love painting more because I love light and clarity and it calms me.

This is how I would have liked to have been understood, but what does it matter after all? It is the *image* alone that is important from the

popular point of view. I am devoted above all to the common cause, *to the greatest Life*, and like the man who wrote my preface . . .[1]

His reflections lead neither to mathematical formulae nor to Cabalistic symbols. They guide him simply and naturally toward pictorial realities: colors and lines.

LETTER TO AUGUST MACKE (1912)

Dated 1912 and probably written from Paris.

It isn't possible that at such a decisive moment you are permitting yourself to prolong a state in which your vision is endangered. I say that this moment is decisive because a complete transformation of vision and above all of the technique of representation is universally taking place. If I write you about your work, it is because I have seen you in your house surrounded by your paintings and there I have seen very clearly the crisis that you have gone through and that is confirmed by your letter.

It has to do with representation, which touches the most proximate . . . sensibility, our very depths; in short, our life. It is the same for all of us who seek to establish ourselves in the fullest sense.

I know (as you have written to me and I thank you for talking to me about it) the miserable devices that are used against those who exert the greatest effort toward this artistic movement. But you know well that these devices are very insignificant and have no possible relation to True Life, for the simple reason that we cannot hinder Life and vital movement. We cannot, because that is precisely what our enemies want the most. It is at such times that the most instinctive artists give way to desire, and it is they who for the most part make the movement. They are the almost anonymous loners who are the true representatives of

1. Reference to Apollinaire's introduction to the catalogue of Delaunay's exhibition at the Der Sturm gallery, Berlin, 1912.

tradition and of the people. Too often we do not rely on these few and we ignore them. They are also the ones whom the enemies and the blind allow to be ignored and the ones who possess the true craft, the true creators who represent life and movement.

Actually, the reality of what I am saying exists and cannot be shaken by any attack nor stuffed into any corner of the Universe. For such work it is necessary simply to see and no one can prevent seeing. I make no prediction here—that is not my *métier*, and what I want to say isn't the least bit mystical. As I have said, I have seen your works and I can speak only in reference to them.

Your order of sensibility pleases me greatly and I believe that you would be able to draw upon a much more important culture if you were not plagued by needs that unhappily are stifled by archaic and antiquated techniques. These needs are of the same character as your sensibility, which pleases me. But then I find that they are constricted, immobilized in the ancient citadels of past art, the old towers of silence which from time to time are restored, but that can never be revivified despite every effort.

Your true sensibility can therefore diminish from isolation and become unhealthy, no longer nourishing your vision. I do not want to envisage such a pass for you.

An indispensable thing for me is the direct observation of nature and its luminous essence. I do not exactly mean with a palette in hand (although I am not against notes taken immediately from nature—I often work from nature—what is called popularly: in front of the subject). But what I attach great importance to is observation of the movement of colors.

It is only in this way that I have found the laws of complementary contrast and the simultaneity of those colors that nourish the rhythm of my vision. There I find the representative essence—which does not arise from a system or an a priori theory. In my view, every gifted man is distinguished by his essence, his personal movement before the Universal, and it is this that I find in your works that I saw this winter at Cologne. You are not in immediate contact with nature, which is the sole source of all inspiration toward beauty. It is here that art touches its vital and critical dimension. It is here that the Spirit can grow in comparison with antagonisms, rivalries, movements; that the decisive moment is born, that a man identifies himself on the Earth. There is

nothing else to do in art. I believe it is indispensable to look at oneself front and back, in the present. If, and I believe it, there is a tradition, it exists only in the sense of the most profound movement of culture. Above all, I see the sun always! Since I desire the identification of myself and others, I see everywhere the halo, the halos, the movements of colors. And I believe that this is the rhythm. To see is a movement. Vision is the true rhythm-maker. To discern the quality of rhythms is movement, and the essential quality of painting is the image [*la représentation*], the movement of vision which functions by objectifying itself toward reality. It is the essence of art and its greatest profundity. . . . I am very much afraid of definitions, and yet we are almost forced to make them. It is not necessary, however, to be immobilized by them. I have a horror of premature manifestos. I add that the simultaneity of colors is perforce equivalent to the sense of profundity. Without it there is no movement—consequently all painting that doesn't accord with these primary necessities will be for me simply an arabesque executed in color or a geometric drawing (which is the same thing). To seek or to want movement in the arabesque is impossible.

The representative vision of art in painting is, therefore, a movement to which these conditions are indispensable, in order that it be vital and representative. It is this which defines the abrupt change between earlier and modern composition. Only the new art is visual representation, the actual movement of our inspiration in its greatest objective creation.

But I do not want to philosophize. I want to remain within the domain of sensibility which holds uniquely to craft, and above all, my friend, to bring to you a little bit of courage and friendship. Do not be angry with me, because everything I have said is only in a spirit of Life, in a movement which I have sensed passing from me to you, that I have felt for a long time already, and that your letter has only augmented. If I have succeeded in that I will be happy, despite the difficulties in the translation of languages and the even greater difficulties of saying concrete things through the abstraction of my vocabulary as painter.[1]

1. Note in red ink at the bottom of this letter:
reading of a book—Russia. I have had an idea—*Sturm*—that there is a relation of the new painting with—*paper reproduction—binding—cost of printing and translation*—Budapest—at morning—towers of Notre-Dame [R.D.]

LETTER TO FRANZ MARC (1913)

Written from Paris on January 11, 1913.

Dear Marc,

I informed Apollinaire of your wishes and the book should appear within a week.

Mme. Epstein has told me of your letter.

Apart from wanting to come and talk things over with you one of these days, as you suggest in your letter, I find that one says pretty much what one wants to just by writing, and I as I've told you, if I were to go to Munich, I guess it would be better for you not to talk about these things.

It's so good to understand one another and to See.

I found, after having had the pleasure of a few looks at your works in Berlin, that looking is more rewarding than any discussion.

I perfer Seeing.

I remember with great fondness your paintings and, generally, those of your friends.

In terms of the development of your art, it seems to me that you are the complete *opposite of the abstract*, and this is principally what I saw and liked in your work.

The young people I've seen have, on the whole, shown great promise. They have that wonderful impulse toward true painting, and I haven't seen any exceptions to this trend. It's the simultaneous impression—the eagerness for life, for light, for color—that I've retained and that give me confidence. I really love those artists who beat all the theories . . . (And let's not forget Rousseau!)

I'd like you to let me have a look at the catalogue of your show, since you *never say a word about yourself.*

I feel that in Art you really have to talk about yourself and what you are doing.

In spite of the fact that I don't agree with the minor cubists, I found their theories of light based on geometry very enlightening. There are Cézanne's writings which have been developed with a certain sentimental and psychological sense all their own. Now, in comparison, I

find a greater sense of reality in the impersonal impressionism of those who, consistent with their individual strengths, have struggled toward truth with all their sensitivity, trying to re-create "light," and who have defined it each according to his own sensibility. Such artists, unequal though they be, have all aspired toward the Goal.

To possess this is splendid . . . now what more could cold theory add? This is not something that my Vision can See, and I have no artistic belief in anything outside the *luminous representation* of Nature—or else it's a question of falling into the abstract, into the literary. This is not to say that I dislike poetry. Poetry certainly has its place.

Poetry is the voice that Light made audible and it is about this that Hermes Trismegistus speaks in his *Pimander.*

"Soon," it says in the *Pimander,* "shadows descended and an inarticulate cry sprang forth that seemed to be the voice of light."

Must not this voice of light be drawing, that is, line? And when light is freely expressed, everything takes on color.

Painting is by nature a luminous language (the procession of Orpheus).

At present, I'm still working on the *Equipe de Cardiff,* which gives me great pleasure.

I received a catalogue from Munich of Le Fauconnier's show. . . . What do you think of it?

Yes, I think art is dramatic, that its perfect expression is found in a Life that is turned toward light!

Everything that is not in agreement with this truth is mystification, error. Considering his time and his milieu, my friend Rousseau knew what he was talking about. His words are not universally accepted— [even] in the big New York newspapers he has his defenders, visionaries who proclaim his genius and who have spoken out with conviction amidst the laughter.

Over and over again I think back on his words, his gentleness, his enthusiasms, his richness, and I have no need to understand in order to love his powerful vision: his expression is antidescriptive, and his profound sensitivity made him the equal of the greatest impressionists. Ignoring typical impressionist techniques, he managed to produce great works and he is the only artist who really represents, in this sense, the *Subject.*

Art, true representation, cannot cheat on time.

Universal representation does not include abstractions.

Systems not based on perfect sciences, but on perfect sensibilities, on beings who are extremely gifted and expressive, go beyond their means, so to speak. Cézanne always searched for his means—didn't he write that he never completed a painting?

Cézanne's doubts are not carried to the sublime, he was not pure—nor was he melodious or dramatic. His perception was always uneven. The appearance of composition in his work comes from his familiarity, both good and bad, with the masters. Rousseau, in fact, also knew the old techniques (perspective, a sort of geometry of color, etc.). Yet through this archaism, what frankness of vision. What a good worker. It's the complete sublime expression of his world, which is more powerful, weightier, less bourgeois than Cézanne's!

It is not the psychologists who saw these things in Rousseau. It is the painters, especially those who like to see and who have seen.

Vision is infinitely perfectible, and I remember the words of Orpheus . . .

People of different countries get to like one another by seeing. In Berlin, I felt out of place only in terms of the language spoken there. . . . Words change. The exhibition of beautiful paintings was not incomprehensible to me. The color I saw there is the same that I use. It is not abstract, limited, or reducible to *black and white*.

There is undoubtedly a simultaneity of complements and agreements and nondivisionism—which is tantamount to saying universality, understanding, which already goes beyond Europe, which extends from man to the Universe.

If the cinema had been a sentient creation, a true simultaneity of images, it would have meant the downfall of Art. But instead it only reinforced human beliefs in other objectives. This successor is doomed to die. The crowds of people who rush off to the cinema emerge finally without conviction.

LETTER TO A GERMAN FRIEND (1912)

*This fragment was written on stationery of the Grand Hotel Bellevue
in Berlin.*

I am the friend of everything that represents. Even in simulacra, as you
say, there is sensitivity, Life: I like primitive things.

But I like light even more.

Berlin *is luminous!*

When Art is descriptive, it declines, it is vulgar, it is its own negation.

Art, like Nature, despises constraint.

Just like my affection for you.

Robert Delaunay and His Friends

NOTES ON ROUSSEAU (1911)

The Douanier, Henri Rosseau, was a close friend of Robert Delaunay's family. It was Delaunay's mother's tales of India that led Rosseau to paint La Charmeuse de Serpents *(The Snake Charmer), which for many years was part of the Delaunay family collection and was sold after World War I to relieve financial burden after the Delaunays' return to Paris from Spain. Delaunay was one of the few mourners, along with Apollinaire and Brancusi, at the Douanier's funeral in 1910, and it was Robert who paid for the removal of Rousseau's remains from a pauper's grave to a thirty-year grave, which was then decorated with a Brancusi carving of an inscription by Apollinaire. The present text, Robert's notes for a biography of Rousseau (published in part in 1952 in* Lettres Françaises*), dates from 1911.*

The great painter Henri Rousseau, ex-customs officer, exhibited for the first time in 1885 at the open Beaux-Arts show. . . . Groups of independent artists . . . the Salon des Tuileries . . . which was called the Salon des Refusés.[1]

1. Salon of artists whose works were rejected by the selection committee of the conservative Salon d'Automne.

I'm simply noting, in this connection, reviews of the time, collected by Rousseau himself in his notebooks, with his handwritten annotations.

The year 1885—these two canvases: *Danse italienne* [Italian Dance] and *Coucher du soleil* [Sunset], were shown at the Salon. One was slit open with a penknife and then they cheated me out of damages, which resulted in my showing them again at the Groupe des Refusés that took place in June.

Reviews

L'Evènement: "We would recommend neither the *Danse italienne* nor the two or three other works to the friends of the *Gaité*."

Presse: "To all those interested, I recommend that they turn left upon entering and stop in front of painting No. 289, entitled *Danse italienne*. It's obviously the work of a ten-year-old child who wanted to draw some little stick figures. It must also be concluded that the child in question doesn't know how to observe correctly, etc. . . ."

Vie Moderne: "This is addressed to the eminent landscape artist Rousseau whose canvases look like scribbles, which were our delight at six years old when a box of nontoxic paints was given to us by an indulgent mother, with our fingers for brushes and our tongues for a palette. . . ."

"I spent an hour in front of this masterpiece observing the expressions on people's faces. Not a single one who didn't laugh to the point of tears. Lucky Rousseau!"

Revue des Beaux-Arts: "The chinoiseries of M. Rousseau are too primitive to have much time spent on them. We are not yet accustomed to this sort of imagery, even though it is quite amusing. . . ."

This is the way Rousseau made his first appearance in the press of his day, which, with the exception of a few more perspicacious experts, never gave up this obstinate bias, poking fun at one of the purest and most sincere of artists.

Rousseau exhibited in 1886 at the Societé des Artistes Indépendants. He was the butt of jokes all his life, right up to this last retrospective show which the Societé asked me to organize. On this occasion—in the year 1911—progressive critics began discussing him as a painter.

He was the most insulted, the most mocked, the most slandered Indépendant, and his notoriety extended beyond the exhibition halls of

Paris (for there were critics who advised the public to go to see Rousseau's works at the Indépendants).

Rousseau's name is closely linked with that of the Indépendants and with that whole period that marks the first signs of innovation, of life, in French painting as well as painting throughout the world!

Rousseau is the grandfather of the artistic revolution in modern painting.

Rousseau's life was admirable, filled with love for his work. I've never known a better man or one who was more willing to help his friends.

How many unforgettable anecdotes his name recalls—real legends, bits of gossip, and journalistic indiscretions! They even went so far as to accuse him of being a practical joker!

Amid all this scheming and pettiness, Rousseau remained indifferent and above it all.

I met him near . . . He already had the fine face of an old man. In his tiny studio at Plaisance, surrounded by his major large canvases, he received his friends: workers, clerks, artisans. There, he was not the Rousseau of those unbearable openings, who would stand around in his top hat amid the mob of people you greet only once a year when you're rubbing shoulders with them at exhibitions. This was the hospitable Rousseau with that cheerful smile that was full of kindness. He was a human being who opened his door to you, jovial, happy to see you— one of those beautifully open men of the people who are encountered by the thousands in France and who have such remarkable gaiety in their eyes.

He lived extremely unpretentiously on a small state pension of about twelve thousand francs and gave private painting, harmony, and violin lessons and sold his paintings to small *rentiers* and to people within his own social class. It was in this Parisian atmosphere and with the contact of its milieu that Rousseau put together what might be called an anonymous oeuvre, which was related in a thousand ways to all popular art and which at the same time bore the personal imprint of a strong will and of stylistic purity—this is Rousseau's whole life and work.[2]

2. The type of painting you find in the suburbs, in the country, in the small market towns; the naive and direct expression of these artisans, paintings of fairs, of amateur hairdressers, of milkmen, etc. . . . of all this painting that springs directly from the abstruse ideas of the people, Rousseau was the genius, its precious flower. [R.D.]

Originally from Mayenne, having fulfilled his military obligations as a musician in the Mexican countryside, then employed as a customs officer, Rousseau the creator had aspirations only for art, music, poetry, and painting. These were the forms of his orphism through which Rousseau sang of his love and, with the surest knowledge of his art, achieved unforgettable works. Rousseau, in his natural and simple surroundings, was loved and venerated; his family scenes prove this better than anything else: baptism, marriage, and many portraits of small children and of relatives. This is Rousseau in his element—in his real milieu—Rousseau, painter of the people.

It was painting in particular that he worked on most. However, he left two manuscripts of plays—*Le Drame d'une orpheline russe* [The Drama of a Russian Orphan], etc.—and many short poems which he adorned with his pictorial ideas.

The proof that Rousseau, in addition to the extraordinary gift he had for painting . . . was an accomplished craftsman and, what's more, had a knowledge of the masters, lies in the fact that in the notebook that contains the . . . of his public shows is pasted the *card* from the Ministry of Education that allowed him to work in the galleries of the Louvre, etc. This card is dated December 23, 1884.

For contemporary artists there is no doubt about the quality of his art, but this essay is intended for the whole lot of stupid, ignorant journalists and critics, who considered this great master incomprehensible. Rousseau represents the entire tradition of painting. Rousseau is not, like Cézanne, a restless and scholarly bourgeois who purified himself through daily contact with nature, to strengthen himself through his period of uneven progress by means of the patience of genius that was influenced and was several times lost amid the influences. Rousseau, [man of] the people, always himself, with the self-assurance of his race, a plenitude from first to last. Here are two tendencies of our time: the anonymous and personal Rousseau and the destructive and personal Cézanne. Two of the high points of art, two men who almost certainly were entirely ignorant of one another. The first, a sureness of mind and hand, a builder who was confident and sure of himself throughout his development, a man who came from the people. Cézanne, the bourgeois, the first to shatter things, the first saboteur. Two entirely distinct forms in this heroic epoch of modern painting. Two primitives of this great movement.

NOTES ON GONDOUIN (1934)

This and the subsequent text on Emmanuel Gondouin were written after his death in 1934, but they are relevant to Delaunay's growing concern with monumental art and with the relationship between architecture and painting. Cf. Francastel, p. 191.

Sunday, December 2, 1934

The great painter Emmanuel Gondouin died in the hospital, poverty stricken, leaving a fortune behind him.

His paintings, which constitute just about his entire output, were bought for two francs (apiece), both canvases and drawings. A number of canvases are as big as 6 by 12 feet; among them there are some masterpieces. I consider that a record.

Only twenty-four years ago, Henri Rousseau died in exactly the same manner and in the very same hospital. He was buried in a pauper's grave. The rest we all know. The Douanier's work is worth a fortune at this time.

The difference is that the very unusual work of Gondouin was not subject to public ridicule as that was of the Douanier.

The Douanier was from a middle-class family. Gondouin frequented the French aristocracy; he was from a family of millionaires. He was dropped, abandoned.

But the worst of it all is the way in which they got rid of his work, with such relief, as if it were something pernicious—like Art!

This is still going on in France in 1934. Not one museum in France owns a Gondouin, who is an artist of his times. Even the meager funds allocated to the Beaux-Arts permitted the purchase of the artist's entire work for only 1500 francs—it was an investment worth more than gold. It was a moral obligation not to let an artist die at the age of fifty at the peak of his creativity.

The day after the sale the work was offered to buyers for one hundred thousand francs.

Those who read these lines should note that I have consciously em-phasized the monetary aspect. They should contrast this great, generous artist, who gave to the four corners of the earth, who distributed during

his life his genius, his generosity—which is the prodigal side of the artist—who exhausted himself, as he created true richness—may they contrast him with the parsimony, with the bourgeois stinginess, this poor richness, this false richness of the so-called *bas de laine*,[1] which infects the country with leprosy and blinds it. Today Gondouin's work shines out, illuminates the world, in spite of his family, in spite of his illustrious friends, in spite of his country, which still refuses to recognize him.

But what's your opinion? Do there really have to be art schools, art libraries, art reviews, art organizations, art seasons, art industries, art shows, Louvre schools? Wouldn't it be more economical to end all that, to shut down the art museums? Why bother to light up Notre-Dame, the horses of Marly, the Arcs de Triomphe and all the rest at night? That costs a lot of money!

In 1934, Emmanuel Gondouin dies in Paris, destitute.

NOTES ON GONDOUIN (1934)

There exists a life of Emmanuel Gondouin in the form of a novel called *Un Roi tout nu* [A Naked King], written in 1922 by a young writer and close friend of Emmanuel's, Albert Adès.

The writer died and the book remained unfinished. It contains photos of the period. The book was recently given to me by Adès's mother, who is staying with us.

It is a moving portrait of the painter that shows Gondouin living and developing among his friends of the time. It gives the painter's character —the most striking aspects of his originality, of his heroism as an innovator, as well as aspects of his genius.

Above all, Gondouin was able to ensure the independence of his art, since he loved to take risks which would stay with him until the end.

1. *bas de laine*: a hiding place where money is kept. The expression is said to derive from the French peasant's old custom of keeping his savings in a woolen stocking.

Even through his worst periods, Gondouin pursued his art.

He goes through the first cubist period as a born colorist. I'd place him among the romantic cubists—those who are not indebted to the return to classicism, or more precisely to neoclassicism, and up to his last watercolors he remains an inventor of rhythm.

From the beginning, his work tends to be frontal and flat. In 1910–1911 and thereafter, he paints large compositions that bear this out: they long for the wall. This is not surprising, since at the same time that he was engaged in painting, he was working on architecture. He designed a house in Cavalaire for Gleizes, who was one of his friends, and built his own next door.

He is thus painter, architect, builder, and constructor.

I met Gondouin about 1930.

His art at that time continued to become even more personal.

The joy of color.

Gondouin's is a totally individual vision of forms, a poetic vision of forms, without ever being literary or altering the format of his works, remaining evocative—in the plastic sense—of forms that recall nature. His painting is constructed. He is a poet of the plastic. Certain canvases are even abstract. He has broken away from all allusion to the object. But in all his works, the purely plastic quality is dominant: this is painting. The laws of equilibrium that he followed were therefore to lead him toward a painting that adhered to the wall. He is thus one of the pioneers who foresaw the mural. He wasn't satisfied with decorating walls, he constructed them with his own hands. I saw him build his last house near the Pont de Saint-Cloud.

Why his house? . . . That house, that enormous work, is finished. During its construction, Gondouin lived in one of the garages. It was his dream house. A very large room, with two others adjoining, was to be his studio. At this point the most trying ordeal of his life began. His great paintings were to decorate these rooms, which you entered by way of a large stairway that supported a stoop.

Gondouin the architect managed his workers, gave directions on the spot, handled the materials, the cement, the iron, interpreted his original plans, but always made modifications in concrete space and not on paper. He set an incredible example of energy. The painter came into contact with the tradition of the builder, always pursuing his dream: the marriage of forms in space, their concretization in the living object. He

handled the resistance of materials manually, lifting them up, fastening them together, pouring them with a trowel, like a laborer and like a leader, with the elegance of a great artist. Gondouin was, at that moment, sublime.

At night, after work: enthusiasm.

Robert Delaunay on Sonia Delaunay

Sonia Delaunay, who married Robert Delaunay in November 1910, was his lifelong companion in the art of simultaneism. As such she was the principal documentation of the power of his vision outside his own work. This section of his writings is therefore an homage to and an appraisal of her achievement. A notation following Sonia Delaunay's major exhibition in Madrid in 1920, written during 1921, has been deleted from this section due to lack of space. Cf. Arthur A. Cohen, Sonia Delaunay *(New York: Harry N. Abrams, 1975).*

SONIA DELAUNAY-TERK (1938)

This and the subsequent documents relative to Sonia Delaunay date from the summation period of Robert's career, about 1938. Cf. Francastel, pp. 198–99.

Coming to the West from the East, she brings with her that warmth, that characteristic and classic mysticism that is never shattered through contact with the West. Instead, she re-created herself by finding her con-

structive means of expression through this contact. She is enlarged, developing and transforming the elements that make up her art into a new fusion—an art that has, so to speak, occidental as well as oriental characteristics, which are precise and indivisible and of which she alone is the creative mold.

Like all artists or poets of the East, she grasps color at an atavistic level. From her first studies, done on her own or under the eye of some academic professor, one feels her lyricism, the need to express herself—though hesitantly in her timid beginnings—through dazzling color.

This color sensitivity went far beyond academic and official instruction because of an innate need that was incompatible with established formulae, because of an anarchic spirit that would eventually be turned into a regulated force. The subjects of her early works were rather commonplace (1907): *Portrait de modèle italien* [Portrait of Italian Model], *Fillette couchée* [Little Girl Lying Down], *Portrait de Mme. Minsky*, etc., are in a clearly colorist vein, but the color is still slave to line, to traditional chiaroscuro. Even so, the colors are dazzling. They have the look of enamels or ceramics, of carpets—that is, there is already a sense of surfaces that are being combined, one might say, successively on the canvas. From her very first studies, a whole reserve of pictorial energy can be felt in its natural state: traditional means of expression not yet freed from the primitive appearance of familiar methods—these portraits have a slightly barbarous, slightly caricatured expression which contrasts with the academic flatness of the time and introduces a sort of spice into the art then existing in France. This was at the peak of fauvism and Gauguinism, when exoticism flourished at the Salon des Indépendants, for which Matisse carried the banner of French taste by channeling this whole avalanche of Slavic painting, mainly of oriental origin, and seasoning it to the Parisian literary taste of the time: the neo-Baudelairian period, the *Femme au chapeau vert*,[1] the era of "everything is order and beauty,"[2] etc. Looking back, I say now that all these attempts at truculence and brutality had, at the time, a certain daring and vital energy, and it is only unfortunate that this energy has now died out among many of the painters who were unable to overcome their individual limitations.

1. Reference to the famous picture by Henri Matisse shown in 1905, *Woman with the [Green] Hat*.

2. Charles Baudelaire (Là, tout n'est qu'ordre et beauté . . .") "L'Invitation au Voyage," from *Les Fleurs du Mal*.

All this was the result of their art and of the repetitiveness that was fatally to succeed it. It marks an epoch in modern painting, the first stage of independence and audacity.

In painting, it is the means, the craft which are seen and which act directly on the viewer. These methods were necessarily limited and their variety quickly exhaustible. Basically, color was handicapped by subservience to line: the latter limits color, paralyzes it, makes it rigid and sacrifices it, so to speak, to an archaic stability.

The break, however, was to come in 1909. Delaunay-Terk made some satin-stitch wall hangings which, by means of their expressiveness, were to bring into view the prospect of liberation. About 1912, we helped inaugurate the birth of color, completely freed from its links with the past and expressed in book bindings of modern poets, in lampshades of regulated colors. With these experiments she first set out toward a form of art as yet unknown. Take the works of Rimbaud as an example of these book bindings. Here we see assemblages of colored paper cut up and pasted together according to a plastic sense arising from a poetic state closely related to the poet of the *Illuminations*. Mallarmé, Laforgue, Apollinaire, Cendrars, etc., make up her very diverse but still technically related collection. The metallic element comes into play in these bindings as so many accents which are counterpointed with the matte or shiny colored paper.

There were also painted' book bindings. One of them, done for Cendrars's "Easter," served as the point of departure for the simultaneous creation of the *Transsibérien*—which at the time had so much repercussion and influence (Cocteau's *Potomak*, etc.). The poem *Transsibérien* gave rise to much discussion and debate in the various newspapers and reviews in Paris and abroad. *Orphism* had come into full swing. From the moment *simultaneism* appeared, there was a great to-do about it. A book two meters high! etc. The book, however, was duly praised by a number of sophisticated critics, and the poem was read in Paris, in the Montjoie loft, which at the time was the meeting-place of the French avant-garde. The book went to the Herbstsalon in Berlin the year of its birth and to Petrograd for a lecture given by Smirnoff on simultaneous contrast and plastic poetry, etc. At the same time, the book was exhibited in London, New York, Moscow, and in various galleries (with a description of the poem). From this same period date her first designs of woman's clothing according to the new laws of color and

technique. Dresses were no longer just a piece of material draped in a fashionable way, but a composite whole, seen as one object, like a living painting, so to speak, or a sculpture built on living forms[3] (see the description in Apollinaire's "The Seated Woman" and in the *Mercure de France*). These dresses inspired Cendrars's beautiful poem dedicated to Sonia: "Sous la Robe, elle a un corps" (*Poèmes élastiques*).[4] An evolution can be observed in the creation of this series of dresses: in the beginning the colors are broken up, giving the body too much visual mobility; in the later ones there is a perfect harmony, in the sense that the parts come together from top to bottom or from front to back and balance out in an imaginative diversification of the original and constantly changing form. This form expands or contracts according to the woman who wears it, according to the way in which the woman herself is built— which gives a mark of authenticity both to the woman and to the dress. No more of those dull nondescript dresses—the personality is now free to express itself and to come into play: forms come and go according to the juxtaposition of such-and-such a color in its proximate relationship or in its relationship to the composition.

This mysterious adaptation of modern color to dresses creates a new and wholly unprecedented architecture, one which is entirely due to the creative originality of Mme. S. D.-T. She also collaborated with new poets,[5] such as Tzara and Soupault, to create the dress-poem, which caused quite a sensation—poetry being admirably and ornamentally adapted, as well as enhancing the entire interest one takes in the dress, which is considered not as an article of clothing, as in ordinary dress-making, but as something complex and unpredictable which follows new laws. These laws bring new, innovative ideas to fashion and transform it in such a way as to rejuvenate it, affecting public interest at the same time.[6] Her efforts in this direction will surely bear fruit at a time when fashion is very much neglected, or rather when it marks a defective passage between what is called taste and the present-day life of women, which is stronger and more active than in the past. Fashion will progres-

3. "whose chiaroscuro effects are replaced by color contrasts that either exalt or break down the human form, depending on what the artist chooses." [R.D.]

4. The famous poem of Cendrars "Sur la Robe, elle a un corps" (On Her Dress She Has a Body), whose title Delaunay misremembered as "Sous la Robe, elle a un corps."

5. Philippe Soupault, "Mme. Sonia Delaunay's Evening Coat" (1922).

6. The idea of these dress-poems dates back to 1914. [R.D.]

sively abandon stiff, antiquated canons . . . and will engage in research that is grander, more architectural, more responsive to modern needs and to the intimate nature of a woman, who, nowadays, generally feels with every step she takes that she's trapped in a uniform. Certainly this research also touches upon a certain human element, and, more profoundly than you might suspect, is more in keeping with the directives of art. It is relevant to present-day life that this is the way it should be. Thus, not only did S. D.-T. arduously pursue these discoveries, she even extended her work to include the very surroundings in which her models move—she was led to create the interior of an apartment on the basis of her vision of human scale: furniture, carpets, wallpaper, all corresponded to an evolution of her ideas. Our time created her style and her means: the visual laws that she invented in her painting were to have their response in space.

Her painting, *Tango, Bal Bullier* (1913), a large color composition, provides a useful reference in this respect. Her large painting *Prisme électrique: Boulevard Saint-Michel*, shown in 1914, was the origin of her clothing creations.

Also from this period date her poster-poems, the first of which was shown at the Herbstsalon in Berlin: a poem by Cendrars, "Zenith," which marks the advent of the picture-poem. Then came the Portuguese period: a large decoration for a public monument—called *Misericordia*—representing mountain village life and compositions using different materials: fabric, paper, etc., for objects, for the glorification of color. In her paintings, she pursued the same experiments in the purification of pictorial methods and she attempted to re-create form by using elements of pure color—but with form simplified by great contrasts. Similar to the change we see in her accessories and dresses, the evolution here is one of progressive elimination of fragmentation and a search for unity and simplification. The grandeur of these new techniques was accomplished by stressing the force of expression.

In *Danses espagnoles*, the vibrating movement of colors is created by mechanical movement. *Danses espagnoles*, Cleopatra's costumes for the Ballets Russes in London, 1918; costumes for the Petit Casino de Madrid, which she set up entirely by herself and where various revues were presented, etc. . . .

THE "SIMULTANEOUS" FABRICS OF SONIA DELAUNAY (SECOND VERSION) (1938)

This is the second version of Robert Delaunay's piece on Sonia Delaunay's fabrics. The longer, less cohesive first version has been omitted to avoid repetition. See Francastel, pp. 204–206.

"Simultaneous" fabrics stem from the most modern trend in painting, which got started about 1912—and which has been developing in Paris ever since. It is in some paintings by R. D. called *Fenêtres* and in Sonia D.'s *Prismes électriques* that the constituent elements of the new art are encountered for the first time.

Finally, after all those foreign influences, after all those orgies of oriental color which the first Ballets Russes brought to France, we have reached, in the field of fabrics, an art that is both modern and intrinsically French. What didn't they use for documenting and adapting *The Arabian Nights*: motifs on oriental shawls, on those of India, and Arabia, and, in the last few years, the neckerchiefs that Russian peasants still wear in the most remote countryside, all of which are but old French drawings colored in such a way as to appeal to exotic tastes. Fashion was centered in the Orient.

Fashion is now undergoing a radical change; it seems willing to depart from the traditional method where fabric is woven and printed for either a dress or a coat, etc. Nothing could be more normal: you wonder how it could be otherwise.

Mme. Sonia Delaunay created her harmonies and rhythms of color from life itself, from the color she has invented with her brush, in the manner of color-poems. She doesn't copy what has already been done. She invents freely. No exoticism, no neostylization. It's truly the rhythm of the modern city, its prism, its illumination, the colors of its river. In short, the surface of the fabric, intimate with the surroundings of everyday life, presents something like visual movements comparable to chords in music, but it provides the body of the material with a definite signifier that gives the objective feeling that the fabric has attained its maximum vitality. The fabric becomes a principal element of composition. One would like to shape it, to use it in such a way as to give the suggested

model its greatest effect, because the principles that lie behind the model are new elements, yet elements that nonetheless have their constant. Here, in this new life communicated to fabric by color, is the real innovation and the specific expression of *simultaneous fabrics*. These are the first series of designs to have come out of her paintings, but they will be multiplied by the perfected use of simultaneous compositions, aided by a manufacturing technique suitable to the colored material and by a more and more judicious use of such materials as woolens and silks, according to their respective processing. This brings to mind the studies of that genius, Chevreul.

This new vigor, which draws none of its inspiration from the familiar aspect of previous styles, represents by far the finest achievement in modern fabric. How natural it will be now to see a woman get out of a sleek new car . . . her appearance answering to the modernized interior of her home, which is also shaking off its old, dusty cornices to rediscover the simple but pure lines of furniture that refer back to the architectural ensemble, becomes sparing in material and sober in decor. Fashion, by definition, is always moving forward. *Simultaneous fabrics* are the materials to be used for future ensembles.

It is to Sonia Delaunay that we owe the first *constructed* fabrics, in the sense of modern fabric. She has truly invented new relationships between color, and as regards future fashion, she is an indispensable precursor. Her designs are a brilliant revelation which will force us to get out of the routine (of all routines) that seem to have held sway over the past years! By imposing new measures, they will consequently influence shape and cut in general. It is in this sense that she creates fabrics that are oriented to an era yet to come. How outmoded and useless it will seem, unless for an objective other than women's clothing, to see flowers or butterflies or animals printed on silks or knits destined to be worn by chic women. Fashion tends more and more toward what is practical; consequently, fantasy tends toward a more rigorous adaptation of the constructed form. What a mistake to want to simulate a bouquet of flowers on a woman's body—even less a Chinese pagoda, oriental mythology, etc.

What Sonia D. has undertaken is a total revision in the values of textile art. The foremost characteristic in her designs is the restraint of the elements that go to make up the whole; to the inexperienced eye, they may appear geometric, but you soon perceive that the surfaces of color are characterized by *rhythm*, which underlies all Art. The origin of

this rhythm is a sort of disjunction. The colors are "simultaneous," i.e., they obey new laws of color contrast and of color surface, which due to her placement of the colors, produce simultaneously, right before our eyes, new and original effects . . . future design, because they are responsive to the painting, to the architecture of modern life, to the bodies of cars, to the beautiful and original forms of airplanes—in short, to the aspirations of this active, modern age, which has forged a style intimately related to its incredibly fast and intense life.

Simultaneous fabrics: modern fabrics that prefigure an *annus mirabilis* of decorative arts and a new vitality in contemporary French art.

THE ART OF MOVEMENT (1938)

When Baudelaire wrote the famous verse: *"Je hais le mouvement qui déplace les lignes"* [I despise the movement that displaces lines], he was far from suspecting that contemporary poets and artists were to manifest a taste for moving forms. At the Salon d'Automne of 1924, there is a *simultaneous cinematic presentation* of fabrics, etc. Simultaneous? What does all this "simultaneism" mean?

As you go by the huge entrance hall to the Grand Palais, if you look around among the shops that decorate it, your attention is drawn to the unusual appearance of the moving boutique decorated with Mme. Sonia Delaunay's fabrics. All that movement undeniably produces on your retina, at first, a new sort of unaccustomed appeal. Then you become intellectually agitated and you try to feel. Especially since, almost at the same time, you perceive other boutiques on either side that seem, by contrast, to take you back to the Musée Grévin, which represents the era of naturalist art. What, then, are the constituent elements of this change, this new state of affairs? I'm not speaking, of course, of the corpselike paintings that line the moldings of the first-floor exhibition hall and a little bit everywhere else. That would be the first episode of Delteil's novel, wouldn't it? The plague in Paris—in *Les Cinq Sens* [The Five Senses]. But with Delteil there is life, great movement.

With Mme. Sonia Delaunay there is that projection of herself which, in the branch of her artistic activities concerned with "fabric," she has been able to bring off with the greatest effect and brilliance (description of simultaneous fabrics). She has combined this visual poetry of color with multiple rhythms that are quintupled by simultaneous changes of speed, that is, regulated by masterful intuition. The cinematic art has been, until now, a play of photos cut in succession that simulate real life—a very sorry medium. The photo, even the ideal color photo taken with a Kodak, will never be as good as a bath taken at a convenient impressionist temperature. You choose your temperature.

At Mme. Sonia Delaunay's boutique, you get a glimpse of what might become a regulated, living spectacle, that is, a spectacle made to order for you.

But what are the procedures that characterize this artist's work? There are a great and varied number of them, and these notes won't give us a chance to enumerate them. There is, certainly, in this nine-by-twelve-foot spectacle, which represents the entirety of the shop front, what Apollinaire was already calling *the art of the shop front:* possibilities of presenting a great show with many episodes, because, by means of an ingenious *brevity* system created by the painter Delaunay, famed for his portraits of poets and his Parisian landscapes, a spool device permits a simultaneous development of colored forms *ad infinitum.* At the same time it is capable, as was foreseen, of being unrolled in another direction besides a vertical one. Just as at the Salon d'Automne, it can be unwound three-dimensionally—in every direction; it can also serve as a moving background for actors.

I still remember the way Cendrars's poem, the *Transsibérien,* looked the first time I saw it, with all its rhythms of wild, vivid colors. The vertical book comes to mind when I realize that poetry can now be projected not in one direction, but in every direction, and that poets will be able to communicate with new signs to the masses, who have less time than ever to read.

The Conversations of
Robert Delaunay

During the winter of 1938–39, Robert Delaunay assembled at his studio a number of young students interested in his views of painting and in his instruction. In the course of these gatherings Delaunay undertook to teach the elements of the new painting. The group that met on Thursdays between November 17, 1938, and July 27, 1939, include at times such distinguished figures as Albert Gleizes, André Lhote, Mme. Theo van Doesburg, Otto Freundlich, and Mme. Gabrielle Picabia. There were always between a dozen and twenty-five people present. Stenographic notes were preserved but like all such notes were difficult to unscramble. The fragments include a programmatic outline dated December 1938, summary notes from 1938–39, and a balance sheet of the previous sessions. The text of the conversations include notes of two meetings held on February 16 and 23 of 1939. See Francastel's excellent and revealing discussion of these two last transcriptions, pp. 213–14.

FRAGMENTS DRAWN UP FOR THE DISCUSSION GROUPS

I Outline of December 29, 1938

Dear Friends,

I drew up for you the other day a summary of our first sessions. Before going any further into the technique of painting I must be certain that everyone here is able to follow the fundamental points of these discussions. We have a job, which is to learn. And I'm going to tell you something that will perhaps be a surprise: I myself am learning. When you were first brought into our studio by Perron, here where Sonia Delaunay and I work every day toward an ideal goal—that of painting—the questions that you beginners asked put me in a defensive position. I'm not defending myself, but this position forces me to formulate the elements of technique as clearly as possible; and this task teaches me how to be more precise, to formulate exactly what the painter's craft consists of. So this is a real field for experimentation. Already experiments have been conducted which have to be formulated and displayed on canvas. We are going to be disclosing these experiments for some time yet, because my experiments carried out in the field of color go back many years. These are your own works that we study at each session, and afterward there is a huge job to tackle, for in the course of our get-togethers, there may be the possibility of having intuitive insights—which have nothing to do with theory—to give you a general idea of what I mean. You've heard of collective musical improvisations? I think the same thing can be accomplished on an entirely different plane, on ours, a pictorial plane.

We have a very real medium, color. But despite thousands of years of the art of painting, *we* are at the beginning in terms of awareness in our craft, which no longer arises from a story to tell, from an object to copy, to reproduce, or to deform. We are back with ourselves and our brushes. The fact of painting is, for us, to reveal our consciousness, to become aware of the elements that constitute this act. It is in this way that we learn, like children, the constructive language of color. I can't remember who wrote, "The man who loses his childhood is done for." It's not discouraging, on the other hand, to start something if you throw yourself into it with all the passion of a faith. *We are on our way.* In the coming weeks we shall devote one session to Cézanne, one to van Gogh, one to

Seurat, and one to Matisse. These sessions interspersed among those that interest us in particular on the present method of precise color will permit us to determine better by comparison—if relationships exist—analogies between our predecessors and the results of our contemporary palette. The keynote of all this being the *métier*—and not the literature—of art.

We want to uncover everything that deals with the great *image of what is human*, in all that is most real, most tangible, most essential to our lives—and what is most profound. Our means to this end must be objective. So before going on, I should like to know what you think and what you have to contribute.

We're ending this year well. Now what are we going to do in 1939?

II Summary Notes from 1938–1939

We have been outlining for your benefit the vicissitudes through which I passed, from the first analytic and conformist cubism (the *Villes*, the *Tours*, the *Ville de Paris*, etc.) to the more abstract cubism where color contrasts already unfold their development, still allowing the exterior signs of painting, such as fragments of curtains, houses, streets, towers (the *Fenêtre simultanée*). That was 1912.

Sonia Delaunay did not pass through cubism, but was formed by a species of fauvism—that is to say by colored pictorial means, representations of deliberately flat figures in the manner of the Byzantine, transmitted through impressionism. Sonia Delaunay confronted no less the prismatic principle of colors: she painted canvases, wooden chests, reliefs, that are very much documents of her initiation into abstract color art, that is to say, to the means to express simultaneous contrasts.

Our first works caused a scandal in the circles of formalist cubism. This is very much the proof that "inobjective" art was born. My friends, those who were alert, didn't understand. There was an atmosphere of perpetual battle at each exhibit. Later, after the 1914 war, the only one of my cubist comrades who was fair to me was Albert Gleizes and his fairness was an act of faith.

In a book which he wrote about me some years ago, he offered an exceedingly precise study of the two positions of man in the universe today—the position of the decadent formalism of the Renaissance, contigent exterior man—and man interiorized, "inobjective" man who re-

discovers the means of art through himself and expresses himself in the universe as an organic and total whole.

But I ought to follow up methodically the rationale of the pictorial craft that freed me after the discovery of simultaneous contrasts when the evidence of objects still persisted. One day about 1913, I tackled the problem of the very essence of painting. I dealt with the technique of color. We called this phase *pure painting* and it was at that time that I made my experiments with the *Disque simultané*.

This earliest disc was a painted canvas where colors opposing each other had no reference to anything visible. In fact, the colors, through contrasts, were placed circularly and opposed one another. But which colors? Reds and blues were opposed in the center, red and blue determining the extraordinarily fast vibrations, physically perceptible to the naked eye. One day I called this experiment a "first punch." Around it, in consistently circular forms, I placed other contrasts, opposing each other simultaneously in the ensemble of the canvas, that is to say within the totality of colors. You see: totality, ensemble of colors, opposing each other by complementarity, the others, in the center, in dissonance. . . . I use a musical word. The experience was conclusive. No more fruit dish, no more Eiffel Tower, no more streets, no more exterior views, but I was taken for an idiot. My friends looked at me with fish eyes. I had tried to cry out to them: I have found it! It turns! But they avoided me.

Modern man was saved. Modern man has discovered himself in the new idea of the "inobjective" universe—modern man, the human phenomenon on the human scale. It was a real man who made his universe cosmic. He had been asleep, for a very long time; he awakened from a torpor of hundreds of years. His poverty has created his wealth. After having looked at himself in the deforming mirror of physics, after having been the amorphous bookkeeper of an accounting of molecules and stars; having made statistics, laws, decrees, new laws, new decrees, and having led himself up to the point of *almost excusing himself for being alive*, for being an atom which is not its own master, he had almost forgotten himself, poor man. Then, oh, living miracle! Man became the true reality, the true plenitude. This was no longer a case of apples in a fruit dish. It was the beating heart of a man in action. He found himself transposed, transported by himself, with the experience of his craft, created by him for himself to serve as a means of barter with his brothers, his friends.

There is the cosmic, visual, positive—and real—poem. There is the

birth of our splendid era which I will not permit to be cornered or monopolized by the uncontrollable false symbolisms: the catchwords, the manuscripts forgotten in a drawer, the old cosmetics of seductive colors. *There is the transposition from a state of trance toward the total idea that we carry completely within ourselves and that we have the chance of making alive.*

I wish I could have spoken about painting with brushes in hand. This universe you can create through your craft—it is in your hands. Children have understood the history of the fruit dish for a long time, but they have no experience of the new craft. When they grow up, despite their talent, we yoke them to an assignment that is out of date—that makes them into little monkeys. We make them, like a Kodak, copy the outside of the fruit dish. We were children ourselves, but for my part I have rebelled for a long time. My vitality and my patience have had it.

If they had given me a craft, a true craft, I would not have had to destroy a great part of my lost life. But today, you and I are conscious of our strength, our reality, through the craft by which we regain faith. You have heard me speak continually of craft. Yes, because you have asked me to speak of it, which is natural on your part, given the disarray of actual teaching and its entailment.

Then we must begin at the beginning. It was required. It was my obligation to make you see that it was unnecessary to perpetuate the dead side that you carried within yourselves. I have to speak to you about something that has given me such a pleasure, and I am thanking you publicly: one of you said, the other night, while talking to me: "since I have been coming here, something in my life has changed." I am happy.

In conclusion:

Canvases and colors—

No chance of health outside—

All anecdotal and literary elements banned for our painterly hygiene—

The picture understood objectively as a whole. Our vision of the world is not panoramic or contingent. We do not explain the world. The true artist is creative.

We must leave a foolish era, which looked for the monster, which was delivered by another monster. I have spoken to you in detail of this past, of this process from destruction to construction, of the little devices that were used for camouflage. *We ourselves are inobjective.* We antiquate everything around us, since we have come up with the new. The new:

I mean life, natural order. The whole world, the most humble craftsman, has eyes which are capable of seeing that there are colors, that these colors express the play, the undulations, the rhythms, the counterpoints, the fugues, the depths, the variations, the agreeable harmonies, the monumental relations: in a word, architecture. I mean order, not order through constraint, but order: a construction which becomes self-evident according to our own sense of proportion: that of Man—Man in movement—not Man who is agitated, anarchic, but real Man, in flesh and in life, Man who feels himself, who calls upon his intuitive faculties which he renders concrete, tangible through the universal language of color.

BALANCE SHEET OF PREVIOUS SESSIONS: 1938–1940

Despite Cézanne, *the first cubist,* and van Gogh and Seurat and their marvelous body of work, none of them had the strength to mount a renaissance. They remained within the exteriorized spectacle—their eye revolved around things. They were great Tourists of Painting. Sometimes they almost reached the goal, because through their palpable conceptions the Man in them worked, with rage as did Cézanne, with hallucination as did van Gogh. But you see, young people, that is not enough.

These same cubists whom I have already called to mind for you accentuated the break, but, nevertheless, despite their courage they hovered about the goal, the object.

Today this has no relevance except for the art historian. We ourselves have not had to equivocate. We have understood, all of us here, I hope, that it is we who are turning and *nothing*, you understand, is able to stop us.

I am consciously using the word "fashion" in a real sense—not as a true fashion-maker, a *modiste*. Moreover, the *modiste* artisan uses it in the true sense.

We have rendered obsolete everything that has actually been done in art.

You are all grown up enough and well enough advised to escape all

the arrows, all septic odors, all the ironies with which you will be gratuitously filled. Gleizes and I were students of Cézanne. We had tough hides, but humility has also helped us to bear all these idiocies. They are going to attack you in the most perfidious and noxious ways because you are Life. Paris is a city of antiquarians. She has underground vaults where they manufacture antiques with the greatest care. The authentic antique. But why would you want them to venerate young sprouts like you? You will have a hard life. They will make you pay an enormous price for your independence—giving giving. It seems to me that you have already understood that: don't make paintings to sell. You are insubordinates, deserters of this false tradition of the Renaissance.

Rambosson told you the other day in his charming chat at the Salon d'Automne that he advised the public authorities to close down their museums—with their Venuses, their Apollos, all their history that is not ours—for a period of time. As far as I am concerned, I would take his advice.

You are the living reality. The craft about which I spoke to you earlier is your only health. It is in your hands. Nothing, you understand me, nothing—nothing—can make you stop. They cannot stop the seeds of nature. May this humus, this High Rot of Paris, make you germinate. You alone are the overturning of values.

We are speaking a totally different language than they. Unlike them we have conviction.

Conversation of February 16, 1939

1. Chiaroscuro, Relief, Color: (Slide of the *Ville de Paris*)
A young painter asked me what is meant by chiaroscuro. I have put it at the rear of my concerns. I have not introduced it into color. I have tried for everything with the least. It simply wasn't my experience. I wanted to create a movement of colors without supplying their resemblance and their description which would have been natural. You know yourselves that whatever happens with color happens so quickly that you are unable to recognize the characteristic properties of colors, but that,

nevertheless, it gives you movement. It is clear that independent of the place of legs, arms, or heads, you have, nevertheless, colored elements which create this movement. That is what I wanted to realize in this picture.

It is an art that approaches the wall, that is to say the plane of the wall. Whenever one introduces chiaroscuro, one makes a hole in the wall. With chiaroscuro you destroy the wall and create in its place a sort of perspective upon the chiaroscuro. Highlight specific characteristics and immediately you have perspective.

(Slide of the *Ville de Paris*, Coutrot Collection)

This is a version which was requested by a collector. It is a picture from my youth. I was—how old? I was twenty-five, maybe twenty-six. At twenty-five I began with little things like that. It was necessary to do that when one is young.

Here is a view of this collector's house. It is a big room. It was built by Perret. Unfortunately, one cannot see the ceiling. This house was intelligently constructed. That is a kind of door that unfolds in six panels. When you want to enter the children's room, which is in back of this picture, you fold the panel together and the picture disappears. This is pretty ingenious. It is a fresco that is almost mobile. It is opposite a splendid landscape of Paris which looks out on the Seine. It overlooks all of Paris.

Here is the panel separated from the figures and from the furniture. It is a painting that completely fills the back of the salon—a salon that opens into the dining room, which is quite big, painted entirely by Dufy.

I should tell you an anecdote while I'm at it. When Dr. Viard went to the Indépendants in 1910 and 1911, he was infuriated by our pictures. He told me, "If I had known you at that time, I would have punched you, I was so irritated by this painting."

But he loved painting . . . in the end he arrived at modern art by logic.

You see this big composition. It was painted with colors. I had carte blanche here and I made use of it. I did not plan my work. I threw myself into it and finished it in two weeks.

This picture is pretty dynamic. It is much more violent in real life. In front of it there is a big tapestry made by Sonia Delaunay that is related to it. On the other side there are pictures by Dufy and there are Picassos and Braques.

(Slide of *Tour aux rideaux* [Tower with Curtains])

This is from my destructive period and is called *Tour aux rideaux*. This canvas was rather unprecedented, particularly from the point of view of composition. It is the only one that has the curtains on both sides. I was thinking about a primitive French portrait that I loved very much. But now I no longer love that king.[1]

(Slide of *Tour vue d'en haut* [Tower Seen from Above], 1922)

Here is a canvas which is still in a room of Dr. Viard's. It's a canvas that was reproduced in the Ozenfant book called *Art*—which appeared in 1927.

This is a work which is quite unexpected as a graphic "Delaunay." It speaks less by means of color than by other things. I want you to see my little reversions from time to time in order to show you that after having done very good and highly colored work, I would commit my little sins.

(Slide of the Viard interior with *Soleils, Formes circulaires*)

This is a very interesting canvas, because it was in process during 1912 and 1913.

It is a canvas which is at Dr. Viard's. You can see the back of the wall. It is a little to one side. It cannot be taken down. This picture marks the first circular phase and is very important from the point of view of the state of mind that separates it, for example, from the canvas with the curtains (*Tour aux rideaux*) you saw before. This canvas no longer explains objects but simply sets down colors. You see that despite everything there are hierarchical arrangements in it. Despite my explicit wish to realize contrasts, I had a lot of difficulty doing it.

Do you see the modulations in tone? If there had not been these contrasts, this black and this white, this green and this orange, those reds of different values, those vibrant relations of violet and red—if there had not been all that—it would have been like the old painting. In this picture the composition and the color assert their authority—this is not to be found in the old painting. But I didn't know how to make the juxtaposed colors stay put throughout the picture. The colored elements contrast well, but they weren't closed. This was the limit that I found in the realism of color.

1. *Charles V* by Fouquet in the Louvre. [P.F.]

(Slide of *New York*, by Gleizes, formerly in the Heim Collection; Loeffier Collection)

Here is a canvas by Gleizes. It is a picture of New York from 1916. It is very beautiful. It is a large, densely painted picture. Here it is almost a relief and that is very good. There are smooth places and clotted, lumpy spots. There he used some sand and other materials.

Note that there are already preoccupations with circular constructions in this canvas, but that the painting still makes use of some elements which are not incorporated into the whole. It has characteristics that do not penetrate the composition. . . .

(Slide of [. . .])

This is either a Picasso or a Braque from the cubist era. See the imitation of antiqued wood, the mandolin, and note that the drawing is always the element that governs the canvas. See how it is constructed not at all in terms of colors but in chiaroscuro. It has a lovely quality, but finally it does not come to grips with the most important question of painting.

(Slide of a Léger from the years 1924–5)

This is a Léger—note that you cannot hang a cubist work upside down.

I need not say this. You know it, but there are many people who hang things upside down. It is advisable to hang pictures as high or as low as the top of a piano.

(Slide of Lhote, *Paysage de Paris* [Paris Landscape], Coutrot Collection)

Here is a mural painting, made after the *Ville de Paris*, which is a little thin. It is completely traditional. The externally cubist dimension of the picture is quite attractive. The slide is not very good; the color is livelier. It is a view of Notre-Dame. It is very Lhote, very characteristic of him. The cubist modulations enable him to effect the gradation of colors, their juxtaposition, a mannerism, and he is not too concerned with making the colors play as color. There is a preoccupation with subject, not anecdote, but landscape as subject. It is a composition in the naturalist vein.

(Slide of Dufy, *Vue de Taormina*, Coutrot Collection)

Here is a Dufy that belongs to this group of paintings. It is not a great Dufy, but it is pretty. Dufy had an undeniable color sense; he had facility, a very amusing verve. He did not copy verbatim from nature. The foun-

tain is deformed; there is imagination, but he still remains within the scheme of traditional painting in the Renaissance sense. There still are, so to speak, planes, distances, and foregrounds. It is very spiritual as regards manner, very vital.

It is amusing to go through all these paintings fairly. It affords comparisons and establishes bonds.

(Slide of *Air, Fer et Eau* [Air, Iron, and Water])

Here is a big canvas that you ought to have seen in 1937[2] and that was on the machine made by MM. Paz and Silva and decorated the whole of this colored architecture. Unfortunately, we didn't take color photographs at the time.

This canvas had been requested for the Beaux-Arts by M. Farcy of the Grenoble Museum, but when M. Farcy asked for it he didn't realize the size of it. It was 14 m. 50 in length and 9 m. 50 in height. He was very worried and had to ask for funds from the City of Grenoble and you know that painting always comes last when it is a question of public funds.

Now I must say something. Americans are very lively people. I honor the two Americans we have here this evening.

I honor Americans because they have a very generous sense of life. This canvas was commissioned for the San Francisco exposition along with several other canvases. They never raised the question of size, being absolutely indifferent whether it was as big as the Concorde, for example. They asked for these canvases, but having seen the direction which their exposition took, that is to say the unfortunate muddle on artistic questions and on the question of the selection which had been made, I didn't reply, and I refused to exhibit at San Francisco. I also refused to exhibit in New York, because I do not want to exhibit any of my works along with others that would make a jarring cacophony. That wouldn't do at all. It's necessary to present these paintings in an environment constructed with sufficient space.

The Americans thought then that the French would offer nothing at San Francisco, and therefore they proposed to hang the canvases properly and bear the necessary expense of exhibiting them according to a definite plan. You know that the exposition of San Francisco was an exposition

2. At the Exposition of 1937.

of art in life, that is to say, that it would show whole environments, which was very interesting.

A journalist who had come from New York said to us that she was responsible for making photographs of the artists' consignments. She went through all the studios in Paris in 1937, sent back four thousand clichés, and naturally chose works not belonging to the same school. It was on this basis that San Francisco asked us to exhibit. This we would not do.

(Slide of the reliefs of the Palais de l'Air [Palace of Aeronautics], 1937)

These are some reliefs. It was a very curious project—there were reliefs which were as high as ten or fifteen or twenty centimeters. When they were sufficiently painted, you could no longer see the reliefs at all, which proves without a doubt that color used correctly forms the relief. Without employing chiaroscuro, there is a relief, a vibration which completely annihilates the chiaroscuros created through the lighting of the whole room. These were panels which were four meters wide by eight meters in height and which were broken down into four parts.

You can see at the back [of the slide] the big panel that had, as we have already said, 1772 square meters.

Next time we will show you how we make a work as a team. We will show you slides of our friends, and how in this atelier one could, through a rational method of working, deal with very large surfaces without falsifying the connections and the whole. The whole was finished according to the rules of art as we understand them.

PICASSO, MATISSE, AND THE NEW REALITY (1939)

A talk delivered on February 23, 1939, after reading of an article from the Nouvelle Revue Française, *February 1, 1913.*

We shouldn't laugh at Picasso. It will soon be necessary to defend him. This is a very equivocal attack. There are some things which are just. But I say it is equivocal because the man who wrote it isn't well informed

about the period. It seems to me that everything isn't said in this article, because he attacks in such a fierce and direct manner, but what is he criticizing?

When one wants to attack something, it is at least necessary to support something by comparison. When Albert Gleizes, in a book he has written which is about to appear, opposes Picasso on the grounds of discoveries that have been made at the same time and even earlier, he takes pains to explain his criticism. He takes the necessary trouble to explain the position of Picasso in painting and he credits Picasso with a great deal of talent. To demolish is very easy. It is crucial all the same to contrast something else with demolition. Picasso has played a role in painting. To argue the contrary would be idiotic, stupid, and pretentious.

Gleizes has said of Picasso that he remained within formalism, that he stays in the old manner within Renaissance space. And indubitably, in the cubist era, the constructive side was never really revolutionary. Cubism did not have the means of innovation, but it had all the same a presentiment. There were even in those sliced and syncopated images different points of view, and the whole created a certain novelty. I believe that one cannot deny the cubist era and Picasso plays a role within that cubist era.

Evidently, now with time we will see that all this squares admirably with Cézanne, that Cézanne had examined the question of the plane, but we can also say of Cézanne that throughout his work he remained within the tradition of Renaissance painting. He remained in space; he did not create a new space; he did not introduce elements capable of creating a new language of painting. Therefore, I believe that this gentleman's critique is incomplete. It is veracious on certain points, notably on Picasso's perpetual anxiety: one has only to look at the whole of his work to see the contradictions and that these contradictions are within the old, traditional mentality of painting. Cézanne worked in no other way and none of the cubists have worked in any other way. We can begin from this position of man only by introducing completely new materials, that is to say, color.

But not color as a coloring upon a drawing, not as a juxtaposition of color patterns as Matisse made. Not one picture of Matisse shows true color quality. Color is always on the surface, never in the composition. There is always a drawing. There is always a certain limit that is not created by the color. Color is still placed like a shimmer, a padding, which is not at all constructive.

Matisse was very influenced by Gauguin. In Gauguin there was a plane, a great mass of very vigorous colors, and alongside that there were objects, persons depicted completely in Renaissance technique. But in spite of all this criticism, if you compare all these painters with the painters of the Renaissance, with Tintoretto, Veronese, you can perceive nonetheless that perspective plays a diminished role here. It is already an indication of what is going to happen. Through their sensibility these artists approached the plane but could not go beyond it.

The actual situation is that of the discovery of the new Reality which Gleizes has so admirably defined. We are only at the beginning, but we are convinced by it and you will be convinced by it through the very experiment that you are going to make by saying to yourselves, "I put down colors. They are reality." We use words incorrectly, and over the years in speaking of the abstract, of the concrete, of the nonfigurative, in speaking of I don't know how many other things, of the fourth dimension, etc., etc., of all sorts of things that were plausible and that were spoken of with good feeling—that's understood—but despite all that, such talk is worthless. Actually, there is only reality.

Ours will be a realist art insofar as it is a copy of reality, exteriorized, and that is why I have used the word "new" which does not always please Albert [Gleizes], but I cannot replace it with any other. It is new because, from my point of view, we have not yet used color with the freedom that we want to give to it, nor in the choice of form, the choice of limit, and in the choice of harmony—harmony in the sense of composition, in the sense of the total life of the work to be made—that is to say, in everything.

(Slide of the *Tour Eiffel*, 1910)

Here is a canvas: the *Tour Eiffel*. This is a "degenerate" canvas, the kind of painting execrated today by the German empire. There are variants of this canvas throughout the world and many in Germany, because before the 1914 war the Germans greatly loved modern painting. It is a canvas of 1910, which was exhibited at the Indépendants in 1911 and caused quite a few arguments. And now we can judge more tranquilly, a posteriori to that which tormented us and made us anxious in our own time. Naturally, we were not very conformist. We anticipated many problems that were completely outside the scope of painting.

The dominant preoccupation of the period forced us to deal with the

problem of space, the problem of plane and color, and especially with that idea which dominated everything I was doing at that time: the desire to shatter the line . . . this famous line of which we have spoken so much during our sessions. See, the continuity of line is shattered—the fruit dish!—and the shattering is explained by luminosity.

Observe, for example, this cumulus cloud which permitted me by means of its luminous ray to break the continuity of the line. I sought points of view juxtaposed from different perspectives. It was a desire to search out a total form that I had not yet succeeded in discovering, because I was at that moment straddling the fence between what we call transitional painting—traditional, rather—and the new reality.

I was in the period of transition toward something else and from the point of view of poetry, from the lyric point of view, this had a definite influence on the poetry of the era, on Apollinaire, on . . . on some other poets as well, who have written poems about this work. Still, poets discovered in that which can be seen only in its essence, a means of reacting to their sensibility. It led them to dream. But this is something else entirely. In the domain of painting, the means were still lacking. Only a great dissatisfaction was present.

(Slide of *Saint-Séverin*)

Before this canvas, I had made another *Saint-Séverin*, which perhaps you know in reproduction. I speak to you of *Saint-Séverin* because you can recognize here on both sides the columns of Saint-Séverin. I did not know that it was an obsession for me to recover the elements which made up form. Here it is full of chiaroscuro. It is one of the canvases with which I passed into cubism—for a short time. We were, with Gleizes, among the first. Thereafter, I was dealing with color, as you know, and I will show you how I got there.

What is curious is that from the point of view of the object, the edges recall Saint-Séverin and yet at the same time there is already the beginning of the circular form that is very dear to me and that is, in fact, begun here. Note the disarticulation from the point of view of ordinary sight. If you compare the landscape to what you normally see —the spectacle of nature is not seen as it is in nature.

There are very precise and clear elements: we recognize the Eiffel Tower but we do not see it like that. I restore planes from a perspective that one would call cavalier. It is a kind of perspective that one uses

a great deal in the theater, a kind of agglomeration of different perspective points which you see at the same time.

GLEIZES: The importance of this issue lies precisely here. A factor enters that was unknown which belongs to painting and to space, and that factor is time.

It's the result of Cézanne. There is a plurality of points of perspective. The perspectival unity is ruptured from within. In my view, all of the painters of this period have discovered something extremely important.

DELAUNAY: I want to add that we recognize Cézanne by small details and modulations. I was very intrigued by the watercolors of Cézanne. At that time we had all thrown ourselves at him like a reputation on which one speculates as in the stock market. At heart we are the grandchildren of Cézanne, as the young will perhaps be our grandchildren. That is the lesson of life.

So now, I take up again what Albert Gleizes has said. The investigation of movement. I support it completely because later it will explain other pictures. I return again to the question and will try to explain myself as much as I can. There is a split in this image, a tearing, not a synthesis. When one considers the object in itself, there is still a perspectival view. There are still luminous effects. There are colored elements and all the ingredients that finally make up a very tormented work. And as I told you just now, I believed that the mobility could be obtained with lines and with juxtaposed fragments, that one could arrive at mobility by relating the top and the bottom, and all sorts of light effects.

I believed that we could do that and yet I perceived that we could not. I was extremely tense and anxious. After this picture I made a greater synthesis that was called the *Ville de Paris*, a picture which the State bought and which was then (and I suppose this is the way to put it) the picture-type of the era, because it was a synthesis of different things, a whole which contained my principal works from that era.

We cannot create mobility with forms that are drawn. We cannot create cinematic mobility, because the cinema is not mobility. It consists of a series of images which appear in very rapid time. This is not mobility. And you will see why. Mobility cannot be obtained except by colored elements, elements judiciously colored, selected, judiciously revealed, and requiring a general composition which didn't exist yet in these pictures. Here, there was tearing: catastrophic vistas, vistas of destruction—1914—war!

(Slide of the *Fenêtre simultanée*)

Nevertheless, the young Delaunay was a little calmer in 1912 and looked optimistically to the future. He has juxtaposed colors to one another and these colors had given him a sensation of mobility, of joy. He still didn't know very well how to use them. He was still a prisoner of the external subject. Despite what we believed at that time, it was a painting—such as one describes now with words which are nevertheless very bad—it was an "abstract" painting. What we wanted even then was to signify a state of purity within painting. One still perceives that there are allusions to houses, here a tower, a sky, but reduced to schemata. At that time I believed that it was necessary to simply place pure colors on the canvas. And you see how this atavistic attitude is a difficult thing to get rid of, whether or not one has matriculated at the Ecole des Beaux-Arts.

In this canvas there are color relationships that were not yet known at this time. I used the expression "simultaneous colors" to define it.

I am going to explain to you what was, to my mind, the purpose of these simultaneous contrasts. Here you have violet, and you have a tonal relationship that is different from these others. You already have a beginning of the plastic where there is no allusion to a subject, to a landscape. Thus, you see here the beginning of a colored architecture that is extremely typical, extremely naive. When I made these simultaneous contrasts, I didn't know where to stop them. I didn't know and I didn't see; I left off as I could. I effected a sort of interpenetration of planes, modulations of colors that created a specific surface and a specific unity.

Despite everything, despite the desire to revert to the plane, despite this element of composition where the colored pigments and contrasts take off (what we called simultaneous contrasts) we employed the phrase *pure painting*. Apollinaire used this term. I called it the *Fenêtres simultanées*.

(Slide of *La Fenêtre, la Tour et la Roue* [The Window, the Tower, and the Wheel], 1913)

I was trying to make a kind of colored fugue and I developed a rough sketch of my conception of the unity of the canvas. In reality, one could see it from all sides, naturally, but there was an effect which was, so to speak, given.

In all events, you see a specific thing. This picture was different from all the pictures you have seen earlier. At this time, the cubists, my

comrades, had not introduced color into their pictures. But I had already envisaged its necessity. I had the idea of mobility inside me, but I didn't know how to express it. I had felt all along that color was a dynamic element, which has its laws, its heights and widths, its relations, its complements, its dissonances, its varieties—a host of things that are quite complicated and that I do not express very well.

You have a part of it here . . . that could very well be a work of Cézanne. And here is a bit which is much more in the degraded than in the pure state of color. This picture, which should not be in my house but in a museum, is called *La Fenêtre, la Tour et la Roue*. I became more conscious while making it of what I wanted to do. The simultaneous contrasts through a plane, through a clear tone, with a not very unequivocal red, a hot tone, and also note a yellow that contrasts with a violet, and at one time one has the beginning of circular form. How curious it is to see pictures one made in those days! . . .

When an artist has an intuition, it can be realized, but unfortunately only by hard work. You see here all at once, a landscape, still reminiscent of the object, buildings that could have been painted by a Paris artist like Utrillo, with the big wheel that perhaps you have not noticed and that is still an objective element. See how difficult it is to attain. It's a very good example for you. One mustn't give up. It's only necessary to have a great deal of discipline and will power. Everything cannot be found at once. I will finish by affirming my belief that talent doesn't exist.

In the middle of this space there are, as it were, depths suggested through color by means of planes, but these are not planes that call to mind objects or conventional forms.

After having painted this picture, I was not at all satisfied, but I felt that I had reached the goal because in this picture there are elements of space, plane, mobility, and in many of these elements, which are rather descriptive in relation to the given of the picture, there is, nonetheless, a whole that was sought and created.

I effectively centered the modulation on the canvas, but I did not yet figure out how to continue it. See, however, that sort of spiral.[1] It already contains the germ of what I was going to develop later.

And watch that kind of circular form which begins the end of the picture. It is a kind of colored embryo that begins to turn. And the

1. A series of paintings begun in 1923 called *Hélices*.

simultaneous contrast in the center: see how it continues to turn. The contrasts of the colors take shape and become a constructive unity, always within the domain of sensibility. Moreover, this was between the years 1912 and 1913, when cubism flourished.

You see how there are masses of colors I tried to juxtapose. Naturally, I smile a bit now because I am a little more advanced, not very much, but a little more. It was necessary for me to find the means to compose the pictures. It was necessary to study the whole gamut of possibilities in order for the color calculations to become enmeshed with a harmony of shades. They would unfold in time, which is to say the modulations of colors against one another would cross-cut and engender mobility.

A physicist could probably explain to you the radiations that produce the relations of colors to one another, but the painter doesn't need to know this. A physicist could probably explain to you the radiations that produce the relations of colors to each other, but the painter doesn't need to know this. A physicist could certainly reveal before these canvases the opposition of hot and cold colors—which are the blues, the violets, and the greens.

In this canvas there is a certain luminosity that is still impressionist. There are little paddings which still denote a lack, a weakness in the science of color. But it is evident that the path even then was a good one. It is clear that we were in the presence of something other than perspective, chiaroscuro, and subject.

(Slide of *Formes Circulaires No. 1*)

Observe here that the circular form begins to be much more prescribed and formulated. You can see the juxtaposing contrasts. For example: a cold tone and a hot one, an orange and a yellow. On the other side, you have a hot tone and a cold tone. Here there is a kind of movement that is established by the exchange among them. Thus, the form begins to emerge in the sense that there are rhythms of specific colors. Clearly, these color rhythms are still transitional. This is not yet a definitive work. It is still broken up. It could still extend itself to a greater height. The color relations could still develop further, create possibilities that could be elaborated even more. But you have the interferences, the movement. You have the exchanges [*des passages*]. And you have everywhere, moreover, the flat plane. Already there is no longer a relation with space insofar as it is visual space. There is the space of the picture, the relation

of colors, the height and width of colors, the phenomenon of vibration of the colors through one another, and, in its development, the subject. The subject very clear and very clear cut, a colored subject.

Fundamentally this is the same problem that I explained to you before about the *Fenêtres*, but with one difference. The colored elements link together. For example, this white and this black interact in the first composition that is centered, organic: the closing of the picture through the big circle that ends it is organic. This, however, is a composition which is not fragmentary and nonetheless it joins itself to two other compositions that you see here and that end in another movement, always with the white and the black. There are, thus, three elements that harmonize with one another, and you have space—because you have all the color relationships which create a kind of perspective, of depth in which the elements play off against one another. We can use the word *figure* to describe these pictures although they are not figurative in the precise sense of the word.

We could still achieve a greater realism in the true sense of the word. We could tighten the compositions and render them much more studied [*voulus*] and more organic. I believe, moreover, that we can pass from one picture to another and to a third and that they constitute a unity. I believe that this leads us to architecure. This kind of painting, in effect, does not demolish architecture, because you can very well have it play on a wall, which would be impossible if, for example, it repeated itself texturally here and below. The word *monumental* has been used in connection with these pictures. I am not able to recall in what circumstances, but I have kept that word, because it seemed to be appropriate to me. While being completely painterly—and not at all decorative in the bad sense of the word—there was in it a movement, a development, very much opposed to decoration, which is generally flat and without connections, always formed of the same motifs which recur infinitely. You have seen, on the other hand, Roman capitals? They are all the same width and height and all their composition and lyricism have evolved around them because they, nevertheless, possessed an order. This remains within the realm of architecture.

(Slide of the Palais de l'Air [Palace of Aeronautics], 1937)

These are some panels about aviation painted on a flat plane by Sonia Delaunay. She has alluded to spirals (*hélices*), to the appearances of

technical particulars, to images of the control panels, etc. Observe that she remained completely within the scope of architecture. She does not deform architecture, she remains within construction.

(Slide of the Decoration of the Palais des Chemins de Fer [Railway Palace], 1937)

This photo was made during the demolition. Until then, one could not see this canvas in all its grandeur, because there were some foot-bridges in front of the large circular movements. In this composition I tried to combine both the particular and the architectural dimension. I stayed within the conception of the architecture that Audoul had pro-mulgated. We collaborated closely.

Working with an aesthetic of the relation and unfolding of colors, a door had opened. Even though Claude Monet was a very beautiful color-ist, he had introduced perspectival elements as all the impressionists did. He was extremely depressed when he made holes in the surfaces.[2] These were unimportant; they affected only a small easel picture. But when it happened on a wall painting, the picture expressed itself on a wall, that could not hold up. You have a surface and on this surface you have rhythmic elements, colors developing in the same way as I have shown you in the preceding canvases. The color relationships in the total work constituted harmony that was very difficult to achieve, because it was a canvas to be executed in 780 square meters. That was a problem. I believe that modern art had never had such an opportunity. You can see that, following the conception of the architect Audoul, the picture is absolutely harmonized with the building. Its monumental scale, aside from being very impressive, is also appropriate. It was, from my point of view, a very beautiful work. It is unfortunate that it no longer survives. It was the most complete mobile synthesis we ever achieved. When one entered this pavilion, it was a perfect symphony of wholes. What was interesting in this work was how much time we put in with Callewaert preparing the canvas. It took us eight to nine days. You see what pos-sibilities there are for teamwork where the team is very well coordinated and where each has his task. (There are immense possibilities for col-lective work that could have enormous importance if applied to the social

2. A mistaken reference to the shrapnel holes which damaged many of Monet's canvases stored in his country home during World War I.

plane.) I would probably have spent a year making this picture if I had done it completely by myself. I didn't apply one stroke of the brush to it, either to paint it, to prepare the canvas, or to mount it. In front of it there was a scaffolding that had cost a fortune, an astronomical sum. There were specialists who had mounted the canvas perfectly. The length of the canvas was painted in widths of two meters. It was sketched out in a garage I had rented to execute the work. The canvas was prepared by Callewaert, who had found a very amusing technique. He employed the kind of broom used by street cleaners. We prepared the canvas with glue and then pushed the broom across. We had very beautiful surfaces. There was a lot of work to be done, to renovate the walls, to repaint the capitals, etc. We managed to work as a team with perfect harmony. There was one person who did all the drawing on the canvas while it was lying flat on the ground. He was a young man named Sico—a perfectionist—who did all this work following the model I had made here in my studio. It was very little and it had been made and conceived to be executed in a very large space. It was a very novel problem for me. I had never done anything like it. My biggest canvases were of three and four meters in size and I had never had such an extraordinary opportunity to conceive a thing in terms of its monumentality with an architect as interesting as Audoul. We adopted his composition which fundamentally comported completely, as my friend Sidès has said, with the architecture of an altar. We succeeded, therefore, in making painting a function of architecture. I believe that this is the true place of painting that begins to be constructive.

Art and the State (1939-1940)

Both documents in this concluding section evidence Delaunay's social and moral concern with his fellow artists and the perpetuation of their art. They date, undoubtedly, from the period 1939 until before his death in 1941. See Francastel, p. 238.

Art is one of the greatest human forces. We submit to it but we cannot explain it. Science tries to split the atom; it seeks to split hairs with formulae. What distinguishes art from science is that art is living—and life never has to be explained.

From its beginning art has always been abstract, and the first millennial signs, engraved or painted, have remained just as alive and inexplicable.

By comparison, however, quality can be discerned and the real creator can be distinguished from the copyist and the imitator. The truly creative work begins to shine and appears before the public as light from the stars immediately after their creation. The motivation for creating is not a theory. Theories cannot be painted. However, the art of a painter, for example, evolves as does a living thing. I spoke before of shining forth. By way of comparison, the more a painting shines, the more life it contains within itself, the more its conception and its creation assure and impose its presence.

What is commonly called a *chef-d'oeuvre* is really the work that re-

mains over and above current artistic production. It is the organism that contains the most vital force and that imposes itself on several generations.

The rest of us artists, who are eternal revolutionaries, have our demands to make during the present period. All civil servants, workers, artisans, etc., have received paid vacations, forty-hour weeks, etc. *We artists demand work.*

It's clear and simple. These are our only demands.

Of course, unemployment was momentarily useful. Now it is harmful. We consider it harmful and idiotic. Artists are beginning to see that they were the clowns and the monkeys who used to entertain a certain class (and some took themselves seriously in their own cage). They are beginning to see that they are no longer common enemies, that there exist higher, more collective, immediate human possibilities to be satisfied.

The work that we lay claim to, to which we all have the right, should be organized—and it can be very easily.

In the first place, from the legal point of view, we should receive a portion of the royalties that museums offer to the enjoyment of the national and international public that visits them every year. Who are the first to live off this public? The reproducers. The millions of photos, castings, and admission fees could go only to pay the interest, to serve as a guarantee for funds placed at the disposal of a single organization of the state or controlled by the state. An organization opened to wide participation of those who are interested in everything that has to do with art work in all its branches. And this is but a very small part, which represents, however, a colossal revenue that can be expanded to an even greater advantage. This would provide an initial sign of possibilities as yet unsuspected.

Second example: the funds spent at a total loss by most of the annual Salons—which spend only for temporary equipment, location, etc.—funds that are not difficult to ascertain from the account books of these societies and that add up to millions spent at a total loss to artists whose work is exhibited under poor conditions. These funds would represent, in a specially managed municipal building, resources to support a host of complementary elements: such as printing presses, colors, canvas, plaster, stone, posters, etc. And these funds are all the more considerable because then we descend to astounding statistics.

Going up the Champs-Elysées on the left, before coming to the Arc

de Triomphe, you are struck by large silver letters that announce, "Paris, the city of art and of thought." The Maison de France thus does its advertising to the world by referring to artists and thinkers. As a result, the *objet d'art* is for France the lifetime ambassador who goes out into the public, to foreign museums, to the private collections, and by means of reproductions, to the humblest places of the inhabitants of the entire earth.

I'll take a very minor example, namely *The Angelus* by Millet and its incalculable number of reproductions. The works of artists and artisans are therefore a product that has as much radiating force as one freely consents to this force.

It is France who has the chance of having the greatest potential in this order of production.

It so happens—and it is no secret—that this great activity is menaced in its internal economy.

Help is being organized from every side: two unemployment funds have been set up. But all that can be done in this direction can only end in temporary salvage, and the situation is already very serious.

In spite of these fine works, suicides are recorded each week. Artists and craftsmen cannot hold up under a situation that continues to be so critical.

It is only in the social and economic areas that the artists can be helped in a useful and lasting way and, most immediately, through an organization on the economic plane.

There are already groups—some in the form of syndicates; others, cooperatives, still others, societies in the form of associations, which have been working for a year as professional organizations. New members come every day to those groups to be registered.

It seems to us entirely possible—immediately—to put an end to unemployment, instead of forever wasting large sums which do not help. . . .[1]

1. The final part of this article lists the works Delaunay proposes for inclusion in a Museum of Inobjective Art, enumerating the price and location of each work and outlining important features of the collection, such as catalogue and exhibition itinerary.

PROPOSAL FOR A MUSEUM OF INOBJECTIVE ART IN FRANCE (1940–1941)

This project includes several stages:

1. Purchase of canvases from French and foreign painters who belong to this movement.
2. These purchases made in the form of monthly payments, which would make it possible for these artists to cope with the difficulties of life for the duration of the war.
3. These purchases would serve as a foundation of a Museum of Inobjective Art in France after the war.
4. As this would become a social act through the aid given to artists during a critical period for them, state aid might be solicited and gratefully acknowledged by requesting that the person who took this initiative be decorated.
5. Moreover, while awaiting the end of the hostilities, this collection might be sent to the United States, its future destination having been made known and a patron having been requested from the French authorities for transport facilities and publicity in the United States.
6. This would provide the collection with an enormous advantage over the one that already exists in America and that, as a matter of fact, has been lacking official ratification in France.
7. Since the artists will have sold their canvases, they can, in addition, consign a certain number of canvases for this publicity trip to be exhibited at the same time and to increase the number and the importance of the collection.
8. This would not prevent the eventual sale of these canvases in the United States as well, thereby increasing still more the aid to the artists.
9. The purchased canvases would have to be assembled in some accessible locale so as to enable officials to be invited to see them.
10. The list of artists is to be drawn up with complete impartiality, without forgetting, however, that in order to get the desired support, French names should predominate.

III.
Essays and Poems about the Art of the Delaunays

Blaise Cendrars, speaking in 1954, declared, "At this time, about 1911, painters and writers were equal. We lived mixed up with each other, probably even with the same preoccupations. It could be said that every writer had his painter. I myself had Delaunay and Léger, Picasso had Max Jacob, Reverdy; Braque and Apollinaire had everybody. . . ."[1]

What is illustrated by the essays and poems of this section is the truth of Cendrars's observation. The poets and the painters interacted. Delaunay and Apollinaire, Sonia Delaunay and Cendrars. The Delaunays, perhaps more than other artists, delighted the poets not only because of their work but because of their marriage and the ménage they established. They lived well; and they drank well; and they shared their good fortune with their fellow artists. Moreover, given Sonia Delaunay's success in the world of decorative arts, in which she invested so much of her creative energy, the home of the Delaunays—its furnishings, objects, their personal clothing (see Apollinaire's essay, "The Seated Woman," infra p. 179)—was also a fact of the modern movement, a further document of the new inobjective art which they had struggled to bring into being.

GUILLAUME APOLLINAIRE: WINDOWS (1912)[2]

The yellow dies down from red to green
When the aras babble in their native forest
Heaps of pilis
There is a poem to be written on the bird
 who has only one wing
We will send it as a telephone message
Giant traumatism

1. Henri-François Reyl, ed., "Propos de Blaise Cendrars," *Arts* (November 1954). Cited in catalogue of Galerie Louis Carré, "La Peinture sous le Signe de Blaise Cendrars," p. 2. The whole subject of the relation of the Delaunays to the poets is discussed in Arthur A. Cohen's "The Delaunays, Apollinaire and Cendrars" (*Critiques,* Cooper Union, 1973).

2. Guillaume Apollinaire, *Calligrammes* (Paris: Editions Gallimard, 1925), pp. 13–14.

It makes your eyes run
There is a one pretty girl among the kids from Turin
The miserable young man wipes his nose with his white necktie
You will raise the curtain
And now look at the window opening
Spiders when hands wove the light
Beauty paleness impenetrable violets
We will try uselessly to have some rest
They will be in midnight
When you have time you have liberty
Signoreaux Lotte serial Suns and the Sea-urchin
 of the setting sun
An old pair of yellow shoes in the presence of the window
Towers
Towers are streets
Wells
Wells are markets
Wells
Hollow trees which protect the wandering Capresses
The Octaroons sing their songs of death
To their maroon-colored wives
And in the north the goose trumpets honk honk
Where the raccoon hunters
Scrape their pelts
Sparkling diamond
Vancouver
Where the train white with snow and night fire flees
 the winter
O Paris
The yellow disc dies down from red to green
Paris Vancouver Hyères Maintenon New York and the Antilles
The window opens like an orange
Fine fruit of light

BLAISE CENDRARS: THE EIFFEL TOWER (1924)

The published extract of a lecture delivered by Cendrars on June 12,
1942, in São Paulo, Brazil. In Aujourd'hui *(Paris: Bernard Grasset,*
1931), pp. 135–49, and in Cendrars, Oeuvres Complètes *(Paris: Denoel,*
1960), pp. 195–200.

To Madame Sonia Delaunay

During the years 1910 and 1911 Robert Delaunay and I were pos-
sibly the only people in Paris to speak of machines and art and to have
the vaguest awareness of the great transformation of the modern world.

At the time I was working in Chartres with B———,[1] on the problem
of tuning his airplane to variable incidences, and Robert, who had
worked for a short time as an ordinary mechanic in an (I have no idea
which) artisan locksmith shop, prowled in blue overalls around the
Eiffel Tower.

One day, returning from Chartres, I fell getting out of an automobile
at the exit of the park in Saint-Cloud and broke my leg. I was taken to
a nearby hotel, the Hôtel du Palais, in which Alexandre Dumas, father
and son, had lived. I remained there in a hotel bed for twenty-eight days,
lying on my back with my leg in traction. I had my bed pushed against
the window. Thus it was that every morning when the waiter brought
me my breakfast and would push the shutters aside and throw open the
windows, I had the impression that he had brought me Paris on his tray.
I saw through the window the Eiffel Tower like a clear carafe of water,
the domes of the Invalides and the Pantheon like a teapot and a sugar
bowl, and Sacré-Coeur, white and pink like a candy shop. Delaunay
came almost every day to keep me company. He was always haunted
by the Tower and the view that he had of it from my window greatly
attracted him. Often he made sketches or brought his paintbox.

It was in this way that I was able to be present at an unforgettable
drama: the struggle of one artist with a subject so completely new that
he did not know how to seize and subdue it. I have never seen a man
struggle and vindicate himself so completely, except perhaps the mortally

1. Probably Blériot.

wounded who are abandoned on the battlefield and who after two or three days of superhuman effort give in to silence and oblivion. The difference between them and Robert Delaunay was that Delaunay was triumphant.

At that time, Delaunay, who had learned to paint from the impressionists, had entered upon a more or less abbreviated fauve period. He exhibited a series of very elaborate landscapes and a dozen portraits with exalted colors. He met the early cubists and all the other young painters at the Salon des Indépendants. Faced with the lax execution of impressionist canvases, pointillist confetti, and incoherence of divisionism and the hysteria of the fauves (in their own youthful pictures), they were experiencing more and more the growing need of returning to more solid forms—definitely not the need of recovering a specific form of the art of the past which in their view was no less inadequate—but rather of themselves retracing the origins of plastic forms, of putting everything in question, of revising all aesthetic values, of despising inspiration and supressing the subject, of seeing all technical problems afresh—from the actual making of colors to the use of sources of light and the weaving of canvas. During these six or seven years from 1907–08 until 1914, Delaunay spent his time in the ateliers of young Parisian painters. What an abundant richness of patience, analysis, investigation, erudition—there never burned such braziers of intelligence! Everything was examined by these painters—contemporary art, the styles of every period, the plastic expression of every people, the art theories of all times. Never before have so many young painters been known to go to museums to screen, to study, to compare the technique of the great masters. They made use of the works of primitive peoples and the aesthetic remains of prehistoric man. They were equally preoccupied with the latest scientific theories in electrochemistry, biology, experimental psychology, and applied physics. Two men who were not even painters had an enormous influence on the first generation of cubist painters: the mathematician Princet, to whom they gave the first of their plastic works and who immediately devised mathematical formulae for them, and the Hellenist scholar Chaudois, who inspected every theory that was put forth with the help of citations drawn from Aristotle, Anaximander, and the pre-Socratic philosophers. This frantic critical and creative ferment was called by Maurice Raynal "The Search for the Fourth Dimension."

Delaunay was untrained but extremely attractive and self-sufficient, tall, strong, well situated in life, temperamental, a sensualist. All the brilliant aphorisms, all the superb theories made him dizzy. He reacted according to his disposition and, since he was a born painter, he reacted with color. Apollinaire recognized this so well that he did not mention Delaunay in his famous *Aesthetic Meditations*, the book he wrote in 1913 about the cubist painters. He had not succeeded in placing Delaunay within the cubist canon, and waited rather for the moment when he would find his own disciples. Apollinaire would then discuss him in a second volume for which he had found the charming title *Les Peintres Orphiques*. Unfortunately the war and his death intervened and thwarted his intention.

This is the way Delaunay worked:

He shut himself in a darkened room where he nailed the shutters closed. Having prepared his canvas and ground his colors, he drilled a small hole in the shutters. A ray of sunlight filtered into the room and he applied himself to painting it, to studying it, and to decomposing and analyzing it in all its elements of form and color. Without realizing it he became addicted to spectrum analysis. He worked in this way for several months, studying pure solar light, plumbing sources of feeling completely remote from all considerations of subject matter. Then he enlarged the shutter hole a little and began to paint the play of colors on a substance as fragile and transparent as glass. Shimmerings, glimmerings, refractions of light. The small pictures assumed the artificial appearance of jewels and Delaunay even mixed precious stones, particularly pulverized lapis lazuli into the colors he had ground. Soon the hole that he had drilled in the shutters became so large that Delaunay opened the shutter doors and allowed the full light of day to enter his room. The canvases of this period which are in a somewhat larger format represent closed windows where the light plays upon the glass and the white muslin curtains. Finally, he drew the curtains and opened the window. A luminous gaping hole appears and the roof of the house across the street is visible in half-light, severe and solid, a primary, brutish form, angular and bent.

More and more Delaunay was attracted by what was going on outside. He now rediscovered the minuscule play which he studied in a ray of sunshine on a gigantic scale magnified in the ocean of light that washes over Paris. The same problems, but in another dimension on

an immense scale. Afterward he painted canvases five and six meters long—*La Ville, Les Trois Grâces sur Paris* [The Three Graces over Paris]—or he tried to reconcile the Academy with all his innovative discoveries in pictures of the Seine with the cathedral spires of Notre-Dame, the suburbs of Paris, and Alfortville. Finally he hit upon a new subject that enabled him to apply all of his discoveries and techniques: The Great City itself. A multitude of new problems were presented—analogies, spiritual and physical compatibilities and contrasts, questions of perspective and material, abstract questions of univocality and synthesis. But in all of this the personality of Paris suffused everything. As time passed and over successive months he contemplated Paris from her heights, his eyes turned toward that extraordinary form, the Eiffel Tower.

It was at this time that I met him.

I spoke to him of New York, Berlin, Moscow, of those prodigious centers of industrial activity scattered over the surface of the earth, of the new forms of emergent life, of universal lyricism. This remarkable young man who had never left Paris, who was concerned exclusively with questions of form and color, had understood everything I was saying from his contemplation of the Tower, from his deciphering the significance of the colored posters that began to cover the houses of Paris, from seeing the mechanical life of the streets born before his own eyes.

And now, think of my hotel window opened out over Paris. It was the same subject as all his preoccupations, a ready-made picture, but one that he had to interpret, construct, paint, carry out, achieve, express. And this was difficult. That year, 1911, I believe, Delaunay made fifty-one pictures of the Eiffel Tower before arriving at the right solution.

As soon as I was able to go out, I accompanied Delaunay to see the Tower. This was our trip around and within the Eiffel Tower. Any formula of art known at that time would have been incapable of defining plastically the phenomenon of the Eiffel Tower. Realism dwarfs it; the old laws of Italian perspective mince it. The Tower rises above Paris, slender as a hatpin. When we moved away from it, it dominated Paris, stiff and perpendicular. When we approached it, it bent and leaned over us. Seen from the first platform it seemed twisted like a corkscrew, and seen from the top, it seemed to sag, its legs spread apart, its neck tucked in. Delaunay wanted nothing less than to show Paris all around her with the Tower situated in her midst. We tried every

vantage point. We looked at it from every angle, from all sides. Its sharpest profile was the one we discovered from the top of the Pont Passy overpass. All those thousands of tons of iron, the thirty-five million bolts, the interlaced connected girders and beams rising three hundred meters high, the scale of those four-hundred-meter-high arches —indeed, the entire vertiginous mass—flirted with us [*faisait la coquette*]. On certain spring days she was supple and laughing, and opened her umbrella of clouds in our face. On other days, when the weather was bad, she sulked, crabby and ungracious, as though she had a cold. At midnight we ceased to exist and all her lights were for New York, with whom she was flirting even at this time. At noon she transmitted the time to ships at sea. I learned the Morse code from her which even now helps me to decipher radio signals. And as we prowled around her we discovered that she had a unique attraction for all kinds of people. Lovers climbed a hundred, two hundred meters over Paris in order to be alone. Couples on their honeymoon came from the provinces or from foreign countries to visit her and one day we even met a fifteen-year-old lad who had hiked from Düsseldorf to Paris to see her. The first airplanes turned around her and bade her hello, and earlier Santos-Dumont had taken the Tower for his first destination during his historic balloon flight; the Germans sought to capture her during the war, not as a strategic but as a symbolic target. I can assure you that it would not have been possible because the Parisians would have killed themselves for her and Gallieni had even decided to blow it up, our Tower!

There are so many points of view from which one can examine the phenomenon of the Eiffel Tower. But Delaunay wanted to interpret it plastically. He succeeded at last with his world-famous picture. He disarticulated the Tower in order to get inside its structure. He truncated it and he tilted it in order to disclose all of its three hundred dizzying meters of height. He adopted ten points of view, fifteen perspectives— one part is seen from above, another from below, the surrounding houses are taken from the right, from the left, from the height of a bird in flight, from the depths of the earth itself. . . .

One day I decided to visit M. Eiffel himself. It was, moreover, a birthday—the twenty-fifth of the Tower or the seventy-fifth of M. Eiffel. I presented myself at a small hotel in Auteuil, cluttered with a *tohu-bohu* of eccentric works of art, all terribly ugly and useless. On the wall of the study of this famous engineer there hung photographs of some of the most beautiful of his works—bridges, designs of railways,

stations. As I alluded to all of this immense productivity and the aesthetic that radiated from it and paid him particular homage for the Tower, I saw the eyes of this old man open inordinately wider and I had the distinct impression that he thought I was making fun of him. Eiffel himself was the victim of Viollet-le-Duc and virtually apologized for having dishonored Paris with the Tower. Afterward this misunderstanding no longer amazed me. I went on to tell him with pleasure that the number of engineers who wanted to participate in the aesthetic of today was becoming more numerous.

ANDRÉ LHOTE: PREFACE TO SONIA DELAUNAY: HER PAINTINGS, HER OBJECTS, HER SIMULTANEOUS TEXTILES, HER FASHION DESIGN (1924)

Sonia Delaunay, ses peintures, ses objets, ses tissus simultanés ses modes *was edited by Lhote and published by the Librarie des Arts Décoratifs in Paris in 1925. The album contains poems by Cendrars, Delteil, Soupault, and Tzara.*

All the artisans who are occupied with ornamenting our homes—house painters, cabinet makers, ceramists, goldsmiths, etc.—have the souls of gardeners. Why is it that throughout their lives they can never free themselves from "the exaltation of the flower"? From the degenerate acanthus, which unfolds along the arched foot of a Louis XIV armchair, to the flabby iris which blurs the lines of a table in the "modern style" (bypassing Louis XIV foliage and the little bouquets of Louis-Philippe), the vegetal reign has almost exclusively provided ornamental artists with their motif during these last centuries.

We have begun to tire of all the vases and baskets garnished with foliage, with ribbons, with birds, all of whose combinations have been exhausted. We want to free our eye from all these floral clichés which have suddenly lost all their charm. The "application" of more or less "decorative" plants on the background of fabrics or porcelain leaves us

cold. It was at this juncture that cubism intervened and temporarily replaced (for the very great good of all the arts) the representation of nature with the play of plastic elements employed in their pure state.

Robert Delaunay and his wife, Sonia Delaunay, were among the first to struggle to purify the art of their time. Starting from the principle that a picture, in order to be complete, must join to its qualities of material, drawing, and color, a special decorative sense—that is to say, a specific geometric simplicity of line—they pursued simultaneously an inquiry into the relation between the economy of the picture and that of furniture and wardrobe. Nothing could be more fertile than such an exercise, nothing more relevant to establishing the required balance in the spirit of the artist-artisan. The object, often refractory by its material nature, presents the artist with strictly technical problems. The object writes its own laws—porcelain has different exigencies than wood or fabric. Intended to please very often unsophisticated persons in the subtleties of high art, the useful object gives the artist a lesson in humility by reminding him of the common feeling for human "convenience" that he easily forgets, intoxicated as he is by abstraction and purely intellectual research. From another point of view, painting is so humble that although it is the most complex art that exists, demanding the most diverse competencies from those who cultivate it, it preserves the artisan in that state of enthusiasm necessary to all creation.

It was while searching in painting to achieve the sharpest color contrasts—according to laws known to the ancients, forgotten for two centuries, rediscovered in part by Delacroix and codified by the genial Seurat, theoretician of *simultaneous contrast*—that Mme. Delaunay discovered, among other things, the abstract ornamentation which we need so much and which gives so fresh and joyous an appearance to dresses and scarves which adorn contemporary women of fashion. More than representational themes, more than bouquets, garlands, butterflies, this ornamentation is a serene architecture and yet attractive with geometric forms arranged according to an easily perceived rhythm.

Caressing hands *(La fleur des mains)* can now be placed on a sky-blue square, contrasting with a streak of beige thread, a distant muted complementary: they can no longer be confused—these hands with the ornaments which surround them. The sinuosity of a calf can be shown under a skirt ornamented with right angles—even thus the viewer would be able to taste the pleasure of simultaneous contrast. I imagine that the hoop skirts of Louis XV *(les paniers Louis XV)*, the 1830 look, the

Second Empire leg-o'-mutton sleeve were invented so that at the moment a woman, finally delivered from them, stepped out of this factitious corsetry, she seemed endowed with even more precious attractions for having been so knowingly dissimulated. The military art of camouflage always existed—we must admit that it is one of the most effective of gentlemanly stratagems. During a period when fashion sometimes indiscreetly revealed the bodies of our contemporaries it was necessary that the little bit of cloth covering them be decorated with the most abstract forms in such a way that the eye was instantly attracted by different figures than those which were revealed in intimacy.

There is much that one can say about the relations that join the art of costume—as Mme. Delaunay understands it—and modern plastic art.

We know that in order to intensify the expression of their surfaces, the cubists often had recourse to contrasts of materials. The smooth part of a picture was contrasted to a granular surface. They went so far as to introduce sand into the paste which covered certain portions of the picture. I am familiar with *assemblages* of different kinds of material: fur, open-stitch wool embroidery, silk, are employed ingeniously by Mme. Delaunay, who brings to the eye a comparable pleasure, that is to say, a tactile pleasure.

Sonia Delaunay must be thanked for her continuously varied invention, for the modest gaiety she has introduced into women's clothing, for the gentle manner in which she has taken the soft undulations of the human body from geometric architecture, for the precision and unexpectedness of her colored contrasts. At this time when the Exposition des Arts Décoratifs appears to uniformed eyes to be the world's homage to cubism, it is necessary to thank it above all for having forced the public by a most agreeable ruse to consider in spite of itself the most fertile pictorial manifestations of modern times.

BLAISE CENDRARS: SIMULTANEITY (1924)

Simultaneity was discovered in 1912 in Delaunay's Fenêtres, *for which Apollinaire wrote his celebrated poem. It was already in formation or transition in* La Ville de Paris *(1911), the* Villes *(1909), in the series of*

Tours *(1910) which influenced Cendrars's poem "The Tower" (1910),* (Dix-neuf Poèmes Elastiques, *Editions Au Sans Pareil). (In Apollinaire's* Aesthetic Meditations, *the first book on cubism, these pictures are classified as a second tendency of cubism.)*

It was the spirited reaction of color-for-color on the chiaroscuro of cubism. Cendrars called the vocation of simultaneity "the simultaneity which corresponds specifically to the state of plastic sensibility that is opposed to any return to imitation of nature or of outdated styles." He has written on this matter in Bulletin de la Vie Artistique.

Our eyes extend to the sun. This contrast is not that of a black and white, but on the contrary, is a dissimilarity. The art of today is the art of profundity. The word *simultaneity* is a term of vocation. Delaunay employs it when he works with everything: harbor, houses, men, women, toy, window, book; when he is in Paris, New York, Moscow; in bed or outside.

Simultaneity is a technique, simultaneous contrast is the newest perfection of this vocation and technique. Simultaneous contrast is from the most profound point of view—reality—form—construction—representation—life. Its profundity is new inspiration. One is aware in this profundity that I am there—the senses are there—and the spirit.

GUILLAUME APOLLINAIRE:
THE SEATED WOMAN (1914)

An article published in Mercure de France.

One has to go to the Bullier on Thursday and Sunday to see M. and Mme. Robert Delaunay, painters, who are in the process of transforming clothing.

Simultaneous orphism has produced innovations in dress which are not to be sneered at. They would have supplied Carlyle with a curious chapter in his *Sartor Resartus*.

M. and Mme. Delaunay are the innovators. They do not burden themselves with the imitation of antiquated fashion, and since they want to be of their own time, they don't innovate in the cut of clothing (in that they follow contemporary fashion), but rather seek to influence it by employing new fabrics which are infinitely varied with color. There is, for example, an outfit of M. Robert Delaunay: purple jacket, beige vest, black pants. Here is another: red coat with a blue collar, red socks, yellow-and-black shoes, black pants, green jacket, sky-blue vest, tiny red tie.

Here is a description of one of Mme. Sonia Delaunay's simultaneous dresses: purple dress, wide purple-and-green belt, and under the jacket, a corsage divided into brightly colored zones, delicate or faded, where the following colors are mixed: antique rose, yellow-orange, Nattier blue, scarlet, etc., appearing on different materials, so that woolen cloth, taffeta, tulle, flannelette, watered silk, and peau de soie are juxtaposed.

So much variety cannot escape notice. It transforms fantasy into elegance.

BLAISE CENDRARS:
ON HER DRESS SHE HAS A BODY (1914)

The woman's body is as bumpy as my brain
Splendid
If you become incarnate with spirit
Dressmakers are in a stupid line
As much as phrenology
My eyes are kilos that measure the sexiness of women

Everything that runs away, advances by leaps into the depths
The stars go thoroughly into the sky
The colors undress
"On her dress she has a body"

Under the heather arms the half-moon and pistil hands
 when the waters shoot themselves out into the back
 with the glaucous omoplates
Belly a disc that moves
The double shell of the breasts goes under the
 bridge of rainbows
Belly
Disc
Sun
Colors' perpendicular cries fall upon the thighs
ST. MICHAEL'S SWORD
There are hands that extend
In the dress's train there is a beast all eyes
 all fanfares all the habituées
 of the Bal Bullier
And on the hip
The poet's signature

ANOTHER VERSION OF
"ON HER DRESS SHE HAS A BODY,"
SIMULTANEOUS DRESS (TO MME. SONIA DELAUNAY)

*Note the changes in the two versions of the poem by Cendrars: a single
fabric presented in two colors. The idea of colors undressing "par con-
traste" is introduced in the later version and reminds us of the contrast
in Delteil's poem "The Style That Comes to Mme. Sonia Delaunay"
(1924), which quotes the original version of Cendrars. In both versions
the poet signs his name on the hips, but there are subtle stanzaic varia-
tions, the last version having one fulcrum alone, the earlier version
separated into more conventional patterns. "On Her Dress She Has a
Body" was included in* Dix-neuf Poèmes Elastiques, *1919; the "Simul-
taneous Dress" (second version) appeared in the* Europa Almanach
(Potsdam: Gustav Kiepenhuer, 1925). Both are dated 1914.

On her dress she has a body
The woman's body is as bumpy as my skull
Splendid if you become incarnate
With Spirit
Dressmakers are in a stupid business
As much as phrenology
My eyes are kilos weighing the sexiness of women
Everything with bumps leaps into the abyss
The stars go thoroughly into the sky
The colors take off their clothes through contrast
"On her dress she has a body"
Under the heather arms
The half-moon and pistil hands
When the waters pour themselves into the back
 with the sea-green scapula
And the double shell of the breasts goes under
 the bridge of rainbows
Belly
Discs
Sun
And colors' perpendicular cries fall upon the thighs
St. Michael's sword
There are hands which extend
There are in the train of the dress a beast,
 all eyes, all fanfares, all the habituées
 of the Bal Bullier
And on the hip
The poet's signature

Robert and Sonia Delaunay with their infant son, Charles, who was born in January 1911.

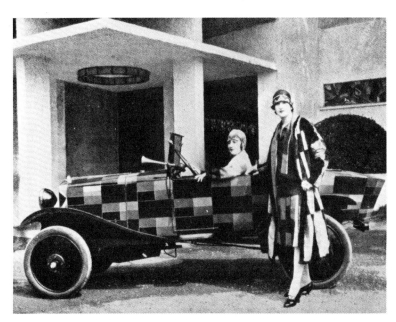

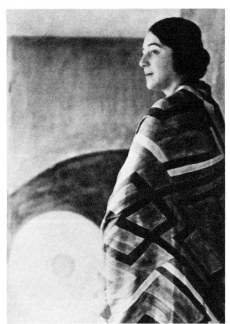

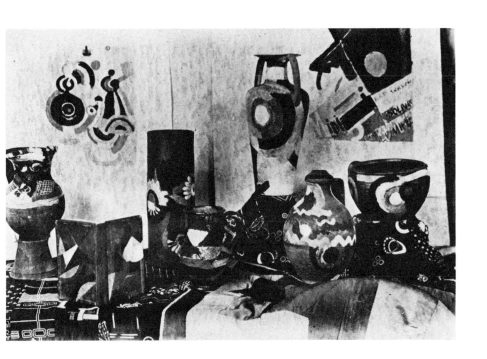

Atelier of the Delaunays at Vila do Conde, Portugal, during 1915. At the left, on the wall, is Sonia's painting, *Jouets portugais* (Portuguese Toys); at the right, the first of her series of paintings, *Zenith*, inspired by a poem of Blaise Cendrars; on the table, peasant pottery decorated by her; and standing to the left, a copy of *The Complete Poems of Jules Laforgue,* covered with a collage by Sonia Delaunay.

Opposite, top: Hand-painted designs for dress, coat, and automobile by Sonia Delaunay, 1925. The automobile is a Citroën B12.

Opposite, bottom: Sonia Delaunay in hand-painted robe in front of her drawings, 1925.

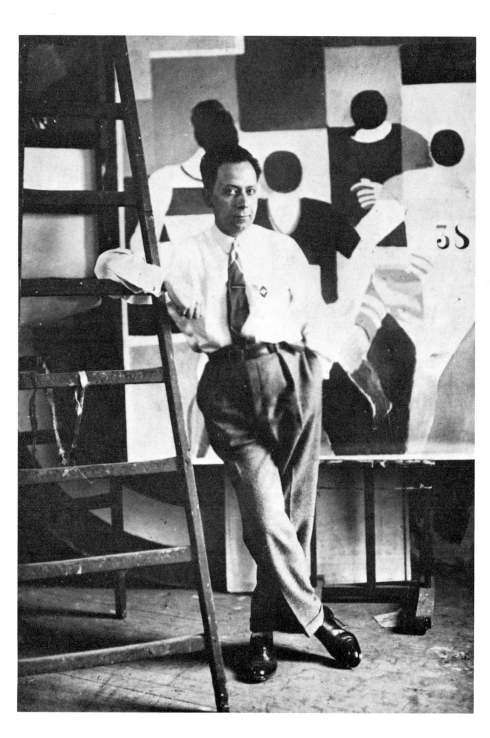

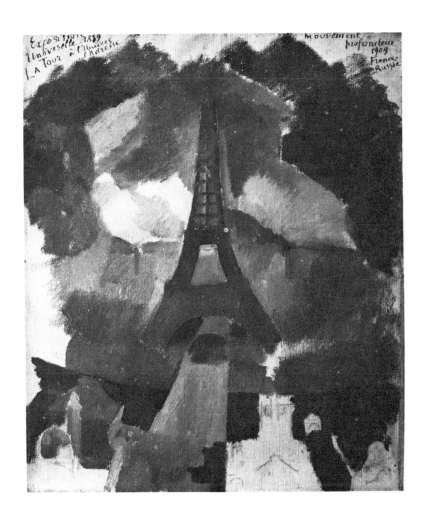

Robert Delaunay's painting, *La Tour* (1909), which celebrated his meeting
with Sonia Terk-Uhde. The inscription at the upper left and right marks
this sentiment, indicating both the opening of the Eiffel Tower in 1889 and
noting the union of France and Russia in their meeting of 1909.
Opposite: Robert Delaunay in his studio in front of his painting, *Les Coureurs*,
1926.

Top: The manuscript of Robert Delaunay's essay, "La Lumière" (1912), which was first published in a translation by Paul Klee in Walden's *Der Sturm* at the beginning of 1913.

Bottom: Robert Delaunay's *Portrait of Guillaume Apollinaire*. (Unfinished; Paris, 1912; oil on canvas.)

Opposite: During the Delaunays' Thursday-evening salon, canvas was sometimes affixed to a door for the amusement of visitors. On this occasion it was painted with a poem by Vladimir Mayakovski, which would date it during the early 1920s. The canvas was recently found at the Delaunays' country farmhouse, which had not been visited since the outbreak of World War II. (Photo by Robert David, Paris.)

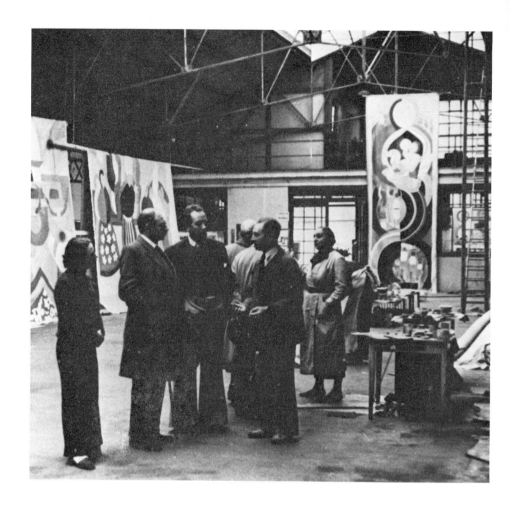

Robert and Sonia Delaunay in their atelier near the site of the Paris Exposi-
tion of 1937, where both artists were completing mural-size paintings for
installation.

Top: Catalogue of work by Robert Delaunay, handwritten by him on special letterhead designed by Sonia Delaunay (1913), and executed in *pochoirs*.
Bottom: Robert Delaunay's maquette drawing for a portfolio, *Album*, which was to have been published during the Delaunays' stay in Portugal. The project was never realized, however. (Photo by Etienne Hubert.)

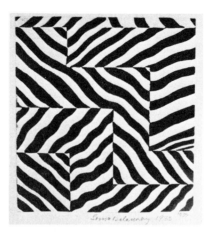

Top: Sonia Delaunay. Drawing in India ink on paper (1933).
Bottom: Sonia Delaunay's studio in her Paris atelier, 1973. (Photo by Elaine Lustig Cohen.)
Opposite, top: Sonia Delaunay and Arthur A. Cohen in the artist's studio, 1973.
Opposite, bottom left: Robert Delaunay. *Robe simultané, construction électrique* (1913). *Collé* with *pochoir* on paper.
Opposite, bottom right: Robert Delaunay's sketch for a cover for Robert Loeb's *Broom,* which was never used (Paris, 1914). (Photo by Robert David.)

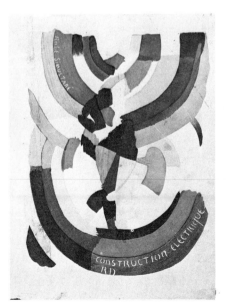

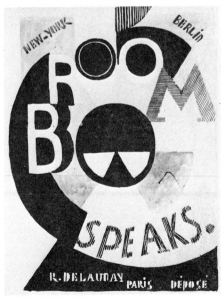

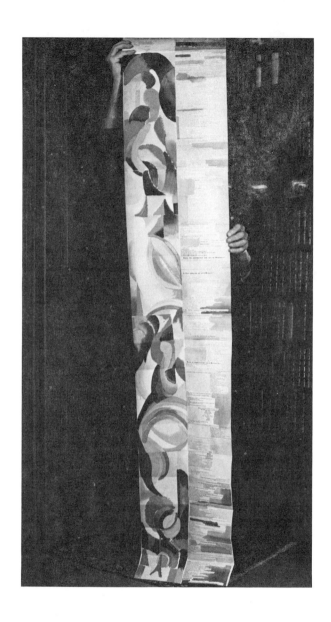

La Prose du Transsibérien unfolded. This first "simultaneous book"—a collaboration of Sonia Delaunay and Blaise Cendrars—consisted of one sheet of paper, folded accordion style. Unfolded, it measured two meters (c. 79″).

CLAIRE GOLL: SIMULTANEOUS CLOTHING (1924)

"Simultanische Kleider," Bilder Courier *(Berlin: April 1924). Translated from the German by Joachim Neugroschel.*

Art is always the expression of an era. It is the language through which people most intensely experience their times and convey a new spirit to the world. Artists are forerunners. Sometimes they are twenty-five years ahead of their contemporaries, sometimes only ten or twenty. Into just a few works of art they pour the contents of what will be the daily fare of later generations. These works of art, at first incomprehensible to the masses, are subsequently disseminated by them. This is how a new direction comes into being. It quickly leaves the narrow path of art itself and expands throughout all areas of life. (Not to be confused with stylization, which very often is a mere coverup for lack of style.)

The last great style of the previous century was the so-called Jugendstil, art nouveau, an atrocious, unrhythmic chaos of arabesques.

There followed the German school of expressionism which produced a new style that is now current in all the artistic activities of public life—scenic design, architecture, interior decorating, etc. Probably no revolutionary art has ever gone so far so fast.

In France we are similarly witnessing a new expansion of artistic possibilities. Ever since the day the painter Claude Monet exhibited a picture entitled *Impression*, people have been suffering from impressionism. Its impersonal countenance left a stamp of insipidity on all things. Then came the explosion: cubism. But it's only now, fifteen years after the invention of that new ism, that we are witnessing the cult of pure color, the yearning for forms and construction in everything around us, last but not least in fashion. The couturiers of Paris have finally gotten up enough nerve to throw convention and historical tradition—which they honored until now—overboard. They have finally abandoned Louis XIV and every other Louis and their epigones and are trying to create the right kind of clothing for our time. Sports, automobiles, air travel, and electricity have been our godparents. Shouldn't we be dressed in a manner befitting these legacies?

The first people to truly sense this were the great painter Robert

Delaunay and his wife, Sonia Delaunay-Terk. In 1910, Delaunay sparked a revolution in art with his deformed *Tour d'Eiffel*, inspiring countless followers in France and particularly in Germany; and now Sonia Delaunay is evoking a revolution in women's wear with her fashion creations. Make no mistake about it: clothing too is a work of art! A Paris designer is not exaggerating when he calls each design of his a *creation*.

It was Matisse who evolved what the impressionists had done, and now the Delaunays are evolving what Matisse did. They have re-created form through color, which they manipulate like musical notes—for every color changes according to the colors surrounding it. They surround every color tone with other tones that endow it with a maximum strength although they remain subject to the dominant color. They have been making wide use of the discs and the semicircle. They work with simultaneism of colors. With the contrast produced by black and white, or by confronting red with a previously forbidden ultramarine. And the results are wholly new vibrations.

Diaghilev's Ballets Russes, for which Bakst and Sonia Delaunay had worked, was gradually preparing the Paris public. After all, Sonia Delaunay, like all Russians, is filled with an atavistic love of colors.[2] They took academic bleakness and dullness, which had done nothing in terms of color but schematically fill out the exterior drawing, and struck it with barbaric gaudiness. What they brought to the French was imagination—something that the French so often lack. At first, of course, Parisian women firmly resisted, since they love to wear black. But Sonia Delaunay, with the beauty and joy of these creations, finally got the Parisians to "join the colors." And today, practically all the great couturiers in Paris are among her steady customers.

Using the principle of simultaneism, which the two Delaunays had first applied in art proper, she now created objects for everyday use; after all, the demand for renovation was by now universal.

The space in which we live, the rooms in which we celebrate, daily apparel and evening wear—she left the mark of joy and good cheer on everything. How can we draw vitality from a dusty room with dusty velvet drapes and traditional massive furnishings in dark-brown oak?

2. This reference to Sonia Delaunay's atavistic sense of color is derived from Robert Delaunay's discussion of his wife's achievement.

The simultaneist room is still young, however. The sycamore furniture is beaming in its bright design, the solar spectrum is caught in the carpet, and the woman here is radiantly reflecting it in her colorful dress. The black, white, and red stripe runs down her almost like a new meander, giving her movements a rhythm of their own. And when she goes out, she dons the delightful mole-coat, which is covered with colorful wool embroidery, so that it almost looks woven. Its harmonic lines are filled in all nuances of brown, rusty red, and violet. When receiving her friends, she wears a tea gown, in which a gaudy triangle cheerfully keeps recurring. But in the evening she wears the coat that is worthy of the moon and that was born of a poem; for the geometric forms of the alphabet were used by Sonia Delaunay as an unexpected ornament, so that now instead of saying that a dress is a poem we can say: This poem is a dress. Sometimes she even weaves a verse in large letters inside an evening cape, or the wearer can openly acknowledge her favorite poem by wearing a quotation from his work, delicately embroidered in wool on a sash. For Sonia Delaunay not only uses the strangest material, she particularly brings out its spirit. Thus, through her daring colors and forms she not only gives us sensual pleasures, she also and especially educates us toward a new style. Simultaneism has begun its voyage through the world.

RENÉ CREVEL:
A VISIT TO SONIA DELAUNAY (1920?)

René Crevel's essay ("Visite à Sonia Delaunay," La Voz de Guipuzcoa [Bibl. No. 122], translated from the French by the editor) is dated 1920, but the date has to be incorrect, since Tzara's Le Coeur à gaz *(The Gas-Operated Heart), to which Crevel refers below, was not presented until 1923. Crevel, one of Tzara's youthful followers, had performed in* Le Coeur à gaz *with Jacques Baron, Pierre de Massot, and others during July 1923 at the Théâtre Michel. Cf. Motherwell,* Dada Painters and Poets *(New York: Wittenborn, 1951), p. 192. Also, Elmer Peterson,* Tristan Tzara *(New Brunswick: Rutgers University Press, 1971), pp.*

77–78, for description of the fight which broke out between dadaists and surrealists on this occasion.

With friends, we staged a production of *Le Coeur à gaz*. Tristan Tzara had brought us together to repeat it at the Delaunays. At the entrance to their apartment there was a surprise. The walls were covered with multicolored poems. Georges Auric, a pot of paint in one hand, was using the other to paint the notes of a marvelous treble clef. Beside him, Pierre de Massot was drawing a greeting. The master of the house invited every new guest to go to work and made them admire the curtain of gray crêpe de Chine on which his wife, Sonia Delaunay, had through a miracle of inexpressible harmonies deftly embroidered in linen arabesques the impulsive creation of Philippe Soupault with all his humor and poetry.

Gaiety and high spirits are rare qualities. When they produce intelligent activity they cannot be honored too much. After five minutes at the home of Sonia Delaunay no one is surprised to find that it contains more than a certitude of its happiness. It is finally not a matter of conversation, sentences, the lure of discussion in which a bit of sophistry easily triumphs over directness; rather you enter the home of Sonia Delaunay and she shows you dresses, furniture, sketches for dresses, drawings for furniture. Nothing that she shows you resembles anything you have ever seen at the couturier's or at furniture displays. They are really new things, but the sense of never having seen something before (which ordinarily accompanies contempt) is here quite simply optimistic. You see new things and already you love them as unexpected fruits whose color, substance, shape can only tempt taste and curiosity.

Finally, then, for those who are bored, weary of systems, old-fashioned triteness and the latest thing, of imitation styles, of days without light, and factory clothing; for those who are exasperated in their banal homes—totally tidy except for a bit of fabric, the corner of a wall, a scarf or a vest on a piece of furniture that assume a touching, human look like a smile, or are as simple as a beautiful animal; for those who cry out in distress, submerged beneath floods or black or gold lamé, crushed beneath the blocks of sculpture which are already hopeless; to those who can no longer bear the unwieldy, the grotesque, the foolish lies which are thrown at the heads of casual strollers under

the pretext of modernism; to those who refuse the vanity of aesthetic verbiage; to those who wish to see work and joy; to those who take pleasure in action—the best criterion of honesty—without which nothing can be seriously undertaken; to those, to all of those, I advise: "Call Sonia Delaunay. ÉLYsées 10–88, and make an appointment for this afternoon."

If I had a topographic sense I would give you a description of their apartment. Unfortunately I can only say that the dining room is on your immediate left, and I would add that it is the domain of Robert Delaunay, first, because of his beautiful appetite, which Philippe Soupault admires so much, and because his paints are arranged there. He works in that room. The door to the living room is directly in front of the door leading upstairs. It was on that door that Georges Auric and Pierre de Massot had signed in their entrance at the time of my first visit. I disturbed the Delaunays pitilessly. I penetrated the room reserved for Sonia Delaunay. This room had yet to be arranged. Sonia Delaunay had not had time and assuredly she would not, for an instant, have dreamed of asking others to look for the fabrics or the furniture for it. A creator, how could she possibly allow a stranger to design tables or sitting chairs? Familiar things, the things of daily life, are poems, and these, freed of hierarchic prejudices, are not considered by Sonia Delaunay essentially inferior to paintings. How could she allow others to be responsible for familiar objects and things of daily life?

When I entered her home, Sonia Delaunay was finishing the design of the costumes which we were going to wear in *Coeur à gaz*. These costumes were very simple, "perfectly sensible," I was going to write. I realize that they were not at all made—as the current expression goes— from bits and pieces. They were created under the crayon—composed and final. They were costumes which scarcely resembled those that could be imagined up until then—their direct audacity was immediately im- pressive. Once more it was demonstrated that spontaneity of inspiration was the only thing worth being realized. Please excuse so many nasty words in such a small sentence, but speaking of immediate synthesis would be hardly an improvement. How is one to speak of each creation by itself when Sonia Delaunay had made a unity? There is color, material, and also muscle and bone. Her furnishings are skeletal out- lines, her dresses are only pretexts to embellish the body. Sonia Delaunay dresses only in the strictest sense—a woman goes forth from her. Can

it be said whether she takes part in her clothing or whether her clothing takes part in her body? She creates, but what she creates is less than a dress, a scarf, than a new person. It could be imagined that she takes from I do not know which mysterious cabinet the adornments destined to such-and-such a woman and which is the source for all her particular nobility and grace.

The great periods in fashion have never been times of rags and tatters nor those of *franfreluches* either. Before the war there was an abominable word that we used often: *chichi*. A desire for amplitude makes us hate today useless details and their stupidity—the love of life which proves that despite specific trials and often frenzied impatience, we are maintaining ourselves well, making ourselves comfortable without *chichi*. Everything is becoming suitable. There is a theoretical agreement. Misfortune is very attentive to politics, absorbed by questions of education. The great promises which we made have not been fulfilled at all. Perhaps the reason is that in spite of good will a sense of respect was lacking, a sense of respect which was invoked only during the Barrés trial.

Sonia Delaunay has such a sense of respect. What is it that she respects? Health, light, simplicity. She detests morbid postures, humid density, complications. She has done the reasonable which is more noble. Sonia Delaunay has known artists, poets, painters, sculptors. She has seen movements come into existence and schools created. She has loved, argued, fought them. Never has she complacently accepted them. She has been obedient only to her secret law, her interior rhythm. It has never been, in her case, a question of loyalty to one group or another.

What are her goals, you will ask? She has none, she never had one, or rather, she has had only one and never more than one: to work for her own pleasure and not to dream of charming or scandalizing the public. From this derives the independence and unity of her creation. She has taste for color, and no reckless taste in color or worthless violence cause her to waste her time. For instance, she conceives a handbag: to realize the final harmony she has to consider a thousand and one shades of color—she gathers them as easily as simple flowers from a garden which yields to her, to her alone, and because she does not ask her neighbor's opinion, her bag has the air of unique thinking, of a perfectly natural thing, of a precious stone, or of an animal, let us say, of a scarab. She carries it to you in her hands. And you long to caress it, to flatter it, to speak with it, and isn't this exactly what one means by living a life?

We have enough beds in which one does not wish to make love, enough dining rooms where one loses one's appetite, armchairs where one has no wish to sit. We must thank S. D. for her dresses, which we want to offer to the most cherished bodies so that they might console us, bodies which we do not always desire before us appealingly naked. We must thank S. D. many times for not being content to celebrate fabrics or scarves in place of women. She has designed very beautiful furniture. I want to recall especially a large square table which could not be more simple and more perfectly proportioned, which she will excuse me if I cannot describe as a painter of colors, but as a poet of verse. I want to thank her again for having suppressed hierarchic prejudice in favor of abundantly loving life, magnificent life, and for offering us masterpieces that embellish our daily gestures. Sonia Delaunay has worked hard since the day when Apollinaire congratulated her and her husband in his "Seated Woman" for wanting to renew fashion. But she has not committed the error of currying approbation from aesthetics. She has not thought about Montparnasse or its little *cénacle* of worshipers. She goes toward the people. I affirm it. She goes toward the unfeeling crowd.

IV.
Sonia Delaunay

The writings of Sonia Delaunay are few and far between and virtually all of her writings have been translated and published in this volume. The paucity of her writing is not a simple reticence (although she would probably agree with Matisse that painters should have their tongues cut out), but rather that she considered her work sufficiently interpreted by her husband so as to require no further explication by her. It is clear that until 1953, when she had her second one-man show at Galerie Bing in Paris (the first having been at Uhde's gallery in 1908), she was principally occupied with establishing the reputation of her husband's work. After his death in 1941 she was responsible for ensuring his retrospectives, attending to the details of the various homages that were tendered to his achievement, arranging his archives, supplying Francastel with the material for his edition of Delaunay's unpublished writings. But throughout this period—indeed from the very beginning of her career—she painted. Even her work as a designer of fabrics and woman's fashions, her graphic design and her interiors were so many exemplifications of research that she pursued in painting. As a result her writings were confined to explications of her work as a decorative artist rather than to discussions of her views of painters and painting.

The interview with which the selection of her writing concludes was conducted by the editor in 1970 and reveals that her passion and conviction, always articulate, were in fact instinctual and immediate, unconcerned with locating herself in history, in theories of painting, and single-mindedly preoccupied with making the work and allowing it to stand as its own documentation of her authority and place in the modern movement.[1]

1. See Arthur A. Cohen, *Sonia Delaunay* (New York: Harry N. Abrams, Inc., 1975), which contains the most complete assessment of her achievement now available.

Sonia Delaunay
by Sonia Delaunay (1967)

This autobiographical text, which appeared in the catalogue of the retrospective of Sonia Delaunay's work at the Musée National d'Art Moderne, Paris, 1967–1968 (pp. 13–15), moves from the third person, in which it begins, to the first. This flavor of the original has been preserved without alteration.

Since she began to paint, the pictorial research of Sonia Delaunay has been directed toward the purity and exaltation of color. From her very first works, she has tried to impart the maximum of intensity to color. Her spiritual masters were van Gogh for intensity and Gauguin for the investigation of planar colored surfaces.

1903–1904

Happily, before her arrival in Paris in 1905, she had spent two winters in Karlsruhe in Germany studying with a professor of drawing. He taught not only drawing, but the structure of plastic expression in a highly disciplined manner. She even attended courses in anatomy in order to study skeletal structure and musculature of the corpses. This discipline has marked her work thereafter, forcing it to have a constructive basis which imparts force to plastic expression, and eliminates chance, indecision, and mere facility.

During this period all sorts of artistic movements had their day. There was impressionism, which spread like a flower in full maturity and was of a sublime purity. But its foundation was old-fashioned and descriptive. It is only with Seurat that color dominates the subject with its purity of expression.

1907

In her pictures of 1907, Sonia Delaunay achieved an extreme exaltation of color with complete flatness. Even Matisse had not yet freed himself from chiaroscuro in his beautiful pictures of that time. Linear contour persisted in his work. Such linear contour—the thread which connects the new vision to the past—is broken by the cubists who destroyed the vision of the object by attempting to seize it from all sides, pursuing even the ungraspable fourth dimension.

1909

Though I did not participate in it, cubism excited me and I knew its development and its history in great depth. I had lived it. I had followed it, beginning with Derain and Vlaminck, who, influenced by Negro art, had exhibited large and beautiful canvases at the Indépendants, along with the first cubist suggestions of Braque and Picasso . . . (I was still married to Uhde and we had thirteen canvases of this period by Braque which I loved enormously). At the same time Picasso painted his *Demoiselles d'Avignon*, clearly influenced by the canvases of Derain and Vlaminck. He possessed a character and force which was only betokened by these painters.

It was during this period that I met Delaunay and our lives became tied together. The passion of painting was our principal bond (Apollinaire, who lived with us later for several weeks—before he moved to 202 Boulevard Saint-Germain—said, "When the Delaunays wake up they talk painting."

At this time, after a neoimpressionist period, Delaunay began his *Tours*, his *Villes, Saint-Séverin*. Little by little, the realistic subject disappeared and its place was taken by color, which itself became the subject. I did not take part in these investigations, but they inspired me to play freely with color: a coverlet for the bed of my child, book bindings, *papiers collés* and the *Transsibérien*, the beautiful poem of Cendrars where colored rhythms accompanied the poem in complete harmony. (It was the first picture-poem.) There were also a considerable number of studies for the large picture—including the *Tango* (those which are in the Musée d'Art Moderne in Paris and at the Museum in Bielefeld). In the fall of 1913, there was a large exhibition in Berlin—the Herbstsalon —where my works of this period were shown: pictures, book bindings, *Transsibérien*, along with works by Robert Delaunay, the futurists, the German painters, Marc, Macke, Klee; and Chagall, whom we had arranged to be invited, etc.

1914

The following year was the *Prismes électriques* with its numerous studios, the large picture, *Prismes électriques* (Musée d'Art Moderne, Paris) was shown at the Salon des Indépéndants at the same time as Robert Delaunay's *Hommage à Blériot*.

1915

Then came the trip to Spain. Revelation of Spanish light which caused every color to vibrate, without the gray haze that envelops them in

France. It was the point of departure for a new song celebrating colors, their contrasts and dissonances. Studies after nature. I took up the movements of dance (tango, flamenco), which means the movement of color. *Rhythm* was introduced into painting by color (Gleizes spoke much later about "time" in painting. He had discovered rhythm). This movement was not descriptive as it was with the futurists, but purely plastic, optical, and lyric. The stay in Spain and Portugal intensified this vision, enriching it with the violence of the light—stripped as it is of gray—of these countries. Color was exalted. I discovered the truth of what Delacroix had written in his Journal—even though I had never read it—that in every pictorial rendering—even in the white of the painting ground—purity and transparency of colors enrich and enhance the possibilities of pure expression. In this spirit, I painted *Le Marché au Minho* [The Market of Minho], a picture inspired by the beauty of the countryside. I also undertook a series of studies in order to realize a more balanced and severe construction, never descriptive, only plastic, colored.

In 1917, having lost (without regrets) our regular income from the rents of eighty apartments in a building in St. Petersburg that had assured us a certain wealth, we persevered despite the difficulties of living in a country (Spain) where we had no home, knew no one, did not speak the language, and had no money. Our ingenuity and talent enabled us, however, to make things that enjoyed a great reception in that country.

Having met Diaghilev, who liked us, in Madrid, I was introduced by him to two persons eminent in Spanish society, and through them I was able to work at earning our livelihood.

Delaunay rented an atelier immediately since his pessimistic nature was not suited for difficult times. He plunged into making large works. In contrast, I was very successful, and, finally, through the intermediation of an English bank, a silent partner (who owned thirteen Goyas and a Velázquez) offered me a store in one of his buildings in the best section of the city. I furnished it in a completely modern style, simple and white, but the prospect of remaining in Spain, where modern painting was ignored and had no share in life, did not delight us.

At this time we came into contact with the surrealists who had been corresponding with us. We had read the first manifestos of Tzara, which were completely in accord with our own ideas.

In 1921 we left Madrid for Paris (I reimbursed the backers of the

boutique, which had not opened). I continued to make sketches for the dance and dress-poems *(robes-poèmes).*

In 1922 Delaunay had an exhibition at Paul Guillaume, Rue de la Boëtie, with prewar pictures and those done in Spain and Portugal. The whole surrealist group was at the opening. Having kept only the atelier at Rue des Grands-Augustins, where we had lived since 1910, we looked for an apartment for nine months and finally set ourselves up on the Boulevard Malesherbes, where I resumed the activities I had started in Spain in order to support us. Delaunay, who was working only when he had something new to add to his development, uncompromising, had realized after his first sale to Léonce Rosenberg that we couldn't live on his art. It was the era of the surrealists: Soupault, Aragon, Breton, Tzara—all of whom became our friends.

Little by little, with great difficulty and by selling the Empire furniture that we owned, I designed new furniture and we relocated ourselves in the echelons of the modern movement. The abbreviated history of my activities during this period are to be found in the volume *Sonia Delaunay* published in 1925.[1]

In 1923, I was commissioned by a fabric house in Lyons to design some textiles. I made fifty designs—colored patterns with geometric forms, pure, rhythmic. For me they were and remained color scales, which were ultimately the purified conception underlying our painting. My studies were completely pictorial, and, from a plastic point of view, a discovery that helped both of us in our painting. Rhythm is based on numbers because color can be measured by its vibrations. This was a completely new concept that opened infinite horizons for painting and could be used by anyone who felt and understood it.

We felt it without being able to define it too clearly, since it occurred to me naturally, although I had been working unconsciously on these suppositions since 1916. They can be seen more clearly in my "rhythm-dance" pictures (1923) and Robert Delaunay's "endless rhythm" pictures of 1933 to 1934.

Having passed through this stage of inquiry which was never theoretical but based solely on my own sensibility, I acquired a freedom of expression that can be found everywhere in my recent work, in all the gouaches, which are expressions of states of soul; which are poems.

1. André Lhote, ed. *Sonia Delaunay, ses peintures, ses objets, ses tissus simultanés, ses modes* (Paris, Librairie des Arts Décoratifs).

The Poem "Easter in New York" (1962)

The poem "Easter in New York," which Cendrars brought to us shortly after we met him at Apollinaire's, moved us so profoundly that from then on until the war he became part of our life.[1]

His life was his poetry. He lived it the way that Delaunay and I lived our painting.

The *Tours*, the *Fenêtres*, Delaunay's *Formes circulaires*, my book bindings, the *Bal Bullier*, and finally the *Transsibérien*, which Cendrars wrote at that time and which I complemented with a colored vision two meters high—that was our life.

The three of us created the beginnings of a new vision of the world that toppled earlier conceptions in the plastic and poetic arts.

This intense creativity was so much a part of our lives that none of us were capable of dissimulation—the key to the rapid success of many of our contemporaries. Dissimulation or publicity never even occurred to me when I presented my simultaneous dresses, sewn with small pieces of fabric that formed patches of color, which produced such a sensation. Cendrars wrote a very beautiful poem about them: "On Her Dress She Has a Body."

His death has upset me tremendously. Cendrars represented to me one of the most luminous moments of my life. With his passing the shadows gather again.

Little by little it will be realized that Cendrars was the truest and greatest poet of our time.

1. Blaise Cendrars, *Mercure de France* (1962), p. 163.

Rugs and Textiles (1925)

This essay was first published in L'Art International d'Aujourd'hui, *no. 15, Paris, Editions d'Art Charles Moreau, 1929.*

This work is intended to present a selection of the fabrics and textiles that reflect the persistent characteristics of the emerging style of our time. We apologize for omissions, but source research was difficult; a number of artists could not be contacted, and numerous photographs were lacking in sharp definition; however, we believe that we are presenting a selection that is sufficiently representative of actual production.

Each era finds its expression in a style. It is interesting to distinguish within a multitude of contemporary manifestations the more or less temporary fluctuations that make up the principal elements of expression and that create the style.

It is not our intention to represent the majority of actual production. On the contrary, it is the minority which succeeds in forming the taste of the general public.

The production of this minority answers to the needs and tastes of the multitudes. However, the introduction of this mass of people is inhibited by routine-minded intermediaries whose public vitality, in the long run, justifies itself.

Style is the synthesis of practical necessities and the spiritual condition of an epoch. We want to examine the sources from which this selection proceeds and the more serious movements of our life to which it is connected.

Our era is above all mechanical, dynamic, and visual. The mechanical and the dynamic are the essential elements of the practical dimension of our time. The visual element is the spiritual characteristic of it.

The spiritual element of a style develops through the mediacy of individual visionaries who by their superior sensibility anticipate future times and express them in their creations. Unconscious of their fundamental role, they act upon the life that surrounds them and create a new vision of it.

Their visions become reality through the mediation of sensible elements that respond, and, under the pressure of these new horizons, seek to transform the reality about them.

The same simplification applies to the expression of objects, architecture, furniture, fashion, etc. Moreover, the aesthetic element accords with the practical.

The dynamism and speed of modern life require a synthesis. The example of mechanical achievements demonstrates that the true beauty of an object is not an effect of taste but is intimately tied to its function. Even this principle has been pushed to the absurd by theoreticians who proclaim the supremacy of utility while forgetting that the spiritual element has always been indispensable to man and that we owe to it the most beautiful human creations.

The simplicity of the forms and surfaces of objects leads to an inquiry into materials and the decorative dimension of surfaces. It is for this reason that we take part in the renaissance of the decorative dimension of cloth, fabric, and, in the near future, of mural painting.

Great plain surfaces, without any relief decoration, suggest an element of fantasy which is provided by textiles, wall hangings, etc. Small tables placed against walls do not go with architecture. Only wall decoration in its architectural form is impressive.

Planar decoration is connected with surfaces. It contributes to their expression; it creates forms which vivify the surfaces of objects. The elements of plane for decoration derive directly from pictorial research and are an integrating aspect of it. They are dependent upon the color relations between them.

Having conquered the opposition, the new style actually enters upon a novel and dangerous phase.

The diffusion of new forms and colors has its origin in the work of a small group of painters who, with different individualities, began about 1905 to free themselves from the worn-out forms of the past. Reaction against the decadence of complicated forms that had survived their time (until a period whose rhythm no longer corresponded at all to them) has led to a search for simplification.

The painters simplified the colored surface of objects by amplifying and exalting the splash of color, and the expression of drawing (Matisse and the fauves). This simplification evolved in the direction of expressing objects by planes. The object itself disappeared. The table became an abstract poetic composition. The object was more implied than expressed (Braque, Picasso, cubism).

But this period was destructive. Pictorial expression was simplified,

but it was negative. It prepared the ground for a new taste but it did not create a new vision, for it had destroyed expression of the object.

The true visionaries of modern times were Gleizes, Delaunay, and Léger. They were not stopped short by games of abstract forms. Freed from the past by their elders, they created a lyric vision, a vision of the future.

Delaunay discovered a technical means of giving new expression to color and form. By opposing planes through the principle of simultaneous contrast, he created a plastic means that expressed the profundity created by the relations of colors without having recourse to *clair-obscur* (chiaroscuro).

Plastic visions of modern cities, advertising, fashion—which had become the poetic leitmotif of our time—are now the basis of every visual expression of the applied arts and luxury industry. By trying to define the present style and indicating its origins it is necessary to recall those artists who have been denigrated and ridiculed for many years, and who were the anonymous precursors and inspirers of the contemporary style.

Certain artists try to rejuvenate their imagination or to hide their poverty of creation by employing geometry: new decoration applied to ancient foundations. Trapped like an arabesque, this approach is as false as every other derivative and new constructive ornament.

The characteristics of the new style in formation are, on the contrary, simultaneity of the colored expression of the surface forms of objects with maximum realization of their utilitarian employment.

LETTER (1926)

Letter from Sonia Delaunay, June 2, 1926.

Dear Sir,

As promised, I am writing in order to give you some technical information regarding my work.

The innovation of the designs that I sent you consists in the building

up of a unity composed of large surfaces on which floral elements are details. This approach is opposite to the impressionism which dominates most of the design industry that permits expression of the individual sensibility to be subsumed by any type of order. In my case, sensibility remains the principal factor, but sensibility is ruled by a rhythm that creates general order—that is, construction.

This rhythm is based upon color relations observed in their scientific interaction and classifiable according to Chevreul's laws of simultaneous contrast. These laws were the scientific discovery of Chevreul, who later verified them in practical experiments with color. My husband and I first observed Chevreul's laws in nature as we encountered them in Spain and Portugal, where the diffusion of light is the purest, and it is less overcast than here. Moreover, the quality of this light allowed us to go even further than Chevreul in finding dissonances in colored light, that is to say, rapid vibrations, which provoked greater color exaltation by the juxtaposition of specific hot and cold colors.

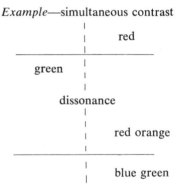

Example—simultaneous contrast

red

green

dissonance

red orange

blue green

We divide colors, or rather we divide the shades of colors into hot and cold.

We begin with a pure color element and create planes, forms, depths, perspectives through it. No longer line or chiaroscuro: these have been replaced by photography and its descriptive cerebral aspect. Painting and decoration have unique color relations which are able to re-create nature more truly and accurately than chiaroscuro. The color range conceived in this manner becomes a more vibrant reality.

Insofar as these color relations allow the physical action of colors to agitate anticipated responses in the viewer, color compositions ar-

ranged in gentle complementarities have a calming effect, while colors agitated by hot and cold dissonances provoke a stimulating response.

I hope that these notes, however clumsily expressed, will recall to you the conversations that we had together. You can see, however, after what I have said that any subject can be rendered with mastery and the personal quality of craft. I would love to prove it to you one day if you need an interpretation of the kind of composition that is more familiar to you than to me.

The Influence of Painting
on Fashion Design (1926)

Lecture given by Sonia Delaunay at the Sorbonne, 1926. This lecture, not published perviously, was translated from Mme. Delaunay's manuscript.

The question of the influence of painting on fashion design is narrowly connected with that of the technique of painting. It is principally from this point of view that I consider the matter.

Moreover, the subject is very large.

I will try to present a compressed synthesis of the pictorial development that interests us. Without making any pretense, therefore, of offering a history of modern painting, I must begin with impressionism and put in relief the facts that help us to understand the influences about which we must speak.

The revolution undertaken by the impressionists was anticipated, begun, and almost formulated by Eugène Delacroix. He was the starting point of the new visual sensibility. I mention the clear genius of Delacroix only in passing and move on to those who fulfilled what he anticipated.

Weary of convention, the impressionists put themselves squarely before nature as though before a new world. They allowed nature to act upon them. The rapprochement of painting and life begins with them.

Impressionism left behind convention and broke with the color sur-
faces traditionalized in academic tricks accumulated since the Renais-
sance. The direct sensibility of the eye trained on nature sought to
reproduce the multitude of elementary tones whose juxtaposition gives
the retina the sensation of a unique color.

An apparently uniform tint is formed from the unification of a host of
diverse tints perceptible only to the eye that is educated to see.

It is an atmospheric, not a synthetic vision.

It is the decomposition of tints into their multiple elements, caught in
prism colors, and then formed by elements of pure color.

Their palette becomes more simple and pure in order to achieve this
expression.

This is what is meant by optical blending *(mélange optique)*.

But the thorough destruction wrought by the new sensibility operates
on traditional foundations of drawing and chiaroscuro.

This is what Seurat, the first among impressionists who sought to
create an interior and constructive order for the picture, said: "Art is
Harmony. It is the analogy of contraries, the analogy of similarities of
tone, tint, that is to say, the red and its complementary green, the
orange and its complementary blue, the yellow and its complementary
violet . . . expressive means are the optical blending of tones, tints, and
their shadings according to very fixed laws."

Seurat remained finally attached to chiaroscuro. He did not succeed
in liberating himself completely from this conventional link although he
was the sharpest and most precise and visionary of the impressionists.
The gap between their time and our own can be clearly seen among the
neoimpressionists who attempted to systematize the principle of color
vision that the impressionists had found through sensibility.

The optical blend was, for the impressionists, a way of establishing
sight on scientific, but nonsystematic, foundations. And so we arrive at
a definition of the optical blend: a simple mixture of variously colored
beams of light at the same point on a screen. Just as a physicist can
reconstitute the phenomenon of the optical blend by the device of a
rapidly turning disc divided into sections of different colors, so can a
painter create a unique shade of color by the juxtaposition of multi-
colored daubs—the eye will not isolate the colored elements or the
daubs. It will perceive only the color that results from the light.

Cézanne belonged to the impressionists but was not satisfied with
analyzing the chromatic ensemble.

The mosaic of colors was not an end in itself for the impressionists, but a starting point for new constructive research.

Cézanne felt that conventional drawing was no longer appropriate to this new expression, and he pursued in his own investigations the idea that color changes correspond to movements on the plane. The planes create volume and mass. While seeking to create volumes, he enlarged the color daub and destroyed the shape and drawing of the object. It was Cézanne who began to break up the line as the impressionists had begun to break down color. The last attachment of painting to academicism ended with Cézanne. In him were all the possibilities of destruction and the promise of new construction. The doors were completely open to the investigations of the future.

During these long years, after the destruction had run its course, frantically liberating itself from every academic attachment in order to at last bring about a new construction, a really new beginning has occurred.

Matisse took up the task enlarged by Cézanne, rendering the relations of colors sharper—in effect, exacerbating them. This exacerbation of color concluded by deforming and breaking the line. The destruction was consummated and became harmonious. In his first canvases he even sought to get rid of chiaroscuro, and tried to achieve the effect of objects —themselves flat—on the surface plane, like a poster. In order to help himself in this way, Matisse sought inspiration in miniatures, Persian faïence, and types of popular decorative arts such as fabrics and toys.

After the dramatic struggle and search for precursors such as Seurat and Cézanne, Matisse liberated sensibility—in a manner perceivable to everyone—from the academic ties that hobbled it. Matisse showed the way in color to many sensibilities who did not have the gift of innovation but who were nonetheless able to free themselves in order to seek new arrangements of color and line.

From the Matisse group, Dufy emerged with an assertive personality. He brought together the influence of Persian faïence and wood engravings of the fifteenth century with the teaching of Cézanne. More than in his paintings or woodcuts, Dufy expressed his personality in a series of textile designs characterized by large fruit and flower motifs organized in a fashion similar to that of his pictures. These compositions possessed a pictorial quality, and although they were enhanced with decorative freshness, they were only copies or more or less conventional interpretations of patterns derived from earlier times. The fabrics of Dufy came

like a ray of sunshine clearing an overcast day. They were taken up by fashion to which they imparted a note of gaiety and the unpredictable, which had not been seen before.

Another painter whom Dufy influenced at this time, sufficiently so that at times they were indistinguishable, was Bakst, who, influenced also by Matisse, turned toward orientalism, which he updated and introduced into the theater. His costumes and set designs for the Ballets Russes were a revelation for the time in which they were executed—no less for the theater and costume design that they influenced through their new colors and their oriental inspiration. In addition they yielded a harvest of imitations. It is for this reason that such costumes were called thereafter "the Ballets Russes style."

Since Bakst was of a stature inferior to Dufy, the influence he exercised was of doubtful quality and his style of design went out of fashion very quickly without preserving the intrinsic quality of Dufy, whose decorative works—even his earlier work—retained their value.

There is another factor which contributed more than the vital quality of these two painters to the influence and adaptation of their creations to clothes.

Some time before the war, couture began to free itself from academicism: the corset and the high collar were dropped, all the devices of female clothing dictated by the aesthetic of fashion but contrary to the health and free movement of women were shaken off. The change in the life of woman provoked this revolution in feminine fashion. The woman was more and more active.

At present, fashion has become constructive, clearly influenced by painting. The construction and cut of the dress is henceforth to be conceived at the same time as its decoration. This new concept leads us logically to an invention that was patented by R. Delaunay and that was last used by me in collaboration with Maison Redfern.

It is the fabric-pattern (tissu-patron).

The cut of the dress is conceived by its creator simultaneously with its decoration. Afterward, the cut and the decoration appropriate to the form is printed on the same fabric. The result is the first collaboration between the creator of the model and the creator of the fabric.

All this is conceived from the point of view of artistic conception and of the standardization to which everything in modern life tends. The tissu-patron can now be reproduced literally on the other side of the world with a minimum of cost and waste of material. In marketing such

a product, the cut and accessory decoration is sold simultaneously with the length of fabric desired.

People who believe that real life is transitory are mistaken. They have announced confidently at the beginning of each new season that geometric design will soon pass out of fashion and be replaced by novelties drawn from older patterns. A profound error: geometric designs will never become unfashionable because they have never been fashionable. Bad geometric design is the untalented interpretation of copyists and minor decorators.

If there are geometric forms, it is because these simple and manageable elements have appeared suitable for the distribution of colors whose relations constitute the real object of our search, but these geometric forms do not characterize our art. The distribution of colors can be effected as well with complex forms, such as flowers, etc. . . . only the handling of these would be a little more delicate.

There is a movement which actually influences fashion as it influences interior decoration, film, and all the visual arts, and renders obsolete everything not submitted to this new principle that painters have been seeking for a hundred years. We are, however, only at the beginning of color research (full of mysteries still to be discovered), which is the basis of the modern vision.

We can enrich, complete, develop this color vision further—others beside ourselves can continue it—but we cannot return to the past.

SURVEY OF ARTISTS
ON THE FUTURE OF FASHION (1931)

This article was written in response to a questionnaire for HEIM, *a semi-annual review (No. 3, September 1931).*

Contemporary fashion does not reflect the direction of the art of this century.

Contemporary art has the courage to make a complete revolution and to start again on a new construction.

The art of our time is visual and constructive.

The craft of fashion is not yet constructive, but rather multiplies details and refinements. Instead of adapting the dress to the necessities of daily life, to the movements which it dictates, it complicates them, believing that it thereby satisfies the taste of the buyer or the exporter. For this reason skirts must be too narrow or too short or too long, and the skirt is not adapted to walking but walking to the skirt, which is nonsense.

Contemporary fashion ought to start from two principles: vital, unconscious, visual sensuality on the one hand, and the craft of fabrication on the other. Not inspiration derived from the past, but grappling with the subject as if everything begins anew each day. The future of fashion is very clear to me—there will be centers of creativity, laboratories of research dealing with the practical design of clothing in constant development parallel to the necessities of life. The investigation of the materials used and the simplification of their aesthetic conception will assume an ever-increasing importance. On these considered and executed foundations visuality and sensibility will have free play and engender their own fantasy.

The price of these perfected creations will reflect the value of the research of the product. They will be sold by industries which will themselves study lowering the costs of production by mass production and concern themselves with the expansion of sales.

In this way, fashion will democratize itself and this democratization can only be beneficial since it will raise the general standards of the industry.

It will also accomplish the abolition of the copy which is the real plague of fashion.

TEXT OF CATALOGUE OF
SIX PAINTERS AT GRASSE: 1940–1943 (1967)

"Six Artistes à Grasse, 1940–1943" was an exhibition of work by Jean Arp, Sophie Taeuber-Arp, Sonia Delaunay, Alberto Magnelli, Ferdinand

Springer, François Stahly, Société du Musée Fragonard, Musée Régional d'Art et d'Histoire, 1967. Translated by the editor.

A telegram from Sophie and Jean Arp asked me to come and stay with them in Grasse. I received the telegram in Montpellier. Delaunay's death had been announced in a moving article by Joseph Delteil in *Le Figaro*, November 1, 1941.[1]

I stayed in Grasse four years. The Arps had left for Switzerland. The Magnellis for Paris.

I stayed in Grasse with my Persian cat, which I carried with me everywhere in an open basket.

Pictures, personal belongings had been left behind in Mougins since I had been forced to leave quickly because of Robert's illness. I had packed them in cases and valises, holding on only to what was completely necessary.

After Arp's tragedy, Sophie dead in Switzerland, I packed up their belongings.

With the hasty departure of Magnelli for Paris, I had done the same for him.

I had no idea how to protect the crates of pictures of the three of us from the bombings.

Some friends had half a garage underground. I arranged the cases there. We put sacks of plaster in front of them to protect them.

In 1945, when we met one another again, lacking only our dear Sophie, we had a large truck bring the crates of pictures back from Paris.

I loved the view of old Grasse from the Grand Hotel. I made several drawings of it.

Some days after our hotel had been taken over by the army, I had moved into the Arp villa, three kilometers from Grasse. It might have been a presentiment (of Sophie's death), but I found it too forbidding there and I once more agreed to live at the hotel despite its occupation by Italian soldiers.

I was present one morning at seven o'clock at the surrender of two

1. Robert Delaunay died of cancer on October 25, 1941.

hundred officers with raised arms, taken prisoner by three Germans in a side-car. The armistice with Italy had just been signed.

Under my window there was a mountain of artillery shells.

The owners of the hotel—English—had rented a villa to which I moved and where I remained until I left Grasse in 1944.

COLLAGES OF SONIA AND ROBERT DELAUNAY (1956)

XXième Siècle, *No. 6 (January 1956), pp. 19–20. Translated by the editor.*

Sonia Delaunay

About 1911 I had the idea of making for my son, who had just been born, a blanket composed of bits of fabric like those I had seen in the houses of Russian peasants. When it was finished, the arrangement of the pieces of material seemed to me to evoke cubist conceptions and we then tried to apply the same process to other objects and to paintings.

Our apartment at that time was furnished in Empire and Louis-Philippe styles; the walls were papered. This bourgeois environment went well with the pictures of Douanier Rousseau that we owned. Little by little, the apartment was transformed: the walls were painted white and the lampshades and cushions dressed in a mosaic of paper and fabric. I rebound books that I loved: Blaise Cendrars's "Easter in New York," which was the talk of Paris at the time, was covered with suede and pieces of paper. In 1913, at an exhibition of cubist work, I showed a simultaneous book whose exterior and interior were made of papers in the manner of an *assemblage*. At this time also I created dresses (about one of which Cendrars wrote his poem "On Her Dress She Has a Body"), vests, hats. Delaunay wore the vest and I the dresses. Our collages and a number of objects were shown in Berlin in 1913. There was a complete Delaunay room at Walden's for whose review, *Der Sturm*, I made a collage cover.

Because the murder of Calmette by Mme. Caillaux had made such a

strong impression on him, in 1914 Delaunay painted a picture, part collage and part painting, that was inspired by his first *Disque* of 1912; he thought that *papier collé* permitted him to express himself better on this occasion. At the beginning of that year we stopped making collages because the materials involved seemed too facile to us in relation to the issues we were investigating.

When I returned to Portugal in 1915, however, the *assemblage* of bits of fabric gave birth to a unique style, according to which I executed a portrait of Nijinsky dancing.

A particular application (more or less direct) of collage is evident in other objects that we created before the war: interiors, furniture, clothes. In 1922 Jacques Doucet asked me for a vest and René Crevel wanted another. A silk manufacturer in Lyons ordered fifty designs from me; and I made some color studies for them as I would for pictures and applied the rhythms of my painting to them. It was in this manner that geometric design was introduced into printed fabrics in 1923. Scarves, ballet costumes, bathing suits, embroidered coats employing the principles of collage were sold throughout the world. All this was recapitulated in the Baraque de la Mode [Fashion Booth] of the Bullier Ball in 1922— total *papier collé* since everything was collage, from the floor covering to the ceiling, and through it all walked the costumed models.

THE COLOR DANCED (1958)

Article published in Aujourd'hui, *No. 17 (May 1958).*

The theater of color must be composed like a verse of Mallarmé, like a page of Joyce: perfect and pure juxtaposition, exact sequences, each element apportioned its correct weight with absolute rigor. Beauty resides in the power of suggestion which enables the participation of the spectator.

Beauty refuses to submit to the constraint of meaning or description.

In 1923 I made an attempt in this direction—*La Danseuse aux Disques* [The Dancer with Discs]. It was an evening organized by the poet Iliazd at the Licorne where Codreano magnificently danced the color. Her costume, made very simply, was composed of three elements: a large cardboard disc, covered with fabrics of different material in different colors, orange and green, fastened around the face of the dancer and completely covering the upper part of her body. A half-circle where two reds and blues were arranged formed her short skirt. Finally, a black circle was attached to her right hand and a white circle to her left.

The rigidity of the costume imposed its obedience. The dancer was obliged to move frontally and her movements had to respect the plane. With great feeling, while altering the position of the plane, Codreano created and unceasingly transformed the relations of the colors.

In this manner a new language of color was achieved from which all description had been banished. The imagination played free.

In 1923, this was a first attempt, a try. If the opportunity had been offered me to pursue this experiment, I am certain that I would have found other means of amplifying the idea, making it more supple, and diversifying the possibilities of its expression by the use of the machine, electricity, etc., which would have helped me accessorily. . . . The terrain would have become immense.

Text of Exhibition Catalogue (1962)

Catalogue of Exhibition of Sonia Delaunay. Paris, Galerie Denise René, May, 1962.

Poetry of words
poetry of colors
the rhythm of verse
is construction
and relation of values
Poetry moves
through all
the creations of art.

Text by Sonia Delaunay
for Portfolio of Prints (1966)

The portfolio, published by Galleria Schwarz, Milan, in 1966, contains a reproduction of Sonia Delaunay's handwritten text accompanying her six prints.

1. The issue is learning again how to paint and finding new means of doing it. Technical and plastic means.
2. Color liberated from descriptive, literary use; color grasped in all the richness of its own life.
3. A vision of infinite richness awaits the person who knows how to see the relations of colors, their contrasts and dissonances, and the impact of one color on another.
4. Add to this the essential element—Rhythm—which is its structure, movement based on number.

5. As in written poetry, it is not the aggregation of words which counts, but the mystery of creation which yields or does not yield feeling.

6. As in poetry, so with colors. It is the mystery of interior life which liberates, radiates, and communicates. Beginning there, a new language can be freely created.

Interview with Sonia Delaunay (1970)

By the editor in her apartment at 16 Rue St.-Simon, Paris, July 22, 1970. The text has been edited for the sake of clarity and flow.

A.C.: You have said, Mme. Delaunay, that your painting is quite different from that of Robert. How would you explain this difference? This is a particularly important question, since most discussion of your work and Robert's improperly draws the distinction between the idea of color and that of technique.

S.D.: First, we should clarify our place with regard to color in the history of painting. This is very important because practically no one—with the exception of a few close friends—is able to understand it.

A.C.: Perhaps it would be wiser then for us to begin with your understanding of Chevreul, for example.

S.D.: No, I have nothing to do with Chevreul; only Robert did.

A.C.: And did he discuss Chevreul much with you?

S.D.: No. I've always loved color. I've worked with color following my own sensitivity, and I did my first paintings—as you've seen—influenced in part by Gauguin, in part by van Gogh; and I was handicapped by drawing. Delaunay did something quite different. He was influenced by the neoimpressionists (that is, the divisionist school) and he read Chevreul. And after reading Chevreul, he reconciled the theoretical element of painting with its plastic element.

A.C.: Yes, but after your fauve period, you started heading in another direction.

S.D.: Yes, that's true. Delaunay began working with Chevreul's simultaneous contrasts, following, nevertheless, his own idea of it. And his construction in turn helped me. It was the backbone of my painting. It enabled me to arrange colors without drawing.

A.C.: What you've just said is significant because of the relationship between your research and the painting that results. It seems to me notable that you have done more research than painting.

S.D.: Yes, but let me explain. First, I put down my impressions. In Spain, in *Les Danseuses*, I was already looking for color and the relations between colors. Then, in the paintings of Portugal and the

215

large Spanish paintings, I did studies in technique. I worked a long time on this, and not according to any specific theory, but rather with what you might call a scientific detachment. There you can see the simultaneous contrast. When, however, we lost all our money and I had to design textiles in order to earn a living, a fabric manufacturer from Lyons asked me to create fifty different designs. I was surprised. I said to him, "I've never done that before," but then I made color studies for my own benefit, and all the fabrics I created represent so many studies or exercises in color, which were valuable as well for Delaunay. For ten years that's what I did—studies; and, though it was on two levels, they had to surface. My ideas for women's dresses were at the same time studies in color.

A.C.: It has always been a question of color.

S.D.: Always.

A.C.: When you design fabrics, cases, book bindings, whatever, it's always a question of the relationship between the color and the material.

S.D.: I've always looked to see what was happening around me. Later I also looked at Mondrian's work, because I like the square. I introduced the square into my own work, while Delaunay still worked with circles. And I always kept up with what was happening in painting, both before and after the war, and when I was by myself, I always looked at what others were doing in order to learn. That way I could select whatever I found useful.

A.C.: This is why it seems to me extraordinary, as you know, that you didn't receive any international recognition between 1930 and the 1950s. How would you account for this?

S.D.: Well, from 1919 to 1930 I did have an enormous success.

A.C.: Here in France?

S.D.: Everywhere, throughout the world. With my fabrics—you saw L'Album '27—I made a lot of money. However, I'm not a businesswoman at all, and I didn't know how to capitalize on it. I'd rather give than sell. I had an enormous amount of success, and Delaunay said, "You don't seek the slightest publicity, yet people climb up five flights. . . ." We were living on Boulevard Malesherbes at the time. Clients came from all the world, beginning at eight o'clock in the morning. Except, I didn't know the . . . and I didn't want to. I don't like business.

A.C.: It's better to work on your painting without clients.

S.D.: And after that, the American crisis.

A.C.: Yes, the Depression.

S.D.: I was making very beautiful materials that were costing me a lot. I made a very beautiful collection, while at the very same time in Lyons they were selling my fabrics at a tenth of their value. We couldn't hold out, and I realized that the workers, who basically didn't like their job, despite the fact that I had already given them an interest in the sales and everything, were eating up all my profits. I was working for others. So I said, "Basically, I earn money with my hands," and I made some fabric designs. And yet I no longer made fabrics that were to be made into dresses, because no one knew how to use them. I made only the design. And then I saw those painters who lived quietly, smoking their pipes at Diane Delaunay's, ignoring the whole question of business. There was a French collector who also bought some of Delaunay's paintings. Delaunay had started to sell seriously at that time, and I decided to drop business. Of course, Delaunay had sold before World War I. He sold immediately in Germany. He had an enormous success. But once the war came, everything came to a halt. Then in Spain I was able to design a magnificent store, because the merchandise was being sold to the Queen. I was considerably successful there, although we remained penniless from one day to the next. We created models ourselves. I was very successful there in aristocratic milieus. In fact, Diaghilev helped me considerably by introducing me to two or three important people, and I ended up having a magnificent store in the middle of Madrid—in the best part of the city—which at that time I had decorated in a completely modern style, the way they do now.

A.C.: The furniture also?

S.D.: No, only the walls. And at that particular time I received a proposal from Paris. Since paintings weren't selling at all in Spain—no one was interested in painting—we decided to leave for Paris. We arrived in Paris, absolutely penniless, amidst the surrealists; but since we owned a few Rousseaus, Breton helped us sell *La Charmeuse de Serpents* [The Snake Charmer] to the great collector Jacques Doucet, and that enabled us to establish ourselves. We rented a place. We stayed two years without . . . well, without really getting settled. We had Empire furniture, which I didn't like at all, so afterward I designed some modern pieces.

A.C.: I saw a photograph of your apartment decorated with Empire furniture covered with fabric that you designed.

S.D.: Yes, but that came later. It was in 1924 that I started making fabrics. Gradually I transformed our apartment into an entirely modern one, and all the German and Austrian architects came to our place: Gropius, Mendelsohn, Loos—Loos liked me a great deal—and the women bought all their clothes from me.

A.C.: That's extraordinary. I didn't know that you knew Gropius.

S.D.: Yes; one time when Gropius came to Paris, I held a reception in his honor and invited sixty people. We really liked Gropius.

A.C.: That was during the period 1924 to 1925.

S.D.: Yes.

A.C.: But was it possible for you during that period to continue your abstract research?

S.D.: I painted all the time.

A.C.: All the time?

S.D.: Yes. You can see photos of me next to a table. I painted all the time, but I didn't speak about myself because it seemed so natural to me that I didn't even think about it. It was a natural function.

A.C.: You said yesterday that you never mixed your dark colors without adding a bit of white.

S.D.: At times a little white.

A.C.: I assume that's because you want to use only pure colors.

S.D.: Yes, always.

A.C.: Do you ever touch up pictures after a time, or is it the case that once you've finished it, it's finished for good?

S.D.: No retouching! I do a picture and that's it. After that, if I'm not happy with the first, I do another one. Delaunay did the same thing.

A.C.: There are a lot of painters who like to go back and rework the same painting.

S.D.: I don't. I received a great working discipline from Delaunay. When he started painting, if he wasn't happy he did another one. He never worked over the same one.

A.C.: Did you have good relations with other painters of your generation?

S.D.: Yes. We always had loads of people around us—poets, writers, painters. As for myself, when I was a girl, I was always surrounded by twenty people or so, friends—both women and men—and we saw each other all the time. And as for Delaunay, he had tremendous creative energy (*d'un esprit animateur*), a poet—and poets would

inevitably come to our place. They came from Russia, from Germany, from all over—from America, too. We had many American friends—friends from all over.

A.C.: You were never in America.

S.D.: I never wanted to go there. I was asked to come in 1926.

A.C.: You'll have to compromise one day, I hope.

S.D.: No.

A.C: You don't want to.

S.D.: I don't like the mechanical side of things there.

A.C.: That's another interesting point. You've said that your research has been grounded on a scientific base. You collaborated with engineers in *Zig Zag*—and with other types of practical scientists?

S.D.: Yes.

A.C.: But was that . . . ?

S.D.: Never mechanical or theoretical.

A.C.: To theorize is not to paint?

S.D.: I'll explain. Our studies in color allowed each of us to discover a life of color as no one knows even now. Color is used now as photography was used before. It is used like the literature of the surrealists, and other painters do the same. Whereas we found the life of color in color itself.

A.C.: Yes, that's something quite different.

S.D.: So, on this basis, as I always say, if people weren't in such a hurry to make money in any way they can, they'd take a look at what we discovered and they'd try it for themselves. Everyone can express himself—that's what Delaunay used to say. We have the same *métier* but different personalities. And we make things that are entirely different. What's more, concerning the rhythmic aspect of color—and this is an entirely new science which bears both on poetry and on all the modern life—we discovered vibrations and undulations.

A.C.: Contemporary music also.

S.D.: Everything.

A.C.: And do you have a particular affection for the dance, for music in general?

S.D.: Yes, but not for modern music.

A.C.: And how about electronic?

S.D.: Oh, no. I can't stand that because it's mechanical. At [Nicholas] Schoeffer's I got the chance to listen to it, and I tried to be convinced. But no. I'm not indiscriminately modern.

A.C.: For you it's always a question of preserving the function of the creator. And if it were possible, with all the mechanical techniques and devices, to deny the personality of the creator, then it wouldn't be art.

S.D.: It wouldn't be art. I'm for the true artist. I have absolute control in painting, and it was only a short while ago that I freed myself from research. Now I can express what I want to when I want to.

A.C.: Tell me something else. I want to discuss a bit how you got involved in graphics, the use in your work of letters, of conceptions represented by letters. You've told me that your research is not for your clients; it's only abstract research into the forms of letters and the relationships between the forms of letters and the colors around them. Can you say what your conception of modern graphics is?

S.D.: I can't, because it's purely immediate.

A.C.: Solely a question of sensibility?

S.D.: That's correct.

A.C.: Don't you have a particular admiration for the form of letters?

S.D.: No. I design them myself.

A.C.: Yes, but you didn't discover other ideograms. They are simply the forms of the letters of the alphabet. And you did something entirely new in the history of art, because you designed posters and similar objects without any relation to another object, for example, your research with Dubonnet; Dubonnet is a word—it has no relation to an object.

S.D.: Yes, it's a pretext. We wanted to make money and to sell the posters, but they weren't even shown.

A.C.: Yes, but you didn't sell things . . .

S.D.: Not even shown. For example, Zenith: Cendrars did a poem for Zenith—which you have—and he was supposed to show it to Zenith. But he never did; and now an official at Zenith, after fifty years, writes to me: "I've been told that you did some things for Zenith," and he'd like to know if I still have some of them.

A.C.: Zenith radio and television?

S.D.: No, Swiss watches. We lived a really poetic life together, but a very difficult one—with terrible money problems, although I had thirty contract offers for my fabrics. I always refused at the last minute, and Delaunay did the same with his paintings.

A.C.: You always wished to preserve your independence.

S.D.: The purity of expression.

A.C.: That's extraordinary. It's something that should be taught to contemporary American artists, don't you agree? Because the rapport between business and the art dealers, the collectors, is extraordinary all over the world, not just in the United States—it's the same in Europe, too. But for you and Delaunay, it's solely a question of making things.

S.D.: Of expressing ourselves.

A.C.: But do you think that we have a community of artists similar to the one you had when you were young? We don't have a close circle of intellectuals, of writers, of artists; it's impossible to be friendly with many people who are interested in the same things.

S.D.: No, painters used to get together before. You know, Delaunay, Léger, Gleizes. They talked painting. They argued a lot, but they talked painting. Whereas now, when two painters get together, they talk prices. Nevertheless, I have many painter friends now.

A.C.: You told me that you'd like to explain your stenciling technique, particularly in *Le Transsibérien*.

S.D.: I don't have any special technique. The story behind *Le Transsibérien* is rather extraordinary because Cendrars was very poor. Then he inherited three thousand francs from an aunt.

A.C.: Three thousand francs—how much is that in new francs?

S.D.: One and a half million now. Anyway, instead of using it for himself, he wrote a poem, *La Prose du Transsibérien et de la petite Jehanne de France*.

A.C.: But you did something else with a poem before that—*Easter in New York*.

S.D.: We met Cendrars at Apollinaire's. The next day he came to our place with *Easter*. I read *Easter* and was so taken with it that I set to work immediately to make a cover for it. I made one with suede and pasted paper, since we were, after all, rather poor at the time. We had some income, but we were poor compared to . . . Anyway, we were able to live. So I made this binding by superimposing paper, and inside I made large paper squares—on the fly-leaves. And that's what Cendrars saw. Then he came every day to our house; he ate with us, since we lived nearby. So, when he got that sum of money, he said, "I want to do *Transsibérien* with you." So Delaunay told us to go ahead with it. Cendrars gave me the poem, and I made an improvisation, an impression of the poem next to the poem itself. Not an illustration, but an impression of the poem. He took charge

of the publishing. He paid for it all himself with his three thousand prewar francs, and he gave it to a stenciling studio. They were artisans who . . . it's a process that has been used a great deal in Japan.

A.C.: Yes, but is there a difference between one copy and another?

S.D.: No. And of the whole edition—there were supposed to be a hundred and fifty copies—he gave us the thirty that were ours, and he took his. With that, the war came. There were even some copies that didn't have any covers. And after the war I found a dozen covers which I sold, some as paintings, and others I gave to Cendrars, who sold many of them as paintings without covers.

A.C.: The first one I bought in the United States was framed like a painting and the poem was framed, but it's not a very good copy because the colors of the stencil have been faded by light. But you have to have it whole like any whole object. And I have another copy, as you know. It's a remarkable thing for the time it was made, because before that book there had never been another like it.

S.D.: But anyway, among the papers that I showed you, there's an article that I did for *Mercure de France*.[1] They did an issue in homage to Cendrars after his death. In this article I wrote that Cendrars had lived his poetry, because it's impossible to tell what's true and what is not. When he speaks of his voyages and all, you just can't tell. No one knows. But he lived all that. Part of the time he was in Brazil. He bought land there. He lived the life of a poet. We always talked and thought painting—every minute of our lives. . . .

A.C.: Apollinaire was very strange. It seems to me that he was a little like a dancer. He dances over all sorts of subjects, all sorts of talents.

S.D.: He had talent, but . . .

A.C.: Sort of an impresario.

S.D.: But he was authentic and very important, especially among the young artists. He was a personality.

A.C.: Yes, but Cendrars was something else.

S.D.: Cendrars was more authentic.

A.C.: And profound, I think.

S.D.: Yes.

A.C.: And Tzara?

S.D.: Tzara was something else again. Tzara was a man of extraordinary intelligence. I was very good friends with him.

1. See translation of this essay, p. 198.

A.C.: Did you have any one particularly close friend in this group?

S.D.: No. But Tzara was much later. He used to come to our house. When we came back from Spain, we entered into the midst of the surrealists because they had written to us all during our stay in Spain; and when we arrived in Paris we were surrounded by them. When Delaunay exhibited at Paul Guillaume's in 1922, all the people at the opening were surrealists. When we exhibited in 1923, I think, at the Société des Artistes Indépendants, they all came with their little bells. They made a huge fuss because our things were poorly hung.

A.C.: I have an extremely delicate question for you, but I think you'll understand why I ask it. Since we have many women artists in the United States the question always arises there as to the difference between the painting of men and that of women, between the so-called "feminine" sensibility and the so-called "masculine" sensibility. What are your thoughts on this question? Since you are, in my opinion, the greatest living woman artist, I think it is important for us to hear what you think about this purported difference. Before our generation, before our century, there were very few women painters.

S.D.: I'm from a very rich family. The husband of my aunt, who raised me, was active in the Franco-Russian exchange. He had a private town house in St. Petersburg with uniformed servants and everything—the whole works—and he had a collection of paintings from the Barbizon school. When he died he left to the relatives who raised me some large engraved albums containing many reproductions that took the place of today's photo; and since the adults' conversation interested me very little, I looked at these albums every night. They were the basis of my painting school. And there I saw a certain woman painter whom I envied—what was her name? There are portraits of her with her daughter.

A.C.: But it's true, isn't it, that these days you're a rarity. To try to distinguish between men and women painters makes no sense. And yet it's nevertheless clear to me that it wouldn't have been possible for Robert to design fabrics, for example.

S.D.: No.

A.C.: Because Robert's work reveals a very analytic and speculative intellect. You're instinctual, direct. You can make a design rapidly and then you can fill out the idea with a series of experiments—and this is a difference solely of temperament, not of sex.

S.D.: No, not at all a difference of sex. And these days I find there's less

and less of a difference. I visited the women's salon and I found it in many ways superior to that of the men, because it was more authentic, more sincere. Last year the women's salon gave me an award. And this year I am the head of a salon that's going to open in the fall —a women's salon, to which I had all the American women I know invited: American, French, all nationalities. They'd like to give the prize to Barbara Hepworth. I like her a great deal. I have a little sculpture of hers.

A.C.: In general, you have a great affinity for sculpture, don't you?

S.D.: Yes.

A.C.: But you have . . . ?

S.D.: Never—never touched it—I'm incapable of sculpting.

A.C.: Robert made some bas-reliefs.

S.D.: But in 1914 he did a painted sculpture. He took a horse—you know, the little horses for children—and he put his disc behind it, then painted both the horse and the disc. It has since been destroyed, but it was exhibited in 1913 at the Herbstsalon. I have photos of that.

A.C.: You have expressed your feelings about contemporary art, and I don't want to ask you any names or particulars. But tell me, in general, what you think of American artists.

S.D.: I don't know them well enough to judge.

A.C.: You haven't seen enough of their paintings.

S.D.: No, I've seen some reproductions. I find that they've been given too much importance, and that hurts them.

A.C.: One last question that interests me: Do you have a favorite palette?

S.D.: I find that in addition to the primary colors I don't need many others. Those are enough for me.

A.C.: That's a good answer.

S.D.: But I despise false colors. My 1907 paintings done on students' canvases that were covered over, you know—there are perhaps some Cézannes or Rousseaus underneath, covered over with white and with Lefranc colors (which are not very extraordinary either). Well, they held fast, not a single color was changed. And the restorer at the Basel museum who restored the Delaunay painting told me that when a painting stands up for fifty years he guarantees it will last forever. It's like enamel.

A.C.: Yes, and the same goes for your canvases, because you used pure colors; and a false color for you is one that's mixed.

s.d.: Mixed with dirty colors. For me, a painting doesn't exist when it's dirty.

a.c.: Do you have any other things you'd like to say, in general?

s.d.: I don't know.

a.c.: On the history of painting? What would you say you've done, in general, for the history of painting?

s.d.: We liberated color, which has become a value in itself, which allows anyone to use it as he sees fit. It's a new language, and Delaunay used to say, "We will be as important an intermediary as Cézanne." It's the ABCs of the new painting, but people are in no hurry to learn it because they want cars, country houses, trips, vacations—a lot of vacation.

a.c.: You liberated color, and it's all that was necessary.

s.d.: Yes, that's all that was necessary. And the real irony is that my punishment—that is, when I lost all my fortune—led me to study color because when I made fabrics I made colored ones, and even that was done in an abstract way. I have all the documents, which are already in museums or will go into museums to teach others. Anyway, there's where we studied color thoroughly.

a.c.: Thank you. That's fine.

s.d.: But there's still one more thing to add: rhythm. Rhythm is something of the future. I use it unconsciously, but it's possible for it to become conscious. And let me add one more thing: I'm entirely against the commercialism of Vasarely, which is disastrous for painting, distorts people's vision, and is cold and mechanical. It's anti-painting. It's a sort of limitless vanity, and a real artist is always modest.

a.c.: But the commercial perversion of the arts is aided by art dealers.

s.d. Art dealers kill painting. It's the art dealers who have killed painting. First of all, they live like princes. They rob the artists. And finally, they aren't the least bit interested in painting.

a.c.: And what about the critics?

s.d.: In France, nil.

a.c.: Nil—no importance. But in the United States, they're terribly important.

s.d.: Yes. And I've received some extremely good reviews. I was astonished.

Appendix

1885–1903 Robert-Victor-Felix Delaunay is born in Paris April 12, 1885. His parents divorce a short while after his birth and his mother, having decided to travel, entrusts Robert's education to his elder sister and his brother-in-law, Charles Damour, who own land in Berry, La Ronchère, not far from Bourges. It is there that Delaunay spends his vacations. He prefers life in the country and the freedom he enjoys there to his studies in the various schools and institutions of the province and then at the Lycée Michelet in Paris, where he shows himself to be a very mediocre student in most of his courses, excepting design and natural sciences. When he reaches the age of seventeen, his uncle, noticing his lack of taste for study, enters him as a decorator's apprentice in Belleville, where he remains two years.

1904–1905 At La Ronchère and then in Brittany, where he spends his vacations, he completes his first pictures, at first influenced by impressionism, then by Gauguin and the Pont-Aven group. In 1905, despite the objections of his family, he decides to dedicate himself entirely to painting.

1906–1907 He is strongly influenced by neo-impressionism without,

226

however, submitting to the precepts of optical blending. He often sees Jean Metzinger, who is then working in the same way. In 1906 he paints the first version of *Manège de cochons* (Carousel with Pigs), a theme he will take up again in 1913 and in 1922 with new techniques. An admirer and friend of the Douanier Rousseau, he introduces the other artist to his mother, whose recital of her travels inspired Rousseau somewhat later to paint his famous picture, *La Charmeuse de serpents* (The Snake Charmer), which Delaunay's mother purchased.

1908–1909 Delaunay is influenced by Cézanne. He paints a highly original self-portrait (1909) and the *Saint-Séverin* series.

1910 Delaunay marries the Russian artist, Sonia Terk.

1910–1912 Numerous important works mark these two years, in particular the *Villes* and the *Tours Eiffel*. During this period, usually considered his cubist period and which Delaunay more readily called his "destructive" period, he studies the fragmentation and dissolution of forms in light. "Nothing horizontal or vertical," he will note much later, "light deforms everything, shatters everything, more so than geometry."

1911 Alongside Metzinger, Gleizes, Léger, and Le Fauconnier, he exhibits three works (including one *Tour* and the *Ville No. 2*) in the famous Room No. 41 of the Salon des Indépendants, which cause a scandal. He also participates in many foreign salons, notably the Indépendants of Brussels, where he represents cubism with Gleizes, Léger, and Le Fauconnier, and in December in the first exhibition of the Blaue Reiter in Munich (*Saint-Séverin, Tour Eiffel*, and two *Villes*).

1912 This year marks a turning point in the work of Robert Delaunay. At Laon, where he sojourns during the month of January, he executes many landscapes and scenes of the cathedral in which he seeks to render depth by a system of color values and not by perspective. He shows the *Ville de Paris*, a vast synthesis of his preceding works, with great success in the Salon des Indépendants; he resumes and concludes his "destructive" period, and in the month of April, opens his "constructive" period with the series of *Fenêtres*. In this same year, in the first *Formes circulaires: soleil, lune,* and above all in the simultaneous *Disque,* Delaunay orients himself to both the circular arrangement of contrasts and the abstract painting of which he is, with Picabia and Kandinsky, one of the first pioneers. Guillaume Apollinaire, indefatigable defender of cubism, is enthusiastic about Delaunay's researches, and his friendship with the Delaunays finds itself reinforced. Delaunay's *Fenêtres*

inspire Apollinaire's famous poem by the same name, and he dedicates an important article to Delaunay in his *Soirées de Paris.*

February 1912 Delaunay's first one-man show is held at the Galerie Barbazanges, followed by many group shows in Germany (Der Sturm, Der Blaue Reiter), Switzerland and Russia (*Valet de carreau*).

1913 In January Delaunay goes to Berlin with Apollinaire. Der Sturm mounts his first one-man show abroad. At the same time he publishes an article, "Über das Licht" ("On Light") in the magazine *Der Sturm* (cf. p. 81). In Bonn, on his way back, he encounters August Macke, whose acquaintance he had made the preceding year. Back in Paris, he shows the *Equipe de Cardiff,* a large composition conceived according to his new pictorial technique, in the Salon des Indépendants. In New York, the *Ville de Paris* is not shown in the famous Armory show (because of its dimensions) and Delaunay, displeased, withdraws his other works. In September he participates in the first Herbstsalon in Berlin with twenty recent works and in October is included in a large show of modern paintings at the Doré Galleries in London. The same year he joins with the writer Blaise Cendrars and with the American painters Bruce and Frost.

1914 In March Delaunay exhibits an *Hommage à Blériot* at the Indépendants, an important composition which marks his last stage of development. The war takes him by surprise at Fuenterrabia in Spain. That year, he concentrates on the study of the technique of painting in wax and redoing many of his earlier paintings in this new technique.

1915–1917 Delaunay moves with his family to Madrid. There he paints the series of *Femme nue lisant* (Nude Woman Reading) and *Gitan* (Gypsy). Then he leaves for Portugal, where he executes numerous still lifes, landscapes, and compositions with human figures (*Femme au Marché* [Woman at the Marketplace], *Femme à la pastèque* [Woman with Watermelon], *La Verseuse* [The Coffee-Pot]). The Spanish light seduces him and leads him to research the relation of dissonant colors to rapid vibrations. In the spring of 1917 he travels to Barcelona and then back to Madrid, where he joins up with Diaghilev and Nijinsky and meets Igor Stravinsky and Manuel de Falla.

1918 He executes sets for the revival of *Cleopatra* by the Diaghilev Ballet (costumes by Sonia Delaunay) and does portraits of Stravinsky and Léonide Massine.

1921 Delaunay, succumbing to material needs, returns to Paris.

1922–1923 He frequents the surrealist circle. He becomes friends with Philippe Soupault, Tristan Tzara, André Breton, Louis Aragon, Yvan Goll, Mayakovsky, etc.

May–June 1922 He has a large one-man show at the Galerie Paul Guillaume, paints the definitive version of the *Manège de cochons* and, during the winter, executes a new *Equipe de Cardiff*, more colorful than the preceding versions.

1924–1926 He returns to the theme of the Eiffel Tower and executes a number of Parisian scenes (*Le Panthéon, Le Carousel*). In 1925 he paints many versions of the *Ville de Paris* (The Woman and the Tower). The most important version is shown in the hall of the French Embassy by 'the architect Mallet-Stevens at the Exposition Internationale des Arts Décoratifs in 1925. From 1924 to 1926 he also executes the series of *Coureurs* (Racers) in which he experiments with new possibilities of spatial expression through colored planes.

1926 He shows six large canvases at the retrospective of the Indépendants in the Grand Palais.

1926–1927 He executes twenty-three studies for the portrait of Mme. J. Heim, going from realism to almost complete abstraction.

1930 Delaunay abandons his figurative themes and returns to a totally abstract art with the large panel of *Formes circulaires* which he paints for the salon of a collector and with the first two versions of the *Joie de Vivre* (Joy of Life).

1930–1935 He returns to the discs of 1912 and 1914 and paints a series of pictures which he entitles *Rythmes* and *Rythmes sans fin* (Rhythms Without End). He executes numerous reliefs in which he utilizes plaster, sand, casein, cork, and cement.

1935 He exhibits the results of his work in the gallery of the revue *Art et Décoration*, in the magazine of which Jean Cassou writes an important article on the subject, "Plastic Mural in Colors."

1936 Delaunay is represented by six works in the large "Cubism and Abstract Art" exhibit organized by the Museum of Modern Art in New York. The organizers of the Exposition Internationale of 1937 ask him for his assistance. He is put in charge of decorating the Palais de l'Air and the Palais des Chemins de Fer. With the help of the architect Audoul and a team of painters he executes some enormous panels in 1936 and 1937, one of which measures 900 square meters, and some colored bas-reliefs.

1938 With his wife, Gleizes, Lhote, and Jacques Villon, he decorates the panels of the sculpture room in the Salon des Tuileries. The three *Rythmes 1938* (Nos. 1, 2, and 3) are to be his last works and can be regarded as his pictorial testament. Delaunay is already suffering from cancer at this time.

1939 He teaches the rudiments of his art to young students who join him at his house each Thursday evening, and organizes a big salon of abstract art at the Galerie Charpentier under the title "New Realities."

1940–1941 He takes refuge in Auvergne, passing the winter in Mougins in the south. His illness worsens and he is taken to a clinic in Montpellier. There he dies peacefully, without pain, on October 25, 1941. In 1952 his remains are transferred to Gambais, in Seine-et-Oise.

BIOGRAPHY OF SONIA DELAUNAY
(Authorized by the Artist)

1885 Sonia Terk is born in Gradizhsk in the Ukraine on November 14.

1890 She is adopted by her maternal uncle and lives in St. Petersburg, where she studies.

1903–04 She studies drawing and anatomy at the Academy in Karlsruhe, Germany.

1905 She makes her way to Paris, where she is a student at Académie de la Palette. Her studio companions include Ozenfant, Dunoyer de Segonzac, Boussingault.

1907 She paints fauvist pictures influenced by van Gogh and Gauguin.

1909 Sonia Delaunay is married to Wilhelm Uhde in London.

1910 She divorces Uhde and marries Robert Delaunay. They settle on the Rue des Grands-Augustins, where they maintain their studio until 1935.

1911 Sonia's son, Charles Delaunay, is born. She executes her first fabric collages.

1912 Apollinaire lives with the Delaunays from early November to mid-December. She creates simultaneous veils, collages, book bindings, and pastels.

1913 She meets Blaise Cendrars; a few months later she illustrates his poem *La Prose du Transsibérien et de la petite Jehanne de France.*
 Her simultaneous dresses and vests are produced.
 She sends twenty paintings and objects to the Berlin Herbstsalon.

1914 She exhibits *Prismes électriques* (Musée National d'Art Moderne, Paris) at the Salon des Indépendants.
 The Delaunays vacation at Fuenterrabia (Spain). World War I is declared.
 Robert Delaunay is released from active service (discharged in 1908).

Charles being gravely ill, the Delaunays decide to settle in Madrid.

1915 They depart for Portugal, where they stay with Portuguese and American painters in the vicinity of Porto.

1916 At Valença do Minho, Sonia Delaunay paints the suite of Portuguese still lifes and *Marché au Minho* (The Market at Minho).

1917 The draft board discharges Robert Delaunay for a second time.

As a result of the Russian Revolution, Sonia loses her income and earns her living as a stage designer. She realizes the interior decoration of Madrid's Petit Casino and the costumes for its first revue. The Delaunays meet Serge Diaghilev.

1918 Diaghilev returns to Madrid, commisions the Delaunays to do the set and costumes for *Cleopatra*, and lives with them for a time in Sitges, along with Massine and Lopouchova. They return to Madrid, where they meet Stravinsky, Manuel de Falla, Nijinsky.

1920 The Delaunays finally settle in Paris at 19 Boulevard Malesherbes. Here they establish friendships with the poets and writers of the surrealist group.

1922 Sonia creates the first simultaneous scarves.

1923 A Lyons textile house commissions Sonia's simultaneous fabrics.

She designs and produces the costumes for a Tzara's play, *Le Coeur à gaz* (The Gas Heart).

1924 She decides to supervise the production of her simultaneous fabrics herself and undertakes the manufacture of wool-stitched coats.

She creates the costumes for a poem by Joseph Delteil.

1925 She participates in the Exposition des Arts Décoratifs and displays a boutique with the couturier Jacques Heim.

Sonia Delaunay, ses peintures, ses objets, ses tissus simultanés, ses modes, an album with preface by André Lhote and poems by Cendrars, Delteil, Soupault, and Tzara, is published by Librairie des Arts Décoratifs, Paris.

1929 The album *Tapis et tissus* is published in Paris, produced by Sonia Delaunay.

1930–1935 She dedicates herself almost entirely to painting.

1935–1937 The Delaunays are commissioned to execute vast mural paintings for the Exposition Internationale in 1937. Sonia wins gold medal.

1939 The Delaunays organize the Thursday gatherings at which Robert Delaunay, already ill, airs his thoughts on art to young artists and architects. Helped by Rambosson, Frédo Sidès, Nelly van Doesburg, the Delaunays organize the first "Réalités Nouvelles" exhibition at the Galerie Charpentier.

1941 Robert Delaunay, gravely ill, has to submit to surgery at Clermont-Ferrand. The Delaunays then go to Montpellier, where Robert dies on October 25. Sonia Delaunay, invited by Jean Arp and Sophie Taeuber-Arp, goes to Grasse, where she also finds Alberto Magnelli. She remains in Grasse until 1944 where she continues to paint.

1944 Three-month stay in Toulouse. Returns to Paris.

1946 Frédo Sidès, taking up the Delaunays' "Réalités Nouvelles" idea, asks her to organize the first Salon des Réalités Nouvelles with him.

1949 André Farcy, curator of the Musée de Grenoble, proposes that she undertake a major exhibition, "Hommage à Robert Delaunay," which she cooperates in organizing at the Galerie Maeght, Paris.

1953 One-man show at the Galerie Bing, Paris.

1958 Show of 250 of her works in major exhibition at Städtisches Kunsthalle, at Bielefeld. Executes four compositions for Tzara's *Le Fruit permis.*

1959 Large exhibition of the work of Robert and Sonia Delaunay held at the Musée des Beaux-Arts in Lyons.

1960 She executes a set of simultaneous playing cards for Playing Card Museum, Bielefeld.
Large exhibition of the work of Robert and Sonia Delaunay at the Galleria d'Arte Moderna, Turin.

1961 Publication of *Juste présent*, poem by Tristan Tzara, with eight etchings in color by Sonia Delaunay. Album of six lithographs in color published by Pagani of Milan.

1962 Album with six prints by Sonia Delaunay published by Galerie Denise René, Paris.

1964 The Delaunay Bequest to the Musée National d'Art Mo-

derne, Paris, containing 49 works of Robert's and 58 of Sonia's, is shown at the Louvre.

1965 Joint retrospective of works by the Delaunays held at the National Gallery of Canada.

1966 Executes mosaics for Fondation Pagani, Legnano, Italy. Completes studies and maquette for stained-glass windows, not installed, for the Église de Saux, Montpezat-de-Quercy, in France.

1967 Major retrospective installed at the Musée National d'Art Moderne, Paris.
Decorates a Matra B 530 sports car for exhibition, "Cinq Voitures Personalisées."

1969 Publication in Milan of two books, *L'Alphabet* and *Robes-poèmes*, reflecting collaboration with friend, Jacques Damase.

1971 Major exhibition of her textile and fabric designs, Musée des Impressions sur Étoffes, Mullhouse, France.
Publication of *Sonia Delaunay: rythmes et couleurs*, by Jacques Damase.

1972 Exhibition "Sonia and Robert Delaunay in Portugal and their friends Eduardo Viana, Amadeo Sousa Cardoso, José Pacheco, and José de Almada-Negreiros," held at The Gulbenkian Foundation, Lisbon.
Retrospective exhibition: "Sonia Delaunay: Tapestries" shown at the Musée d'Art Moderne de la Ville de Paris after which the exhibition travels to the Corcoran Gallery in Washington, D.C.
During the Venice Biennale at the exhibition of "The 50 main works from the first half of this century," her work represented at the Correr Museum in Venice.
Patrick Raynoud completes documentary film on her career.

1973 Creates eighteen gouaches for a new edition of Rimbaud's *Illuminations.*
Recevies the Grand Prix de la Ville de Paris and is commissioned to design stained-glass windows for the Chamber of Commerce in Paris.

1974 Exhibitions take place at the Musée de Grenoble and the Städtische Kunsthalle in Bielefeld.

At the opening of new exhibition galleries in the Wallraf-Richartz-Museum in Cologne where two important works of hers are placed on exhibition, she receives the Stephan Lochner Medal.

1975 Executes poster for the International Women's Year commissioned by UNESCO.

1976 Continues painting, executing important *auto-portrait.*

Bibliography

WRITINGS BY ROBERT DELAUNAY

1912 1. Text published by Guillaume Apollinaire in *Réalité-Peinture pure*, Paris, 1912.

1913 2. "Über das Licht." *Der Sturm* (Berlin), vol. III, no. 144–45, January 1913, pp. 255–56. (Translation by Paul Klee.) English translation by Maria Pelikan in *Vriesen/Imdahl: Robert Delaunay: Light and Color*. New York: Harry N. Abrams, Inc., 1967, pp. 6–9.

1914 3. Lettre ouverte au Sturm. *Der Sturm* (Berlin-Paris), vol. IV, no. 194–95, January 1914, p. 167 (letter of December 17, 1913 to Herwarth Walden).

1917 4. "El Simultanisme del senyor i la senyora Delaunay." *Vell i Nou* (Barcelona), no. 57, December 15, 1917, p. 672–79. Two letters from Delaunay to Joan Sacs, presented by Joan Sacs.

1924 5. Réponse à enquête "Chez les Cubistes." *Le Bulletin de la Vie artistique* (Paris), no. 21, November 1, 1924, pp. 484–85.

1925 6. Arp and Lissitzky. "Simultaneisme." In *Die Kunstismen*. Zurich: Eugen Rentsch Verlag, 1925. English translation by Arthur A. Cohen appears in this volume. (See p. 74.)

1927 7. Maurice Raynal. *Anthologie de la Peinture en France de 1906 à nos jours*. (Text.) Paris: Montaigne, 1927. Pp. 113–18.

1947 8. Text published in "Pour ou Contre l'Art Abstrait." *Cahier des Amis de l'Art* (Paris), no. 11, 1947, p. 58.

SELECTED WRITINGS ABOUT
ROBERT DELAUNAY

1912 9. Guillaume Apollinaire. "Marie Laurencin, Robert Delaunay," *L'Intransigeant* (Paris), March 5, 1912, pp. 2 ff.

10. ———. "Réalité: Peinture pure." *Les Soirées de Paris* (Paris), no. 11, 1912. Reprinted in: *Der Sturm* (Berlin), vol. III, no. 138–39, December 1912, p. 224 BC–225 A. In: G. Apollinaire, *Il y a*, Paris: Messein, 1925; new edition, Paris: Messein, 1949. Pp. 117–19.

11. E. V. Busse. "Die Kompositionsmittel bei Robert Delaunay." In: Wassily Kandinsky and Franz Marc, eds. *Der Blaue Reiter*. Munich: R. Piper & Co., 1912. Pp. 48–52, ill.; English translation by Henning Falkenstein, with the assistance of Manug Terzian and Gertrude Hinderlie, in: Klaus Lankheit, ed. *The Blaue Reiter Almanac*. Documents of 20th Century Art. New York: The Viking Press, 1974.

12. Maurice Princet. "Robert Delaunay." Preface to the catalogue of the · exhibition of R. Delaunay, M. Laurencin, Galerie Barbazanges, Paris, February 28–March 13, 1912.

13. André Salmon. *La Jeune Peinture française*. Paris: Messein, 1912. Pp. 15, 28, 52, 53, 54, 56, 58, 101.

1914 14. Guillaume Apollinaire. "Die moderne Malerei." *Der Sturm* (Berlin), vol. III, no. 148–49, February 1913, p. 272 ABC.

15. ———. *Les peintres cubistes: Méditations esthétiques.* Paris: Figuière, 1913. Pp. 22, 23, 25, 29, 73. New edition: Geneva: Pierre Cailler, 1950. Pp. 24, 25, 27, 70, 74.

16. ———. *Robert Delaunay*. Album with 11 plates; includes the poem "Les Fenêtres" and catalogue of the Robert Delaunay exhibition at Gallery Der Sturm, January–February 1913.

17. Paul Bommersheim. "Die Überwindung der Perspektive und Robert Delaunay." *Der Sturm* (Berlin), vol. III, no. 148–49, February 1913, p. 272 C–273 AB.

1914 18. Guillaume Apollinaire. "Les Réformateurs du costume." *Mercure de France*, no. 397, January 1, 1914. "Els Delaunay i la moda del vestir," *Vell i Nou* (Barcelona), vol. II, no. 57, December 15, 1917. Reprinted, with minor changes: "La Femme assise," *Nouvelle Revue Française* (Paris), 1920, p. 30.

19. ———. "Simultanisme-Librettisme." *Les Soirées de Paris* (Paris), no. 25, June 15, 1914, pp. 322–25.

20. Arthur Cravan. "L'Exposition des Indépendants." *Maintenant*, no. 4, March–April, 1914, pp. 1–17.

21. Marc Vromant. "Du Cubisme et autres synthèses." *Comoedia* (Paris), April 15, 1914, p. 1 D–F, 2 A–F; with two reproductions.

22. ———. "La Peinture simultaniste." *Comoedia* (Paris), June 2, 1914, pp. 1 D–F, 2 A–F; with two reproductions.

1915 23. Willard Huntington Wright. *Modern Painting: Its Tendency and Meaning.* New York–London: John Lane, 1915. Pp. 259–262, 323.

1920 24. Gustave Coquiot. *Les Indépendants.* Paris: Ollendorff, n.d. Pp. 181–82, 196. English translation by Ralph Manheim in: Robert Motherwell, ed., *Dada Painters and Poets.* The Documents of Modern Art, New York, George Wittenborn & Co., 1951.

1921 25. Waldemar George. "Robert Delaunay et le triomphe de la couleur." *La Vie des Lettres et des Arts* (Paris), no. XI, 1921, pp. 331–33.

1922 26. André Salmon. *Propos d'atelier.* Paris: Crès, 1922. New edition, Paris: Ed. Excelsior, 1938. Pp. 141, 160, 188, 205–6.

1923 27. Philippe Soupault. "Robert Delaunay, peintre." *Feuilles Libres* (Paris), No. 33, September–October, 1923, pp. 167–175.

28. ———. "R. Delaunay." *Het Overzicht* (Anvers), no. 18–19, October, 1923, pp. 99–102.

1924 29. Sheldon Cheney. *A Primer of Modern Art.* New York: Boni and Liveright, 1924. Pp. 110–11, ill.

30. Florent Fels. "Propos d'artistes: Robert Delaunay." *Les Nouvelles littéraires* (Paris), October 25, 1924.

31. Ivan Goll. "Le Peintre Robert Delaunay parle." *Surréalisme* (Paris), no. 1, October 1924.

1925 32. Joseph Delteil. "Robert Delaunay, peintre de jour." *Les Arts Plastiques* (Paris), no. 1, March 1925.

33. Arp and Lissitzky. *Die Kunstismen.* Zürich: Eugen Rentsch Verlag, 1925. Pp. X, 21.

34. Ilarie Voronca. "Simultaneismul in Arta." *Integral* (Bucharest), 1925, no. 6–7, pp. 2–3.

1926 35. Carl Einstein. *Die Kunst des 20. Jahrhunderts.* Propyläen-

Kunstgeschichte, vol. XVI. Berlin: M. Propyläen-Verlag, 1926. Pp. 67, 79, 80, 92, 126, 142, 149, 159, ill.

1927 36. Maurice Raynal. *Anthologie de la peinture en France de 1906 à nos jours.* Paris: Ed. Montaigne, 1927. Pp. 27, 28, 30, 31, 113–18, 223, ill.

1929 37. Guillaume Janneau. *L'Art Cubiste: Théories et réalisations.* Paris: Ed. Charles Moreau, 1929. Pp. 20, 21, 22, 24, 50, 51.

1931 38. Blaise Cendrars. *Aujourd'hui.* Paris: Grasset, 1931. Pp. 124–28, 135–49.

1933 39. Pierre du Colombier. *Tableau du XXe siècle, 1900–1933: Les Arts, la Musique et la Danse.* Paris: Denoël et Steele, 1933. Pp. 79, 80–81.

 40. Herbert Read. *Art Now.* London: Faber and Faber, 1933. Second edition, 1934; new edition, 1936; revised and enlarged edition, 1948 and 1950. P. 96, pl. 168.

1934 41. Germain Bazin. "L'Orphisme." In: René Huyghe, ed. *Histoire de l'Art Contemporain: L'Amour de l'Art.* Paris, 1934. Vol. IX, chap. IX, ill.

 42. Gertrude Stein. "Autobiographie d'Alice Toklas." *Nouvelle Revue Française* (Paris), 1934, pp. 127–29, 266.

1935 43. Jean Cassou. "R. Delaunay et la plastique murale en couleur." *Art et décoration* (Paris), March 1935, pp. 93–98, ill.

1936 44. Alfred H. Barr, Jr. *Cubism and Abstract Art.* New York: The Museum of Modern Art, 1936. Pp. 6, 26, 29, 42, 46, 73, 77, 82, 92, 133, 207, 243, ill.

1937 45. Raymond Escholier. *La Peinture française*, XXe siècle. Paris: Floury, 1937, Pp. 74, 76, 98, ill.

1938 46. Amelia Defries. *Purpose in Design.* London: Methuen, 1938. Pp. 48, 49, 50.

 47. Jean Girou. *Peintres du Midi.* Paris: Floury, n.d. Pp. 198–201, 203.

 48. Christian Zervos. *Histoire de l'art contemporain.* Paris: Cahiers d'Art, 1938. Pp. 241, 311, ill.

1939 49. Charles Terrasse. *La Peinture française au XXe siècle.* Paris: Hypérion, 1939. Pp. 18, 20, 30; pl. 48.

1940 50. *Museum of Living Art. A. E. Gallatin Collection.* New York: New York University, 1940.

1942 51. Peggy Guggenheim. *Art of this Century.* Catalogue of

collection—objects, drawings, photographs, paintings, sculpture, collages, 1910–1942. New York: Art and Corporations, 1942. Pp. 66, 67.

1944 52. Bernard Dorival. *Les Étapes de la peinture française contemporaine*, vol. II: *Le Fauvisme et le Cubisme*. Paris: *Nouvelle Revue Française*, 1944. Pp. 198, 200, 215, 217, 283–87, 290, 291, 326.

1945 53. Egidio Bonfante–Juti Ravenna. *Arte Cubista*. Venice: Ed. Ateneo, 1945. Pp. 22, 23, 24, 31, 135.

54. René Huyghe. *La Peinture actuelle: La Peinture française*. Paris: Ed. Pierre Tisné 1945. P. 13, pl. 11.

55. Gaston Diehl, ed. *Les Problèmes de la peinture*. Paris: Confluences, 1945. Pp. 52, 111, 247, 327, 328.

1946 56. Jean Cassou. "Robert Delaunay." Preface to the catalogue of the Robert Delaunay exhibition. Paris: Galerie Louis Carré, December 17, 1946–January 17, 1947. Pp. 15–19, ill.

57. Carola Giedion-Welcker. "Robert Delaunay." *Das Werk* (Winterthur), no. 8, 1946, pp. 273–79.

1947 58. R. S. Davis. "Institute acquires cubist masterpiece." *Bulletin of the Minneapolis Institute of Arts* (Minneapolis), 1947, Oct. 4 (XXXVI, Bi, 24).

59. Jacques Lassaigne, Raymond Cogniat, Marcel Zahar. *Panorama des Arts*. Paris: Aimery Somogy, 1947. Pp. 23, 50, 95, 163, 220, 250, 254, 274, 283–84, 291, 299, ill.

1949 60. René Huyghe. *Les Contemporains*. Paris: Ed. Pierre Tisné, 1949. Pp. 66, 67, 68, 69, 95, 96, 97, 111, 112; reproduction: pl. 86.

61. Michel Seuphor. *L'Art Abstrait: Ses origines, ses premiers maîtres*. Paris: Maeght, 1949. Pp. 14, 15, 16, 29, 31, 41–47, 85, 95, 101–8, 117, 179, 285–88, 289, 291, 292, 302, 303, 307, 318, ill.

62. G. di San Lazzaro. *Painting in France, 1895–1949*. London: The Harvill Press, 1949. Pp. 32, 61, 65, 96, 126, ill.

63. F. Gilles de la Tourette. *Robert Delaunay*. Preface by Y. Bizardel. Paris: Librairie Centrale des Beaux-Arts, 1950. 25 pl.

64. Florent Fels. *L'Art Vivant de 1900 à nos jours*. Geneva: Cailler, 1950. Pp. 100, 237; ill.

65. Georg Schmidt. "Franz Marc und August Macke im Kreise

ihrer Zeitgenossen." Basel: *Öffentliche Kunstsammlung.* Pp. 121–23.

66. *De Picasso au Surréalisme: Historie de la Peinture Moderne,* vol. III. Geneva: Skira, 1950. Index, ill.

1951 67. Juan Eduardo Cirlot. *La Pintura abstracta.* Barcelona: Ed. Omega, 1951. Pp. 22–24, 27, 28, 63, pls. 16 and 17.

1952 68. Paul Ferdinand Schmidt. *Geschichte der modernen Malerei.* Stuttgart: W. Kohlhammer Verlag, 1952. Pp. 136, 142, 204, 224.

69. Pierre Francastel. *Peinture et société.* Lyons: Audin, 1951. Pp. 209, 220, 250–52, 257, 260, 275; pls. 67 and 68.

1953 70. Damián Carlos Bayón. "Discusión del Cubismo." *Ver y Estimar* (Buenos Aires), vol. IX, December 1953, pp. 18, 21, 24–26, 28, 30, 31, 35.

71. Adrian Heath. *Abstract Painting: Its Origin and Meaning.* London: Alec Tirandi, 1953. Pp. 15, 16, 17.

72. Walter Hess. *Das Problem der Farbe in den Selbstzeugnissen moderner Maler.* Munich: Prestel Verlag, 1953. Pp. 74, 82–86, 113, 147, 161, 171.

73. "Le Cubisme." *Art d'Aujourd'hui* (Bologna), series 4, nos. 3–4, May–June 1953, ill.

74. Maurice Raynal. *Peinture Moderne.* Geneva–Paris–New York: Skira, 1953. See index, 3 pl.

75. Gustav Vriesen. *August Macke.* Stuttgart: W. Kohlhammer, 1953. Pp. 92, 95, 114–19, 124, 134, 263–64.

1954 76. Alfred H. Barr, Jr., ed. *Masters of Modern Art.* New York: The Museum of Modern Art, 1954. Pp. 76, pl. p. 77.

77. Jacques Lassaigne. *Dictionnaire de la Peinture Moderne.* Paris: F. Hazan, 1954. Pp. 75–77, 212, ill.

78. Werner Haftmann. *Malerei im 20. Jahrhundert.* Munich: Prestel-Verlag, 1954. See index, pl. 14.

1955 79. Pierre Francastel. *Histoire de la peinture française,* vol. II: *Du Classicisme au Cubisme.* Paris: Elsevier, 1955. See index, ill.

80. Robert Genaille. *La Peinture contemporaine.* Paris: Fernand Nathan, 1955. Pp. 82–84, 163–64, 248, 264, pl. 8.

81. Werner Haftmann. *Malerei im 20. Jahrhundert.* Munich: Prestel-Verlag, 1955, pp. 133–37, ill.

1956 82. Marcel Brion. *Art Abstrait*. Paris: Albin Michel, 1956. Pp. 129–35, ill.

1957 83. Jean Cassou. Preface to catalogue of the Robert Delaunay exhibition. Paris: Musée Nationale d'Art Moderne, 1957.
 84. Pierre Francastel. *Robert Delaunay: Du Cubisme à l'art abstrait*. Unpublished documents with a catalogue by Guy Habasque; bibliography. Paris: S.E.V.P.E.N., 1957.

1959 85. John Golding. *Cubism: A History and an Analysis, 1907–1914*. London: Faber and Faber Ltd., 1959.
 86. Guy Habasque. *Cubism*. Geneva: Skira, 1959.

1960 87. Werner Haftman. *Painting in the Twentieth Century*, 2 vols. New York: Frederick A. Praeger, 1960.
 88. Cecily Mackworth. *Guillaume Apollinaire and the Cubist Life*. London: John Murray, 1961.

1961 89. Jean-François Revel. "Le Cubisme mis en regard de l'art abstrait." *Connaissance des Arts*, February 1961.
 90. Eduard Steneberg. "Robert Delaunay und die deutsche Malerei." *Das Kunstwerk*, vol. 4/XV, October 1961, pp. 3ff.
 91. Joshua C. Taylor. *Futurism*. The Museum of Modern Art. Garden City, New York: Doubleday & Company, 1961.

1962 92. Johannes Langner. "Zu den Fenster-Bildern von Robert Delaunay." *Jahrbuch der Hamburger Kunstsammlungen*, vol. VII, 1962.
 93. Hans Platte. "Robert Delaunay." Introduction to catalogue of the Robert Delaunay exhibition. Kunstverein, Hamburg; Wallraf-Richartz Museum, Cologne; Kunstverein, Frankfurt, 1962.
 94. Madeleine Vincent. "Trois Tableaux de Robert et Sonia Delaunay au Musée des Beaux-Arts de Lyon." *Bulletin des Musées et Monuments Lyonnais* (Lyons), vol. III, no. 1, 1962, pp. 1–8.

1963 95. Raffaele Carrieri. *Futurism*. Milan: Edizioni del Milione, 1963.
 96. Francis Steegmuller. *Apollinaire: Poet Among the Painters*. New York: Farrar, Straus and Company, 1963.

1964 97. Georg Schmidt. Catalogue of the Kunstmuseum, Basel, 1964. Pp. 221 ff.

1965 98. Guillaume Apollinaire. *Les Peintres cubistes: Méditations*

esthétiques. Presented by LeRoy C. Breunig and J. C. Chevalier. Paris: Editions Hermann, 1965.

99. Robert Rosenblum. *Cubism and Twentieth-Century Art.* New York: Harry N. Abrams, Inc., 1965.

1967　100. Maurizio Calvesi. "Futurismo e Orfismo." *L'Arte Moderna.* Fratelli Fabbri Editori (Milan), vol. V, no. 43, 1967.

101. Gustav Vriesen and Max Imdahl. *Robert Delaunay: Light and Color.* New York: Harry N. Abrams, Inc., 1967. Contains comprehensive bibliography through 1966.

1968　102. Roger Shattuck. *The Banquet Years.* New York: Vintage Books, 1968.

103. Marianne W. Martin. *Futurist Art and Theory: 1909–1915.* Oxford: Clarendon Press, 1968.

1969　104. *Apollinaire.* Paris: Bibliothèque Nationale, 1969.

105. Guenter Metkin. "The Delaunay's [*sic*] Theater." In Henning Rischbieter, ed., *Art and the Stage in the 20th Century: Painters and Sculptors Work for the Theater.* Greenwich: New York Graphic Society, 1969. Pp. 105–6.

1972　106. Leroy C. Breunig, ed. *The Documents of 20th Century Art. Apollinaire on Art: Essays and Reviews 1902–1918.* New York: The Viking Press, 1972.

107. Arthur A. Cohen. "The Delaunays, Apollinaire, and Cendrars." *Critiques, 1971–1972.* New York: The Cooper Union School of Art and Architecture, 1972.

1975　108. Bernard Dorival. *Robert Delaunay: 1885–1941.* Paris: Damase Editions, 1975.

WRITINGS AND PRINTED BOOKS BY SONIA DELAUNAY

(All translated by Arthur A. Cohen unless otherwise noted.)

1927　109. Sonia Delaunay. "L'Influence de la peinture sur l'art vestimentaire." Lecture delivered at the Sorbonne. January 27, 1927.

1929　110. ———. *Tapis et tissus. L'Art International d'Aujourd'hui,* no. 15. Paris: Editions d'Art Charles Moreau, 1929. 50 pp. of illustrations drawn from the work of S. Delaunay and others.

1930　111. ———. *Compositions, couleurs, idées.* Paris: Editions d'Art Charles Moreau, 1930. No text; 40 pp. of illustrations.

1932 112. ———. "Les Artistes et l'avenir de la mode." *Revue de Jacques Heim* (Paris), 1932.

1956 113. ———. "Collages de Sonia et de Robert Delaunay." *XXe Siècle* (Paris), no. 6, January 1956, pp. 19–21.

1958 114. ———. "La couleur dansée. 50 ans de recherches." *Aujourd'hui* (Paris), no. 17, May 19, 1958.

115. ———. [Letter to a client] in *Sonia Delaunay* (exhibit. cat.). Städtisches Kunsthalle, Bielefeld, 1958.

1966 116. ———. Untitled text accompanying portfolio of lithographs. Milan: Galleria Schwarz, 1966.

1967 117. ———. "Sonia Delaunay." *Rétrospective Sonia Delaunay* (exhib. cat.). Musée National d'Art Moderne, Paris, 1967.

118. ———. Statement in *Six Artistes à Grasse, 1940–1943* (exhib. cat.). Société du Musée Fragonard, Musée Régional d'Art et d'Histoire, Grasse, 1967.

1969 119. ———. *Robes-poèmes*. Text by Jacques Damase. Milan: Edizioni del Naviglio, 1969. 27 reproductions.

1970 120. [Arthur A. Cohen]. "Interview with Sonia Delaunay." Paris, July 22, 1970. Translated by Keith Cohen.

1971 121. ———. *L'Alphabet*. Text by Jacques Damase. Paris: Éditions Emme, 1969. English edition, New York: Thomas Y. Crowell, 1972.

Selected Writings about or Containing Discussion of Sonia Delaunay

1920 122. René Creval. "Visite à Sonia Delaunay." *La Voz de Guipuzcoa* (Bilbao), 1920.

1922 123. Ramón Gómez de la Serna. "Los Trajes Poemáticos." *La Voz de Guipuzcoa* (Bilbao), 1922.

1923 124. Guillermo de Torre. "El Arte Decorativo de Sonia Delaunay-Terk." *Altar*, no. 35, December 1923.

1924 125. Claire Goll. "Simultanische Kleider." *Bilder Courier* (Berlin), April 1924.

1925 126. André Lhote, ed. *Sonia Delaunay, ses peintures, ses objets, ses tissus simultanés, ses modes*. Paris: Librairie des Arts Décoratifs, 1925. Preface by André Lhote. Poems by Blaise

Cendrars, Joseph Delteil, Tristan Tzara, Philippe Soupault; marginal texts by others. 20 color plates.

1948 127. Louis Parrot. *Blaise Cendrars.* Paris: Pierre Seghers Editeur, 1948.

1950 128. Michel Seuphor. *L'Art abstrait, ses origines, ses premiers maîtres.* Paris: Maeght, 1950.

129. Michel Seuphor. "L'Orphisme." *Art d'aujourd'hui* (Paris), no. 7–8, March 1950.

130. F. Gilles de la Tourette. *Robert Delaunay.* Paris: Librairie Centrale des Beaux-Arts, 1950.

1954 131. Roger Bordier. "L'Art et la manière." *Art d'aujourd'hui,* no. 6, September 1954, pp. 12–14.

132. Jacques Lassaigne. *Dictionnaire de la peinture moderne.* Paris: F. Hazan, 1954.

1956 133. Leon Degand. "Sonia Delaunay et l'exaltation chromatique." *XXe Siècle,* no. 7, June 1956.

1957 134. Pierre Francastel, ed. *Robert Delaunay: Du Cubisme à l'art abstrait.* Paris: S.E.V.P.E.N., 1957. Unpublished documents with a catalogue by Guy Habasque; bibliography.

135. Michel Seuphor, *Dictionnaire de la peinture abstraite.* Paris: F. Hazan, 1957.

136. Guy Weelen. "Robes simultanées." *L'Oeil* (Paris), December 1959, pp. 78–84.

1960 137. Boris Kochno. *Diaghilev and the Ballets Russes.* Translated by Adrienne Foulke. New York: Harper & Row, 1960.

1961 138. Bernard Dorival. *L'École de Paris au Musée National d'Art Moderne.* Paris, 1961.

139. Cecily Mackworth. *Guillaume Apollinaire and the Cubist Life.* London: John Murray, 1961; New York, Horizon Press, 1963.

1962 140. Nino Frank et al., eds. *Blaise Cendrars (1887–1961).* Paris: Mercure de France, 1962. See Robert Goffin, "Blaise Cendrars," pp. 105–12; Jacques-Henry Lévesque, "Sur Blaise Cendrars: Extraits d'un recueil alphabétique," pp. 88–104; Emile Szittya, "Logique de la vie contradictoire de Blaise Cendrars, pp. 64–76; A. t'Serstevens, "Cendrars au bras droit," pp. 77–83.

141. Michel Ragon. "Sonia Delaunay a fait entrer le cubisme

dans la mode et dans la vie." *Arts* (Paris), no. 866, April 25–May 1, 1962, p. 11.

142. Madeleine Vincent. "Trois Tableaux de Robert et Sonia Delaunay au Musée des Beaux-Arts de Lyon." *Bulletin des Musées et Monuments Lyonnais*, vol. III, no. 1, 1962, pp. 1–8.

1963 143. Carlo Belloli. "I Delaunay e la grafica" (The Delaunays and Graphic Design). *Pagina* (Milan), June 1963, pp. 4–22.

144. ———. "La componente visuale-tipografica nella poesia d'avanguardia" (The Visual-typographical Component in Avant-garde Poetry). *Pagina* (Milan), October 1963, pp. 5–47.

145. G. d'Aubarede. "Sonia Delaunay évoque des souvenirs." *Le Jardin des Arts* (Paris), January 1963, pp. 2–9.

146. Bernard Dorival. "La Donation Delaunay." *La Revue du Louvre* (Paris), 1963, pp. 283–88.

147. R. V. Gindertael. "Sonia Delaunay et la poésie pure des couleurs." *XXe Siècle* (Paris), no. 21, May 1963.

1964 148. Pierre Cabanne. "Sonia Delaunay est depuis 50 ans à l'avant-garde." *Arts* (Paris), February 26–November 3, 1964, p. 8.

1965 149. Jean Clay. "The Golden Years of Visual Jazz: Sonia Delaunay's Life and Times." *Réalités* (English edition), 1965, pp. 42–47.

150. Charles Goerg. "Les Marchés au Minho de Sonia Delaunay." Geneva: *Bulletin du Musée d'Art et d'Histoire de Genève*, 1965, pp. 203–13.

151. Michel Sanouillet. *Dada à Paris*. Paris: Jean-Jacques Pauvert Editeur, 1965.

1967 152. Maurizio Calvesi. "Futurismo e Orfismo." *L'Arte Moderna* (Milan), Fratelli Fabbri Editori, vol. V, no. 43, 1967.

153. Gustav Vriesen and Max Imdahl. *Robert Delaunay: Light and Color*. New York: Harry N. Abrams, Inc., 1967.

1968 154. Michel Hoog. "Oeuvres récentes de Sonia Delaunay." *Cimaise* (Paris), October–November 1968, pp. 32–63.

1969 155. Guenter Metkin. "The Delaunay's [*sic*] Theater." In Henning Rischbieter, ed., *Art and the Stage in the 20th Century: Painters and Sculptors Work for the Theater*. Greenwich: New York Graphic Society, 1969. Pp. 105–6.

1971 156. Jacques Damase. "Sonia Delaunay, la grande dame de l'art abstrait." *Art* (Paris), 1971–1972, pp. 29–36.

157. ———. *Sonia Delaunay: Rhythms and Colors.* Greenwich: New York Graphic Society, 1972. (Eng. transl. of French ed., Paris, Hermann, 1971). Critical text and extensive color, black-and-white, and documentary illustrations.

158. Jacques Damase and Edouard Mustelier. *Sonia Delaunay.* Paris: Galerie de Varenne, 1971. Expository text and comprehensive bibliography; numerous color, black-and-white, and documentary illustrations.

159. Kornfeld & Klipstein. *Modern Kunst* (auction catalogue 142, Berne, June 10–12, 1971), p. 142 (detailed description of a copy of *La Prose du Transsibérien*).

1972 160. Arthur A. Cohen. "The Delaunays, Apollinaire, and Cendrars." Critiques, 1971/72. New York: The Cooper Union School of Art and Architecture, 1972.

161. Paulo Ferreira. *Correspondance de quatre artistes portugais . . . avec Robert et Sonia Delaunay: Contribution à l'histoire de l'art moderne portugais (années* 1915–1917). Paris: Presses Universitaires de France, 1972.

162. A. t'Serstevens. *L'Homme que fut Blaise Cendrars. Souvenirs.* Paris: Éditions Donoël, 1972.

1975 163. Arthur A. Cohen. *Sonia Delaunay.* New York: Harry N. Abrams, Inc., 1975.

164. Cindy Nemser. "Sonia Delaunay." *Art Talk: Conversations with 12 Women Artists.* New York: Charles Scribner's Sons, 1975. Pp. 34–51.

165. Michael Peppiatt. "Sonia Delaunay: A Life in Color." *Art News,* vol. 74, no. 3 (March 1975), pp. 88, 91.

166. Jacques Damase, ed. *Sonia Delaunay, 1925.* Paris: 1975.

Selected Exhibition Catalogues of Robert and Sonia Delaunay

1959 167. *Robert et Sonia Delaunay.* Musée de Lyon, 1959. Introductory text, "Les Delaunay," by René Jullian; biography, bibliography. Color reproduction on cover (Robert Delaunay), two color plates (Robert Delaunay), one color plate (Sonia Delaunay), numerous black-and-white reproductions.

1960 168. *Robert e Sonia Delaunay.* Galleria Civica d'Arte Moderna,

Turin, March 1960. Introduction by Jacques Lassaigne; essay, "Les Delaunay," by Guy Weelan; biography; bibliography. Color reproduction on cover (Robert Delaunay), two color plates (Robert Delaunay), one color plate (Sonia Delaunay), numerous black-and-white reproductions.

1965 169. *Robert and Sonia Delaunay.* The National Gallery of Canada, Ottawa, 1965. Foreword by Charles F. Comfort, Director; introduction by Bernard Dorival; text of catalogue by Michel Hoog; unpublished autobiography of Robert Delaunay; biography of Sonia Delaunay; documentary comment on the artists by other artists, critics, poets; extensive discussion on each work. Color plate from each artist on cover. Four color plates (Robert Delaunay), two color plates (Sonia Delaunay). Numerous black-and-white reproductions.

1972 170. *Sonia e Robert Delaunay em Portugal e os seus amigos Eduardo Vianna, Amadeo de Souza-Cardoso, Jose Pacheco, Almada Negreiros.* Fundàçao Calouste Gulbenkian, Lisbon, April, 1972. Texts by Paulo Ferreira and Fernando Pernes; extensive biographical material; documentary photographs and reproductions in color and black-and-white of all artists. Color reproduction on cover (Robert Delaunay).

SELECTED EXHIBITION CATALOGUES OF SONIA DELAUNAY
(Containing Text and Illustrations)

1958 171. *Sonia Delaunay.* Städtisches Kunstalle, Bielefeld, Germany, September 14, 1958. Numerous texts by and about the artist, critical biography, bibliography, and list of exhibitions. Five color, numerous black-and-white reproductions.

1962 172. *Sonia Delaunay.* Galerie Denise René, Paris, May 1962. Brief texts by Robert and Sonia Delaunay. Comprehensive biography, bibliography, list of exhibitions. Color reproduction on cover; black-and-white reproductions.

1964 173. *Sonia Delaunay Negli Anni Venti* (Sonia Delaunay during the Twenties). Galleria Minima, Milan, May 13, 1964. Essay by Carlo Belloli: "Sonia Delaunay e la totalità visiva del colore." Biography. Black-and-white reproductions.

174. *Donation Delaunay (Robert and Sonia Delaunay)*. Galerie Mollien, Musée du Louvre, Paris, February 1964. Text by Jean Cassou. Monochrome cover of fold-out catalogue by Robert Delaunay.

1966 175. *Französiche Spielkarten des XX Jahrhunderts*. Deutsches Spielkarten Museum, Bielefeld, Germany, July 15, 1966. Brief essay on design of Delaunay's playing cards. Ten color reproductions.

176. *Sonia Delaunay*. Gimpel & Hanover, Zurich, October 1965; Gimpel Fils, London, February 1, 1966. Text by Michel Hoog; biography. Color reproductions.

1967 177. *Rétrospective Sonia Delaunay*. Musée National d'Art Moderne, Paris, 1967. Introduction by Bernard Dorival, biography approved by artist, autobiography by the artist, critical text and discussion by Michel Hoog. Color reproduction on cover, color frontispiece, 24 black-and-white reproductions. 1967.

178. *Sonia Delaunay: Tapis*. Galerie d'Art Moderne, Basel, February 1967. Brief text by Jacques Damase.

1969 179. *Sonia Delaunay*. Galerie Denise René, Paris, November 1968. Brief texts by Sonia Delaunay. Color reproduction on cover. Three color plates; numerous black-and-white reproductions.

180. *Sonia Delaunay: Tapeti*. De Nieubourg Galleria di Ricera, Milan, January 12, 1968. Text by Jacques Damase; biography. Black-and-white reproductions.

1969 181. *Sonia Delaunay*. Galerie du Perron, Geneva, May–July 1969. Prefatory note by the gallery; extracts from various writings by and about the artist. Three color plates; black-and-white reproductions.

182. *Sonia Delaunay*. Gimpel and Weitzenhoffer, Ltd., New York, November 11, 1969. Brief text by Michel Hoog; biography. Black-and-white reproductions.

183. *Sonia Delaunay*. Navigliovenezia, Venice, June 1969. Brief biographical text and short text by Sonia Delaunay.

1970 184. *Sonia Delaunay: Opere 1908–1970*. Il Collezionista d'Arte Contemporanea, Rome, December 2, 1970. Texts by Magnelli, Robert and Sonia Delaunay, Apollinaire, and Murilo Mendes. Five color plates, numerous black-and-white reproductions.

185. *Sonia Delaunay: Tapis et oeuvres graphiques.* La Demeure, Paris, 1970. Text by Jacques Damase; biography. Color reproduction on cover, black-and-white reproductions.

1971 186. *Sonia Delaunay: Étoffes Imprimées des années folles.* Musée de L'Impression sur Étoffes, Mulhouse, 1971. Texts by J. M. Tuchscherer, Maiten Bouisset, Michel Hoog, and extracts from writings by Robert Delaunay; biography; selected bibliography; afterword by Madeleine-Robert Perrier. Color reproductions on cover, two color plates, numerous black-and-white reproductions.

1972 187. *Sonia Delaunay.* Galleria III, Lisbon, and Galleria Zen, Porto, Portugal, May 1972. Texts by Bernard Dorival, Charles Goerg, Edouard Mustelier, Jean Cassou, and Pierre Francastel, organized by Fernando Pernes. Six color plates, including cover, numerous black-and-white reproductions.

1972 188. *Sonia Delaunay. Tapisseries.* Musée d'Art Moderne de la Ville de Paris, Paris, October 1972–January 1973. Introductory text by Jacques Lassaigne. Biography; bibliography.

1973 189. *Sonia Delaunay: Wall Hangings.* The Corcoran Gallery, Washington, D.C.

190. *Sonia Delaunay. Peintures, Gouaches, Lithographies, Tapisseries.* Espace "2000," Brussels, 1973.

1974 191. *Sonia Delaunay.* Musée de Grenoble, 1975.

192. *Sonia Delaunay Retrospektivausstellung.* Städtisches Kunsthalle, Bielefeld, Germany.

1975 193. *Robes & Gouaches Simultanées "1925."* Galerie de Varenne, Paris, 1975.

194. *Hommage à Sonia Delaunay.* Musée National d'Art Moderne, Paris, 1975–1976.

195. *Sonia Delaunay. Tapisseries-Lithographies.* Syndicat d'initiative de Tournus et du Tournugeois, L'Abbaye de Tournus, 1975.

196. *Sonia Delaunay: Retrospectivausstellung zum 90. Geburtstag.* Retrospective on the occasion of her 90th birthday. Galerie Gmurzynska, Cologne, 1975. Text by Jacques Lassaigne. Critical biography, numerous black-and-white and color reproductions, documentary photographs.

Index